"Donna Rubinstein is more than qualified to write about the business of modeling. Her word is invaluable to anyone seeking to pursue a modeling career."

—Eileen Ford

"Donna Rubinstein has a true understanding of the fashion and modeling businesses. Her knowledge, experience and honesty make her advice invaluable. A reading must for those who are getting into the business."

—Katie Ford, CEO, Ford Models

"I have always appreciated Donna Rubinstein's acute sense of fashion and her ability to recognize future top models and stars. She has helped launch the careers of many models, too many to even mention. I am convinced that her book is going to be a winner since Donna is herself a winner both in her business and personal life."

—Monique Pillard, President, Elite Model Management Corp.

"*The Modeling Life* provides an overall view of the many ways to enter the world of modeling, as well as addressing the importance of self-love and being your own person first."

—Jan Planit, Vice President, IMG Models

"A true professional dedicated to the industry in giving the opportunity to create amazing careers for young adults."

—Irene Marie, President, Irene Marie Model Management

"Donna Rubinstein has launched the careers of many young stars. Developing healthy, well-balanced relationships between models, parents and agents, she has supported our industry's growth in her positive leadership to all of us."

—Page Parkes, President, Page Parkes Models Rep.

THE MODELING LIFE

THE ONE (AND ONLY) BOOK
THAT GIVES YOU THE INSIDE STORY
OF WHAT THE BUSINESS IS LIKE
AND HOW YOU CAN MAKE IT

DONNA RUBINSTEIN

with
Jennifer Kingson Bloom

A PERIGEE BOOK

A Perigee Book
Published by The Berkley Publishing Group
A division of Penguin Putnam Inc.
375 Hudson Street
New York, New York 10014

First edition: June 1998

Published simultaneously in Canada.

The Penguin Putnam Inc. World Wide Web site address is
http://www.penguinputnam.com

Library of Congress Cataloging-in-Publication Data
Rubinstein, Donna.
The modeling life / Donna Rubinstein with Jennifer Kingson Bloom. — 1st ed.
 p. cm.
ISBN 0-399-52409-6
1. Models (Persons)—Vocational guidance. I. Bloom, Jennifer Kingson. II. Title.
HD8039.M77R83 1998
659.1'52—dc21 97-38351
CIP

Printed in the United States of America
10 9 8 7 6 5 4 3 2

For my mom and dad

CONTENTS

PART ONE
WHAT'S IT LIKE TO BE A MODEL? ▲ 1

PART TWO
CAN YOU BE A MODEL? ▲ 147

FOREWORD

When my daughters, Niki and Krissy, entered the modeling field, I took a deep breath, fastened my seat belt, and held on for the ride. And it was quite a ride! Really, that's how fast things happened.

I am asked all the time to give advice to young girls (and their parents) who want to model. I only wish there had been a book written like this back when we started. It would have given us a lot of advice and much-needed direction. We were fortunate to meet up with a man—we call him J.R.—early in my daughters' careers who gave us that second opinion and valuable direction we so desperately needed. He is Niki's manager today.

What I can tell you is that you can have a good career on your own terms. You need to work with a good agency (of which there are many) and an agent who truly believes in you. Everyone is an individual with different needs and situations. Niki and Krissy were very different in their needs and their development.

At first, modeling was something the girls did on the side. Just as you might pursue a career in gymnastics, ice-skating, swimming, softball, or other challenging activities, they pursued modeling. It was something they were good at and it was as competitive as any sport. People may think modeling is a glamorous business, but you have to understand it is a job. It takes a lot of time and dedication on your part to succeed and possibly turn it into a professional career.

If you have the right look and the right information, you will achieve success. You need to be the very best that you can be—be professional, punctual, well groomed, and keep yourself healthy.

Don't forget your family and friends. This is a short-lived career and, when all this is over, they will still be there for you.

Through the years, Donna has become a friend to many young models just starting out. For most, she gave them their first start. Think of her as your friend and take her advice, and learn about this exciting career you've been thinking about.

Wishing you lots of success,

Barbara Taylor,
Niki and Krissy's mom

ACKNOWLEDGMENTS

My first debt of gratitude is to my writer, Jennifer Kingson Bloom; thank you for your patience, hard work, and support, as well as being able to decipher my handwritten notes and visuals. To Diane Frieden, thank you for reading my proposal and for introducing me to Elyse Cheney of Sanford J. Greenburger, my agent. Thanks, Elyse, for your keen business sense. Thanks to Dolores McMullan, my editor at Perigee Books, and her assistant, Erin Stryker. And thanks to John Duff, publisher of Perigee, for personally overseeing this project.

I am most grateful to those who have contributed their models, granted permission for use of their material, and those who helped with legalities. Thanks for your support and encouragement: Carey Arban, Tyrone Barrington, John Bass, Cheri Bowen, Kathy Campbell, Francine Champagne, Serene Cicora, Scott Claxson, JD Cohen, Elizabeth Costa, Patti Cromeenes, George and Isabel Dassinger, Steve Deck, Sara Dixon, Petra Flannery, Wendy Ford, Andrew Fox, Chris Garber, Susan Georget, Colleen Graham, Betty Lane Grambling, Marie Green, Dallas Hartman, Bill Heil, Dan Hollinger, Lewis Huynh, Carolyn Johnson, Susan Kaleta, Mark Kalish, Chris Kilkus, Keenya Knight, Al Lacayo, Paige Larson, Paula Palm Lewis, Judy Linton, Kristy McCormick, Mel McFarland, Kristy Meyers, Harold Mindel, David Mogull, Melissa Omafray, Page Parkes, Jan Planit, Patty Raso, Mark Reed, Jean Renard, Helen Rogers, Gwen Saiman, Marion Smith, Mitchell Solarek, Janet Speck, Jan Stewart, and Calvin Wilson.

It would be a long list if I enumerated all those I have worked with throughout the years who have enabled me to pursue my career, culminating in writing this book. Thanks to those who called me every day professing to have the "next star."

I especially express my gratitude to Mrs. Barbara Taylor, who has supported this particular project by the generous sharing of her family's personal and professional lives. Thank you for your friendship and professional insight. And to Krissy, you are in my thoughts.

For the many, many editors and stylists, past and present, at *Seventeen,* in particular to Meredith Berlin, Caroline Miller, Midge Richardson, and Nancy Hessel Weber, thank you for your creativity, talent, and for providing a perfect working environment.

To the models who shared their experiences with me for this book, thank you for your time. It is through your stories that the readers will draw inspiration. Thanks to the photographers for permission to use their photographs in this book. And special thanks to Leigh Crystal for her help with the cover.

To my friends, who have been there for me, always insightful, encouraging, patient and understanding, I am grateful. Specifically to Winnie, for making the first connection, to Madalyn, for seeing this project for me, to Emme and Phil, for sharing their experiences with me. Thanks John, for your gift with words and inspiration. Thanks Don (and for taking my photo), Jason, and especially Claire, for your advice and humor.

Above all, to my family, my parents, Linda, Pamela, Brooks, and the next stars, Taylor and Jake. Thank you for your love, input, encouragement, and understanding. And to Jim, thank you for your love and support. I love you all very much. And as for . . . divine intervention, I remain thankful.

INTRODUCTION

"All our dreams can come true—
if we have the courage to pursue them."
—Walt Disney

You have less than thirty seconds to make an impression on me.

That's how long it usually takes me to decide if you might have what it takes to be a model.

Since I see pictures of maybe a hundred young people a week, and go to modeling conventions where I see about a thousand girls a day, my first impression is what I have to go with.

And my hunches have a good track record: I hired models for the covers and pages of *Seventeen* magazine for almost a decade. I have seen young girls go from shy teenagers to famous models and actresses. Think of supermodels who are household names, like Niki Taylor, Tyra Banks, and Kate Moss, and actresses like Cameron Diaz and Liv Tyler. I knew them all when they were in high school, and I helped launch their careers.

There have been dozens and dozens of other models whose talents I spotted, whom I hired, and who have gone on to successful careers—not necessarily at the level of supermodel, but certainly in ways that were satisfying and lucrative. Not a day goes by when I don't see a model whom I worked with at the beginning of her career who is now on a television show or commercial, a magazine cover or advertisement, a billboard or other promotion.

My name is Donna Rubinstein. To the dozens of aspiring models who write me poignant letters every week asking for advice on breaking into the business, I am "Ms. Rubinstein." To the girls I work with—and to everyone

in the fashion industry—I'm just "Donna." When an agent at a modeling agency has a hot young prospect, she's likely to tell her: "Go see Donna." When a young model is discussing career options with her parents, chances are she'll say: "Let's ask Donna."

Working with young people is one of the most rewarding aspects of my job. I love seeing girls when they are starting out in the business—raw, green, but with such boundless potential—and watching them blossom into well-rounded professionals. I like hanging out with them, hearing their thoughts and ideas and concerns as they gain familiarity with a career that forms the cornerstone of dreams for so many girls. I most enjoy the lasting friendships I make with the girls I have worked with.

In short, I've spent a very large part of my adult life in the company of fashion models, and an equally large chunk isolating the qualities that make a person a model. The purpose of this book is to share my experiences with you. I hope to give an insider's glimpse of what it's really like to be a top model: the pace of the day, the ups and downs of the career, the tedious and frustrating sides of the job as well as the glamorous ones. I'll talk about the various aspects of a model's life—her business and professional life, as well as her social and home life—while drawing on my own observations and the experiences of well-known and lesser-known models.

I've also included a chapter that describes the general qualities I look for in a model and a quiz for readers who want to size up whether they have what it takes to be a model. After that, for readers who think they might have the right stuff for modeling or who just want to know more about how the industry works, I've included a step-by-step guide. This, the last part of the book, is meant to offer easy-to-follow advice for girls who want to get into modeling but need help figuring out how and where to start.

Finally, in the appendix, I've listed some of the nation's top modeling agencies, plus some contests and conventions that offer direct access to major modeling agencies at minimal costs. Not every state has an agency that feeds models directly to premier fashion magazines and advertisers, and girls who live far from major metropolitan areas may have to travel some distance to find representation from a major agency. Many girls start at smaller, local agencies, then graduate to the larger ones. At the same time, there are opportunities for models at some level of the business everywhere in the country—it's a career one can pursue and succeed at without leaving home.

The stories in this book of how different models got started and how their careers have progressed are examples of one of my central points: that each person is an individual and should base her decisions on her specific needs, wants, desires, and limits. I've included stories of girls who have gotten discovered through schools and conventions, not to say that it works for everyone—in fact, it works only for a very few—but to illustrate that it worked for these specific girls, who might have been discovered a different way. There is no one formula for getting into this business or staying there. These examples should be just that—examples, inspirations—not patterns that need to be followed precisely.

To be sure, these examples show the success that can be achieved through modeling. But also keep in mind that there are thousands and thousands of girls who will never make it. Some will spend a lot of time and money to find that out. I am hopeful that this book can help you avoid getting sidetracked.

One thing to note is that some of the models interviewed for this book may not still be in the business by the time you are reading it. The industry is fickle and many models find it's not for them. Some models in this book may have stopped getting work or decided they would prefer to do something else. Some others may even be stars or on their way to stardom. All the interviews for this book were conducted a year ago, and a lot happens in a year. People—particularly young people—change and develop. For a teenager, a year is a very long time in which a lot can happen. The industry changes, too, so that a girl who is in high demand may not be sought after a year later.

Also note that I could not have possibly included every reputable agency or a fraction of the amazing models who are out there. I would have loved to. There are many great agencies and talented models I have not included, and I wish to acknowledge them all.

By the time this book comes to you, there will be girls in the industry being discovered, testing, and even working who—at the time of the writing—were not models and may not have ever thought about being models. It's an interesting point to think about.

Not everyone can be a model. Even a lot of beautiful women, whom you might pass on the street and think, "She should be a model!" aren't cut out for the job for one reason or another. I've met tons of gorgeous girls who would seem to fit the right profile—tall, attractive, clear skin, great hair—who were

totally wrong for modeling. Maybe they couldn't move in front of the camera or couldn't convey their personality in a photogenic way. Or maybe they couldn't physically or emotionally handle a career in modeling.

And plenty of models who *do* start careers decide to quit the business, for all kinds of reasons. I've seen lots of girls who seemed to have all the right ingredients in place—the physical characteristics, an agent, and even regular work—who decided for personal reasons that modeling didn't suit them. Even though people told them they should model, they found out that the business, with all its demands and fierce competition, was not to their liking.

At the same time, I've met lots of people whom you would never in a million years pick out from the crowd as potential models, but who had "it"—that elusive, magnetic "it"—that transformed somewhat ordinary looks into fabulous modeling careers. It all depends on the person—her "look," her ambition—and the timing. The climate of the industry shifts constantly, standards are ever-changing, and not every model's "look" fits what is in demand at any given moment.

The modeling and fashion industries are based on supply and demand. Currently the standards in the industry are such that models who are naturally thin are the ones who are in demand, the ones who are working. There are very exact body proportions that a model needs in order to pursue a career: some girls are naturally thin and have no trouble maintaining these proportions, but problems arise when girls try to fight their natural body shapes by slimming down to industry standards. You can read more about this issue in this book in chapter 9.

Traveling around the country to scout for models and give advice, I am constantly struck by how strong and deep young people's passions are about models and what they represent. I am always hearing from girls who say their entire bedrooms are covered with pictures of models that they cut out from magazines every night. I talk to teenagers who say they would "do anything" to be a model—and I tell them that's an unhealthy approach, and why. Modeling is a great job for a lot of people, but it isn't a career that people should have to make enormous personal or financial sacrifices to enter.

Another important point potential models should know up front is that modeling is not an easy job—if it were, a lot more people would do it. Over and over, the models who were interviewed for this book told me they were surprised at how grueling and difficult modeling turned out to be, and that

their friends and family all assumed that it was easy, too. Having "what it takes" is a lot more than looking good, and even people with all the right personal ingredients still find that the work takes a lot out of them.

I lecture at modeling conventions, appear on television talk shows, and get inquiries from all corners of the globe about modeling. The most common questions I am asked, over and over again, are "How can I get into modeling?" "Do I have what it takes to be a model?" and "What's it really like to be a fashion model?" For every young person who has asked me those questions, as well as for those who have always wondered, I have written this book.

WHAT'S
IT LIKE
TO BE
A MODEL?

BEGINNINGS

"When you are content to be simply yourself
and don't compare or compete, everybody will respect you."
—Lao-Tzu

'M FASCINATED BY the stories I hear about how girls get started in modeling. Every model you see in magazines, ads, and on the runway got started somewhere, somehow.

There is no set formula for beginning a career. Some girls happened to be shopping in a department store when an agent from a top modeling agency dropped in during her lunch break. Other girls get spotted at rock concerts, on city buses, and even at the supermarket. Still others made an effort to get "found" by entering a modeling convention or contest. And there are lots of girls who went to an "open call" at an agency in their hometown, showing up during the two or three hours a week that an agency sets aside to see girls with no experience or references.

I'll say to an agent, "How did you find her?" and the agent will say, "Oh, she just walked in off the street to our open call." Or an agent may say that a photographer spotted her somewhere—shopping malls, airports, and bus depots seem to be common places to be discovered—and recommended her to an agency.

Major modeling agencies also rely on a network of institutions to recommend models to them: smaller agencies, schools, and conventions around the country. The big agencies send scouts to find new models through these channels, and they also scour the major agencies in Europe and elsewhere abroad.

Timing is one of the biggest factors for girls who are trying to get started, in addition to having the talent for the job to begin with. One frustrating fact is that timing is totally out of one's control. No matter how carefully a girl follows the necessary steps, modeling may not happen for her if she's not in the right place at the right time, not seen by the right person, or if her "look" is not in vogue.

Unless a girl lives near a big city like New York, Los Angeles, Chicago, Miami, San Francisco, Seattle, or Atlanta, she typically begins working with a local agency, one in a smaller town. If she shows particular talent, she may be referred to a larger agency in one of those cities. Representation by a major agency is every model's goal, the key to landing big jobs and contracts.

There are many ways to get "discovered" or to make it happen for yourself. Some girls always wanted to model and did everything they could think of to boost their chances. Others never considered modeling until a scout or photographer suggested it. For some models, getting a break took time, energy, and a large emotional and financial toll. For others, it was practically effortless.

Since I work with so many girls at the beginning of their careers, it's also fun for me to track which ones take off. A handful of the girls I have worked with have become superstars. I know some girls who started modeling and then decided that the industry was not for them, that they would prefer to do something else, like go to college or pursue a different career path. Some girls continue modeling throughout school, enjoying lucrative careers that boost their self-confidence but never elevate them to the status of superstar. Many girls are content working on the local level. Each model is different.

Models' stories are as varied and unique as their own looks and personalities. What they have in common is that each girl was at the right place at the right time, and that the right person spotted her potential.

There are things an aspiring model can do to enhance her chances of being seen by that major agency, but keep in mind that timing and persistence play a big part.

GREAT STARTS

When a girl is really right for modeling, the industry often finds her before she finds it—especially in New York City.

Take Filippa Von Stackelberg, who is only fifteen and attends ninth grade in New York. Even as a preteen, she had been stopped on the street twice by modeling agents who asked her to get into the business. By the time she was thirteen and a photographer approached her out of the blue, she started to get the feeling that modeling was her destiny. Though she had previously considered herself too young, three inquiries in such a short time were a sure sign that something about her was right for modeling.

Filippa let the photographer introduce her to Next Management (agent), and her career took off like wildfire.

Filippa's first job was a story for *Seventeen*. After that, it seemed like everybody wanted to use her. She has appeared in *Marie Claire* and French and Italian *Vogue,* walked runways for Cynthia Rowley and Jill Stuart, and done ad campaigns for Gucci and Abercrombie & Fitch. She has already had her first taste of fame, and it has been slightly overwhelming.

Read about Filippa's reaction to seeing herself in an ad for The Gap in chapter 4: School and Home Life.

Filippa said she was thrilled and amazed when she first started seeing her pictures in major magazines, but now it has become routine. A serious student who only works after school and on weekends, Filippa turns down jobs other girls would die for. "I don't mind turning down jobs," she said. "Sometimes I don't care if I get a job I'm up for because I know if I don't get this one, there will be others. I'm still young."

When a girl is really "hot"—has the right look at the right time—her career can take off in an instant, like Filippa's did. Imagine winning major campaigns for upscale designers like Gucci when you are only thirteen! Part of it, of course, is timing: Filippa has the current look. With an innocent, doelike face and a slender, small-boned body, she radiates the kind of sweetness that advertisers and photographers are looking for.

If you are fortunate enough to live in New York City—which is considered the modeling and fashion capital of the United States, if not the world—it is quite possible that you will get discovered if you have modeling potential.

Scouts are roaming all over the city, as are other people in the industry who routinely refer girls with the right "look" to reputable agencies.

But living in New York is by no means a prerequisite to being discovered. Another girl with great success grew up in Utah—a state that has never been known as a fashion capital! Jenny Knight, fifteen, now lives in New York and models full-time. She travels constantly to jobs in Los Angeles, Cuba, Morocco, Paris, Miami, and Milan.

"I started when I was thirteen with an agency where I'm from in Utah," said Jenny, who fulfills her educational requirements through a correspondence school. "This local agent showed my pictures to Click Model Management in New York, who is now my agent."

That simple introduction has led to a great career: Jenny has appeared on television commercials for Armani jeans; in ad campaigns for Versace, Krizia, and Versus; and in runway shows for Romeo Gigli, Marc Jacobs, Sonya Rykiel, and other top designers. Her magazine credits include *Seventeen*, American and French *Elle*, French *Marie Claire*, and Italian and German *Vogue*. She has worked with such prominent photographers as Gilles Bensimon, Andre Rau, Arthur Elgort, Ellen Von Unwerth, and Wayne Maser.

OPEN CALL

One of the most direct ways to get a modeling career started is by literally walking into the office of a major modeling agency. (Make sure you arrive the day and time they specify!)

Nina Kaseburg, a sixteen-year-old model in Seattle, did it on a whim during a school break and has been working steadily as a model ever since.

"For a few years, people had kind of started telling me, 'Oh, you should model,' " she said. Then one of her mother's coworkers, who had once been a model, persuaded Nina to try her luck at an open call.

"I was fairly reluctant to give up any part of my summer vacation, even if it meant an hour," Nina recalled. "But my mother's friend asked me to go to Seattle Models Guild for the open call at 4 P.M. I decided, 'This is the only time I'm going to do it, I might as well.' "

At the open call, a woman from the agency gave some opening comments to the crowd. "She was saying, you need snapshots, and if you're under 5'8" don't even bother to stay five more minutes," Nina said. "I'm only 5'7½", and I didn't have any snapshots, but I stayed. They told me to come back with some snapshots, and when I did I was signed."

Knocking on the door of a major modeling agency with amateur snapshots of yourself may sound like a pretty scary thing to do, and most people who do it are turned away. Yet they represent only a fraction of the people who seek out an agency's attention. Every week, most agencies receive hundreds of letters and pictures from people who want to become models. All but a few of these people get rejected without so much as a letter or a phone call in reply.

But agencies are always on the lookout for fresh talent—that's why they have their scouts checking out shopping malls and the like, and that's also why each agency reserves a few hours during the workweek to review people who walk in off the street. Anyone can come in.

Usually, just a cursory glance at a girl and her pictures can clue an agent in as to whether or not she can be a model. It's a really short process. Those who get rejected often feel it's unfair and that the agent didn't take a close enough look at them, and those who get accepted are often shocked that such a brief meeting could turn into a modeling contract right away.

Some people are referred to an agency by a professional, but others have to rely on their own courage, determination, and confidence. One model I know, nineteen-year-old Kristin Klosterman, walked into an open call when she was fourteen at her current agency, Irene Marie Model Management in Miami, and was pleasantly shocked when the agents freaked out over her looks.

Then things moved fast. The agency asked her to sign a contract right away, Kristin went and got her mom, and they signed the contract and began taking test photographs (pictures taken to show potential clients the range and versatility of a model's looks) the same day. Days later, Kristin was working for a French catalog as a professional model.

Open Call:
What's It Like?

▼

Tomiko Fraser, a twenty-two-year-old model who grew up in New York City, got discovered during an open call at Wilhemina, her first agency. She described the experience as "very frightening, very overwhelming."

Tomiko said: "You walk into a reception area full of about thirty scared girls. I had heard from other girls that it's very rare that they pick girls from these open calls. I said, 'I'm just going to try it, but I'm not going to get it.' They finally called me back in, and they said, 'We like you and we want to represent you.' I was ready to faint! I mean, this is one of the biggest agencies in the world. They put me on a test board, and I was considered a 'new face' model. We tossed my old pictures and started from scratch."

▲

CONVENTIONS

Another way to have an agent from a major market see you is for the agent to come to you. Conventions provide this service.

Modeling conventions take place all over the country, all the time, and thousands of girls participate in them (for an entrance fee). The sponsor companies invite about twenty or twenty-five reputable agents from major markets around the country to view the thousand or so girls whom the company selected through a screening process.

Lots of girls who try out don't make the cut to attend the convention, and even for those who do, the odds of being signed by one of the agents are pretty small. At each convention, some do gain agency representation. It takes standout model looks to be found at one of these events, but it happens if a girl really has what it takes.

I go to lots of modeling conventions to scope for talent for *Seventeen,* and I'm always impressed by the courage of the girls who take the initiative to participate in them.

Take Jessica Biel, who is only fourteen but is already an actress in Los Angeles. Jessica got discovered at a convention where she lined up with hundreds of other girls to be looked over by agents. Jessica's tremendous looks and presence got her noticed, and her success as a model quickly led to her landing a role in the television show *Seventh Heaven,* where she now has a multiyear contract.

Jessica grew up in Boulder, Colorado. "When I was eleven, I was with a small acting

agency in Denver," she said. "Through them, I attended the IMTA (International Modeling and Talent Association) convention in Los Angeles. I paid money to attend, but I got three agents out of it."

After Jessica chose an agent, LA Models, she started going on lots of go-sees and did her first modeling job for the Limited II clothing line. Along the way, she and her parents have found they had a lot to learn about the industry. "In the beginning, we were clueless," Jessica said. "I said I wanted to do it, and they just said, 'Sure, go for it.' "

Most of the models I spoke to who got discovered at conventions say that several agents were interested in them at the same time—a sure sign that the girls were right for the business. Lindsay Frimodt, a fifteen-year-old model from San Francisco, got seven callbacks from the ProScout convention she attended—and she was only thirteen at the time. But know that it only takes one reputable agent to start your career.

Conventions are especially valuable for girls who live in small towns or rural areas, who are less likely to encounter an agent or scout from a major market. While girls who live near major markets could send their photos into the agencies there or attend an open call, those who don't have access to reputable agencies are in a tougher position. These conventions perform a service by bringing the agents from the major markets to them.

Breaking in from a small town can be difficult, but it's certainly not impossible. Lots of girls who were interviewed for this book did it.

Carrie Tivador is a great example. Working as a model once seemed like a distant dream for the young teen from a suburb of Toronto. "When I was thirteen, I heard on the radio about an open call for a modeling convention called Model Search America," Carrie said. "I went, and was selected for a contest in Rochester, New York."

The convention was a smash for Carrie, who said she was "so surprised" by the ten callbacks. "I hadn't thought that anything was going to happen," she said.

Because Carrie lived so far from Manhattan, she would have to work first through a local agency. She was referred to an agency near her home, which helped her fill her portfolio with test photographs. Carrie's first job was for *Seventeen.*

I met Carrie at that convention in Rochester, and her looks caught my eye. She had beautiful clear skin, bright eyes, and great blond hair. She was

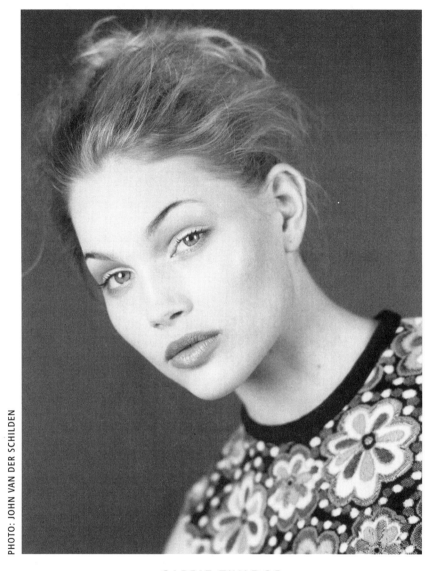

PHOTO: JOHN VAN DER SCHILDEN

CARRIE TIVADOR

a bit on the short side—only 5'5"—but she had a wonderful, youthful face, so I kept her in mind.

Back home in New York, I got a call from Next Management telling me she would be in town for the week. I saw Carrie on a go-see on a Tuesday, and again she looked great. The timing was perfect, since we had a job to shoot

Friday which was a "beauty" story—meaning we were only looking to photograph faces, so height didn't matter—and Carrie was in town until Saturday. The photographer liked her, and Carrie was selected as the model. If she had come to New York the next week instead, I would still have thought she was great, and I would have kept her in mind for the future, but she wouldn't have gotten her big shot at modeling that week. Back home, Carrie's work included catalog for M.A.C. cosmetics, and *Flare*.

At the time of this writing, Carrie had just signed a contract with Cover Girl cosmetics and finished her first assignment for the company. In the next chapter, "Work Life," you can read about her experiences on that Cover Girl shoot.

CONTESTS

Another way to get your modeling career going is to enter contests sponsored by magazines, agencies, clothing manufacturers, and cosmetics companies. To enter, you usually only have to fill out an application (for little or no fee) and submit some photos, but like conventions, modeling contests are a long shot—thousands and thousands of girls enter, and only a handful win.

While the chances of winning are indeed tiny, those who *do* win find the rewards are great—winning a contest can indeed be a launching pad for a modeling career. Again, if a girl is from a small town and her options are limited, this is a route for her to consider.

You don't necessarily have to be the top winner of a contest to gain agency representation and make a start in modeling. Marysia Mann was a finalist in the *Seventeen* contest in 1995 but did not win, yet she has gone on to get more work. Shaundra Hyre was one of forty girls selected as finalists for Elite's contest; though she was not selected as one of the fifteen international finalists, the agency did agree to represent her.

Modeling contests are like a giant lottery—except that your chances of winning are greater if you have innate modeling potential. Take Jennifer Davis, who is nineteen but was only fourteen when she started getting interested in modeling. She took classes in etiquette and makeup in Dallas, where she's from, and at the end of the course there was a photography session. Jennifer submitted the pictures from her session to *Seventeen*'s contest.

PHOTO: RANDY HARRIS

JENNY FILLER

Jennifer didn't win, but she was one of eight national finalists in 1991 and her potential was spotted.

"I had never been out of Dallas in my entire life, and I flew off to New York. I was like, 'Wow! I really want to do this!' " she said.

After that, Jennifer, represented by Kim Dawson Agency, went on to

model for top designers, appearing on runways in Paris, Milan, and New York. She did magazine work, print advertisements, and appeared in a television commercial. Read about Jennifer's next career decision in chapter 6.

A famous example of someone who didn't take top honors at Elite's Look of the Year contest? Cindy Crawford. She placed in the top twelve but did not get a money contract.

Contests aren't always as simple as just sending in your picture and waiting for a reply. Some contests have numerous "levels" of competition.

As model Jenny Filler explains, you may have to jump through a lot of hoops to reach the end of a modeling contest. Jenny entered the Elite Model Look contest when she was thirteen. Her previous experience was with a local agency and modeling school in Ocean Grove, New Jersey, where she took classes in applying makeup and in walking on a runway. The classes concluded with a show attended by New York agents, and an agent from Elite Model Management expressed interest in Jenny. Her New Jersey agent suggested she enter the agency's contest.

First Jenny had to make it through four local and regional levels of competition. Then she earned one of forty spots in the "nationals," which were held in New York City.

The process was long and arduous, but Jenny had a good time, especially when she reached the national finals. "It was fun," Jenny recalled. "We went shopping and had photos taken. The finals were held at the Fashion Cafe."

From there, Jenny was one of fifteen winners picked to go to the international finals in Nice, France. "I was surprised and happy," she said.

Jenny had never been out of the country before. Her father came with her to Nice. "I was glad he was there," she said. "It gave me some security and comfort. Some of the other young girls had parents there, too."

About eighty contestants from around the world attended the international finals. "We had rehearsals for the show, photo shoots, and at night there were parties," Jenny said. "I was a little intimidated by the competition, but I got over it. Everyone was nice, and I became friends with another girl from the U.S. We practiced a lot. I wasn't that nervous."

Jenny won fourth place in the contest, earning a money contract. "I was ecstatic," she said. "At home, the local newspaper had me on the front page three times in a row. Everyone at school was saying, 'That's great!'"

A Model School Student Starts Her Career

▼

Melanie Hansen, nineteen, lives in Spokane, Washington, and enrolled in a modeling school there four years ago.

"My mom brought me to modeling school because she wanted me to walk like a lady," Melanie said. Little did her mother know that the instruction would lead to a career that has put Melanie on the pages of *Marie Claire* and *Glamour*.

Melanie learned runway techniques, makeup application, and skin-care routines. Most important, she said, the classes gave her confidence.

"At first I wasn't sure if I really wanted to model for a career or not, so the training center seemed like a good, safe place to start," she said. "In Spokane, there is not much opportunity to be seen, so I thought this was the best way."

Through the school, Melanie had some test shots taken and brought them with her to a major modeling convention called IMTA (International Modeling and Talent Association). "There were a lot more people competing than I ever imagined," she said. "I guess I didn't realize how many girls wanted to be in this business! There were also so many agents there. It made me realize that I was going to have to take it seriously."

MODELING SCHOOLS

Although it is by no means necessary to attend a modeling school, it is a way that some working models get their start. Many modeling schools have little to offer other than finishing school–style classes, but others have connections to major agencies.

Models who decided to go this route and were fortunate enough to gain agency representation say that the classes helped them mature, develop, and evaluate whether modeling was right for them. They also said this was the only way they knew of at the time to break into modeling. (Readers of this book know there are other options.)

For more information about modeling schools and examples of girls who got their starts there, see chapter 10, "Preparations."

SOMEONE CAME UP TO ME . . .

A lot of models say their first brush with the business was when someone from the industry approached them out of the blue.

It's natural—and wise—to be suspicious of someone who comes up to you and asks if you're a model or if you would like to become one. A rule of thumb is NEVER to trust anyone who asks for money up front, promising to make you a "star." (For more advice on this front, check out chapter 15, "Scams and Cautionary Tales.")

It's essential to do your homework after

someone hands you a business card. Make sure the person and his or her agency is reputable, and watch out for scams, which are rampant in this business. It's also good to keep in mind that being spotted on the street, in some public place or another, is one of the most common ways to get a start in modeling. Be cautious, not paranoid!

Among the places you might get discovered are . . .

▲ **At the mall (the most popular place?)**
"I live in New Jersey, and when I was twelve, I was in a mall with my friend, her sisters, and her mom," said Jenny Filler, fourteen. "Someone came up to my friend's mom and said, 'Your daughter is pretty,' and she said, 'Which one?' And the woman pointed at me and said, 'Her.' My friend's mom said, 'She's not my daughter.' I had never thought about modeling before, and I thought I was too young to model, so I waited. Then I went to a local agency."

And:
"It was a model scout I met at a shopping mall who got me into modeling," said Holly Barrett, eighteen, of Orlando, Florida. "I had just gone there to shop, though I had always had modeling in the back of my head. They were running a search at the mall for a convention run by New York Model Contracts, and I just happened to run into the scout and she brought me over to the search. As it turned out, she brought me to New York and I went to see all the different agencies to get a feel of who would be best to represent me. I went with Ford."

To Melanie's surprise, she won second runner-up for Female Model of the Year and had twenty-nine agencies interested in her! She signed with agencies in New York, Chicago, Milan, Paris, Athens, Australia, and Germany.

Through her success, Melanie never regrets her decision to pay for classes. "Going to the training center was good because I got a lot of advice and help," she said. "I still call them to talk it out, to see if I am making the right decisions or not."

Melanie went further to say she didn't think she would have made it in modeling if it hadn't been for the guidance from her school. The classes taught her how to show her personality during castings, and the expense was something she accepted as a given. "It's like starting your own business—it costs money to build a career."

▲

And:

"When I was nine, I just happened to be at a shopping center and they were doing a photo shoot with a lady from the agency I am with now," said Melissa Tominac, sixteen, who is represented by Ford/Robert Black Agency in Phoenix. "I did little kids' stuff occasionally, but being so young I wasn't really interested in it. I started doing more adult work after I was thirteen and I got my braces off."

▲ A department store

"I was in Saks Fifth Avenue in New York, sitting there waiting for my mom to get her hair cut, and this agent just handed me her card," said Heather Dunn, eighteen, of Atlanta. "The next night they took me out to dinner." (Talk about timing: Heather was visiting New York during a school vacation.)

▲ A rock concert

"I was at an Alanis Morrisette concert," recalled Krystina Riley, fifteen, of Sacramento, California. "I was approached by an agent from an agency that wasn't as reputable as I might want, and a neighbor told me to look into Look Model Agency. I went on an open call—I got there after school—and they just kind of looked at me and said 'Yes.' I guess they just know right then and there whether they want you."

▲ The supermarket

"When I was thirteen, my mom picked me up from my ballet class and we went to the supermarket," said Amy Smart, twenty, of Los Angeles. "A photographer came up to me. I was so excited—I always wanted to model. So we took some pictures (after my mom had him checked out), and he brought me to an agency called Prima. I have just switched to Elite, mainly because my longtime agent at Prima left."

Read about how Amy's career progressed in chapter 3.

▲ A coffee shop

"I always wanted to be a model. When I was little I would do all these poses for my grandma and she would take pictures of me and pretend I was a model," said Katie Hromada, fourteen, of Seattle. "Then when I was twelve, I was in a coffee shop and one of the agents from my agency, Seattle Models

Guild, was telling me about it and invited me to go down and see them. I started doing test shoots and really liking it. I started out doing newspaper ads, just little things, and then I went on to Japan and then did magazine and catalogs back home."

▲ The boardwalk

"I was walking down the boardwalk by the beach in New Jersey, and a scout from one of the agencies came up to me," said Janelle Fishman. Janelle said that being discovered was the fulfillment of a dream. "When I was really small, I would always tell my mom I wanted to do it. When I got new clothes, I would always show them off to my father, pretend I was walking down the runway."

▲ A bus stop

"When I was fifteen, an agent spotted me at a bus stop in Vancouver, where I'm from," said Charlene Fournier, who is twenty-one now. She lived far outside the city and was waiting for a bus to take her home.

"He approached me and asked if I was a model, and I thought it was just a line. He gave me his card. I begged and begged my mother—people had been telling me I should get into modeling for a year, because I'm tall—and my mother brought me in to an agency. She said, 'I'm not putting one red cent into this,' and they said, 'No problem. We'll send her to New York.' After that, I went to Paris when I was sixteen."

Charlene lives in Miami now and models full-time. She's a great example of someone who broke into the business through timing and who was able to launch a successful career without making a huge investment of time or money.

KNOWING SOMEONE

Having connections helps, but it's in no way essential. One story that comes to mind is the time I was working with the owner of a company that made temporary tattoos.

He asked me to look at a picture of his daughter to see if I thought she could be a model. I get that all the time—"Can I show you a picture of my daughter?"—and usually I'm pretty skeptical. But I always look.

But when he pulled the snapshot from his wallet, I was blown away. She was thirteen, a bit on the short side at 5'5", but definitely model material. I hired her for a "beauty" story, where height didn't matter.

After I saw her photos, I knew she had potential and I referred her to Elite agency's New Faces division. Her dad also knew someone there. She started working for us again and stayed in high school, then went to London for the summer to model. Her name is Nina Zuckerman, and she's seventeen now, living in New York, going to school, and enjoying a modeling career.

There are other girls who got started because they had a relative who was a model or who had some other sort of connection to the fashion industry.

"Cheryl Tiegs is my third cousin, and all my relatives tell me I look just like her, so I was always wondering if I could do it," said Danielle Bassett, who is sixteen and lives in San Francisco.

Ironically, it was not her supermodel cousin who got Danielle involved— she's never even met Cheryl—but her own mom, whose boss put Danielle into a television commercial for the jewelry company he owns.

"I was fourteen and 5'8" then," Danielle said. "The guy who did the commercial put me in touch with three agencies, and the third was Look. We signed the contract the day I went in. It was very overwhelming, but exciting."

And lots of other younger models say they started in part because a relative was already modeling. Danielle Lester, who is seventeen and lives in Austin, Texas, had a mother and a sister who were models, and got her start one day when she was tagging along to the local agency that represented her sister.

"My sister's agent was like, 'Who are you?' and I said, 'Her sister,'" Danielle said. "I did end up getting some work from them, but my mom took me to meet with the Kim Dawson agency, in Dallas, the one she was with when she modeled, and I ended up going with them."

Another girl whose mother had modeling experience, Breann Nelson, said she had dreamed about modeling since she was a little girl. "When I turned thirteen, my mom decided we should go around to agencies in LA," said Breann, who is fifteen. "I went into Nina Blanchard [now called Ford

Models] and they decided they wanted to sign me right away. It was my dream to be in *Seventeen* and *YM* and have my friends see me and stuff."

MEETING SOMEONE

You never know who is going to end up making the connection for you. You can get into modeling through . . .

▲ **A friend**
"I got into it through a friend of the family who was a photographer," said Amy Owen, twenty-eight, of Chicago. "He used me for hand modeling, because I had nice hands when I was fourteen years old. Elite had just opened across the hall from him. At the time, I was baby-sitting for his children and making three dollars an hour, and he said, 'You can make a lot more from this.' I went to Elite and they said, 'You can junior model, as well.' "

▲ **Your school**
"I had thought about modeling, but I hadn't really done anything about it," said Brittny Starford, eighteen, of Dallas. "I was sixteen and a sophomore in high school, and I was on drill team [cheerleading] and they had a casting for a catalog for drill team outfits. They came to our school and picked some girls to do a catalog. The photographer worked for JC Penney and he got me an appointment with them. I was really lucky in that I got to start working for Penney's before I even had any pictures. I used that money to get pictures made."

▲ **A fashion show at a mall**
"When I was about fifteen, I was in a mall near my house in Tennessee and tried out for a 'back to school' event with eighty or ninety other kids," said Charlotte Dodds, nineteen. "One of the judges was from a local model school, and she picked me and two other girls to attend her modeling school. It did cost money and it didn't really teach me much, but it did really help me. If I hadn't gone to the school, I wouldn't have had the chance to go to the AMTC (American Modeling and Talent Convention), which I won. I then got signed by a major agency, Next, in New York."

It Helps to Be Tall

▼

Jessica Blier is only twelve years old, but already she's 5'9". The kids in school used to make fun of her and call her the Jolly Green Giant.

Even when she was eleven (and only 5'6"), she and her mother thought she might be ready for modeling. At the end of fifth grade, her mother took her to an open call at the Irene Marie agency in Miami, the closest city to her home in Davie, Florida.

"Five days after my first test shot, I got my first job," Jessica said.

It was an ad for Sears that ran in *Seventeen* and *Teen* magazines. Her next job was editorial, and other jobs have been coming in steadily.

Not surprisingly, since Jessica has broken into modeling, her classmates have stopped teasing her about her height.

"When I was really little, like four, people were saying, 'You're going to be a model when you grow up,' and I was like, 'No, I'm going to be a ballerina,' " recalls Jessica, who attends a regular public high school.

For Jessica, becoming a model was a natural extension of her strong interest in the world of fashion. "I have always been really sophisticated ever since I was a little girl—I was always putting on makeup," she said. "But I don't act like I'm thirty-eight. Sometimes I act like a kid when I'm around my friends."

▲

▲ **A professional**

"I knew someone in the advertising business who took my pictures to a person at Meijer's department store," said Nikki Vilella, twenty. "They said they wanted to hire me but said that I had to have an agent first. So I went to a local agency and started to build my book. When I was in high school, I would drive one and a half hours away to work for Meijer's!"

Then again, there are the occasional girls who do have connections but choose not to use them. Bianca Englehart, seventeen, had an older sister who was a model and deliberately did not approach her sister's agency. "I wanted to do it on my own," she said.

Bianca, a model in Miami who has appeared in *YM* and was featured in *Fashion Spectrum* as "one to watch" among upcoming models, chose instead to attend a model "camp" sponsored by her current agency, Page Parkes Models Rep. "For me, I wouldn't feel accomplished if I had just followed my sister," she explained. "It feels really great that I got something on my own."

Read Bianca's camp experience in chapter 10.

STARTING AS A CHILD MODEL

Some teenage models actually did start when they were young children—they are the kids you see in advertisements for toys or children's clothing.

It's rare that a child model will turn into a

PHOTO: KARL SIMONE

JESSICA BLIER

junior or adult model. Most child models are small for their age, so they be-have more maturely but look younger, and never develop the height that is necessary for older models. And some child models lose interest in modeling.

Cassie Fitzgerald, who is seventeen, is an exception. She started mod-eling when she was seven, appearing on Barbie boxes for Mattel and in

newspaper advertisements. I had been seeing photos of her since she was eleven years old, and by the time she was fourteen, she was right for the teen market.

Because she had been modeling for so long, including work for *Seventeen, The Face, Sassy, Teen,* Speedo swimsuits, and German catalogs, she knew what to expect and what was expected of her. "I have never had a modeling class—I have just basically learned from being with other girls, seeing them when I was younger," said Cassie, who is represented by Ford in Los Angeles. "You learn to know what way your body looks the best, what side looks the best, what profile looks the best."

Another rare model who turned a child modeling career into a successful life as a working teenager is Kim Matulova. Kim is sixteen now, but she started modeling when she was only six.

I first saw Kim's pictures in *Vogue Bambini,* when she was working as a child model. I finally got to work with her when she turned thirteen. She was very professional and quite comfortable in front of the camera—which was due in part to her lengthy experience in the business. In the teen market, Kim has modeled for *Seventeen* and *YM,* the Delia's catalog, and department stores like Macy's, Dayton Hudson, and Bradlee's. She is represented by Ford Models.

STARTING AS AN ADULT

As a teenager, Nicole Blackmon, twenty-five, had always had modeling in the back of her head—especially at prom time, when modeling scouts often came to her school. But throughout high school, she was never chosen.

It wasn't until Nicole was twenty-two, attending San Francisco City College and training to be a firefighter (of all things!), that a representative of Macy's West approached her in the gym and asked her about junior modeling. When Nicole said she didn't have an agent, the Macy's representative sent her on appointments that led to representation by her agency, City Model Management in San Francisco.

Nicole has since worked for magazines like *Seventeen, Sassy,* and *Essence.* She has done runway shows in New York for Cynthia Rowley and Diesel, and appeared in commercials for Toyota, Lee jeans, Noxzema, and Levi's. She lives

in New York (where she is represented by Wilhelmina Models) and is engaged to be married.

"After I took the firefighter test, I had also just shot the Esprit campaign, so modeling became my priority," she said. "I thought, 'I'll try this out now.' "

She modeled locally in San Francisco for about nine months. "I remember doing about two test shots, then I put the photographs in my book and started working. Then I went to London for two months."

Another model who started relatively late is Tomiko Fraser, who is twenty-two and began modeling when she was nineteen. After graduating from high school, Tomiko was working part-time jobs in New York City and deciding what her next move would be.

"I was working in a restaurant," Tomiko recalled. "The owner of a small agency approached me and said, 'You should give it a try.' "

Modeling was something Tomiko had always had in the back of her head, and people often suggested that she try it out. But she was reluctant. "I always viewed the business as fickle and not very stable," she said. "But enough people approached me that one day I walked into Wilhelmina and they signed me on the spot."

Starting out as an adult has been a tremendous advantage for Tomiko, whose maturity and professionalism enhance her natural beauty and grace. For her, modeling has been a means to an end: she is working to earn money for college and to pursue her goal of opening a chain of after-school programs for inner-city children. She grew up in a modest family in the Bronx, and she has been able, through modeling, to travel abroad and expand her horizons.

SUPERSTARS START SOMEWHERE, TOO!

KATE MOSS

Kate Moss came into my office when she was seventeen years old during her first trip to New York. She had already started her career in London, having

landed on the cover of a British magazine called *The Face*. Kate giggled a lot the first time I met her. She didn't say much, but she had a quirky smile.

She had already been discovered by an agent from Storm Models in London, who approached her in an airport. After she appeared in *The Face*—which included a profile about her—I booked (hired) her for *Seventeen* without having even met her. All I had seen of her was that issue of *The Face* and a composite photograph of her (a photocopy, actually).

The job Kate was photographed for was in England, where she's from. Twice a year editors go to London and Paris for the designer collection runway shows. Those are always great times to photograph models in those cities, especially young girls who are still in school and perhaps too young to travel to New York. I booked Kate with another model named Katherine. In the photos we took, the two of them looked like teenage friends who were just hanging out, riding bikes, and laughing on a boardwalk by the beach. It may have helped that they happened to be real-life friends as well.

That issue was in February 1991. So when Kate did arrive in New York and was represented by Women Model Management, she already had "tearsheets" from *Seventeen*.

Kate could have gone the route many young models do—working slowly to build a career—but the industry had something else in mind for her. When Kate hit the scene, she represented what was new and fresh at the time. It was the era of the supermodel—girls who were bigger than life and beautiful, like Cindy Crawford, Claudia Schiffer, and Linda Evangelista. Kate was the opposite—she was small and frail by comparison.

The industry embraced her waiflike look. Even though Kate's body is naturally thin, her look sparked controversy—and helped keep the bookings flowing in. Kate worked for tons of other magazines. She landed the cover of *Harper's Bazaar* in 1992 and signed a huge contract with Calvin Klein. Kate has walked runways for all the major designers in New York and Europe. Though she's only 5'7", her presence is comparable to models who are much taller.

As styles and fashion have changed, Kate has been able to transform herself. She looks great with no makeup as well as when she's highly styled and made up. As I'll explain in later chapters, adaptability and versatility are two of the true signs of a superstar model, and Kate is a shining example of both.

LIV TYLER

The first time I met Liv Tyler—the actress, star of *Stealing Beauty, That Thing You Do,* and nearly a dozen other movies—she was fifteen years old, and nobody had ever heard of her.

Liv was with her mother, who had made the appointment to see me. (An appointment for a potential modeling job is called a go-see or a casting.) When Liv walked into my office, I was struck not only by her obvious beauty but also by her sweetness and self-confidence. It takes a lot of courage for a high school sophomore to come in and present herself to the model editor at *Seventeen,* and most of the ones who come through my door have butterflies in their stomachs and shy, awkward looks on their faces. Not Liv. She was outgoing from the start.

Liv sat down and showed me a few photos—one of herself and her mom walking down a city street, another of the two of them in an apartment. She told me that the pictures were taken by another model, Paulina Porizkova, a family friend.

But it wasn't Liv's famous father (lead singer of Aerosmith) or her ties to other celebrities that made her an obvious candidate for modeling. It was her own inner qualities—her composure, grace, and maturity—that enhanced her natural good looks and helped catch the eye of the camera. It goes without saying that Liv's superstar connections and intimate knowledge of the world of acting and modeling gave her a leg up in entering the industry, but when it came down to it, the ultimate responsibility for making it all happen rested on her shoulders.

It didn't take long for Liv to get her first job for *Seventeen*. She was on the cover in November 1992 and did ample work after that (among her early credits were a national Bongo jeans campaign and a Pantene hair commercial).

When I first worked with Liv, she was just as I had expected—beautiful, and brimming with personality and energy. These were qualities I saw on her first go-see. Even now with a handful of films under her belt and worldwide recognition, she is still the sweet, confident, beautiful, talented girl I met when she was just starting out.

A MODEL IS BORN, NOT MADE

The way I see it, whether or not a girl is cut out to be a model—and whether or not she has what it takes to be a supermodel—is determined when she is born. From that point on, as she grows and develops, she is shaped into the person she is, who may or may not make a good model. It is that person who stands on view before the scout, photographer, or agent.

Also at the time of her birth, she was equipped with all the genetic makeup that determines whether she has the physical attributes and emotional stamina necessary for modeling. Those innate traits can't be changed. A model cannot be manufactured—she is simply a person who possesses all the qualities necessary to thrive in the world of photographic fashion.

Thus, from the moment you are spotted or reviewed by someone in the fashion world, there is little you can do to change who you are or how you come across to other people. Who you are comes from your genes, your background, your education, your upbringing, and life's experiences.

Of course, there are aspects of the business that can and should be learned—like how to work with a crew of strangers, how to walk on the runway, how to get along with your agent. Models must master logistical and mechanical issues: how to work with the lights in a studio; what to pack for a location trip; how to develop rapport with a photographer; and how to move with ease. As she grows more self-aware, a model will also learn the nuances of modeling. She will figure out her best camera angles and what lighting flatters her features. At the same time, she will grow in professional sophistication: she will learn, for example, how to promote herself and her career and how to manage and invest her money.

For all these skills, there must be a strong "base" to work with. That base is who you are as a person, with all your strengths and weaknesses.

WORK LIFE

"Success is getting what you want;
happiness is wanting what you get."
—Dale Carnegie

ORKING AS A MODEL doesn't mean being photographed for a major magazine or ad campaign every day. A lot of your time is downtime—waiting for appointments or jobs to begin, going on castings to get jobs, working out in the gym, taking care of yourself, talking to your agents . . . and still more appointments.

In the modeling business—unlike many other fields—one day may be totally different from the next. Models' schedules are unpredictable, and jobs may be frequent or sporadic. What is consistent is that each day builds on the last one in enhancing a model's breadth of experience, level of professionalism, and knowledge of the industry.

Because most models start out so young, they are often jarred to find that work life isn't as glamorous as they had assumed. There are situations that are disappointing, grueling, and even frightening, for which maturity is the paramount necessity.

Going to a photo shoot is an intense experience. I go to them all the time, and I'm still impressed by how much it takes to put everything together. One of the most exciting aspects of working in this field is the opportunity to watch artistic creativity in action: when the photographer and the model are in synch, there's an electricity in the air, and everyone on the set—from the stylists and assistants to the makeup artists and hair people—shares the feeling of taking part in a truly dynamic enterprise. My satisfaction and excitement

come from being a part of the process and knowing that my selection of the model has contributed to the beauty that is taking shape. It's like fitting together the pieces of a puzzle to create images and stories.

First off, here's a rundown of the various types of modeling jobs that are out there, as well as the ways they can be pursued on a large or small scale.

TYPES OF WORK

Editorial modeling is the type of work that most people think of when they think of models. It is magazine work, involving models who appear both on the cover and in its "editorial" pages. These pages are fashion spreads that are designed by the magazine's own staff, not by any fashion designer or advertiser. The magazine editors pick the clothes and concept they want, and hire the models to fit that picture.

Editorial models are the cream of the crop. They tend to be the high-profile, high-exposure girls people come to know by their first names. The best editorial models are able to move well in front of the camera and know how to project different emotions. They have some degree of acting skills, which enable them to immerse themselves in the feel of the clothes and the mood and image they are trying to depict. Editorial work is the most creative type, and models are freer to experiment and break new ground.

When a crew working on an editorial assignment is truly innovative and in synch, you can feel a certain chemistry—I've seen some of the most unbelievably creative scenarios emerge from what might otherwise have been a pedestrian workday. Sometimes the model working with the photographer can make ordinary clothes and simple settings come to life. With editorial work, the goal is to capture the audience's attention.

Surprisingly, editorial work is among the least well paid jobs in modeling. Many starting models are surprised to learn that working for magazines usually pays significantly less than working for an advertiser. That's partly because editorial is considered the most prestigious work and partly because the magazines don't have such deep pockets as the advertisers.

Established models take editorial jobs for the prestige and the exposure it gives them. I know models who have lucrative ad campaigns or tons of catalog work who nonetheless very much enjoy doing editorial work. Although it

doesn't pay nearly as much as their other jobs, they pursue it because they can be more creative, have more input, and work with people they like. Starting models should take it for the same reason, and because it helps "launch" them. People who hire models for more lucrative assignments (like advertisements) always notice the models who appear in editorial spreads.

A starting model who has only test shots in her portfolio always finds that it is her first editorial jobs that get her going with more work. Those tearsheets from magazines are important not only because they show people how beautiful and versatile a model is but also because they prove to potential clients that someone else thought she was great enough to book (meaning hire).

For most starting models, an editorial print job is unlikely to result in a cover photo—or even a full page in a magazine. Even if a model's first job only merits her half a page or less, there's still no reason for her to get discouraged. When a brand-new model is used for the first time, it's usually to test her out and see if she's good enough to use for a larger job later on.

Obviously, it is the full-page magazine photos and covers that models and agents like to see in their portfolios. To earn those precious tearsheets, an agent often deems it a good idea to send a girl to foreign markets to build her portfolio. In these foreign markets—Paris, London, Milan, Madrid, Munich, Sydney, São Paulo—there is more editorial work than in the United States. New York is the capital of editorial work for modeling, but many models who work in New York have "graduated" from other markets in the United States and abroad.

Runway modeling, and runway shows in general, are theatrical performances. More and more, they are being orchestrated as miniature Broadway shows or rock concerts. They have the same energy as other live performances.

Runway work is more prestigious today than it was in the past, in part because of the huge crossover between editorial models and runway models. There was a time when you were either a runway model or a print model. Now designers who stage their collections twice a year are booking (hiring) runway models who are seen on magazine covers. The most successful editorial models find that designers ask them to walk down the runway in the same outfits they will wear in magazines or advertising campaigns. The designer does this to maintain a consistent image and reinforce his or her status and style.

Who attends runway shows? Magazine editors, photographers, agents, and other people who book models. These shows are perfect opportunities for clients to see how an individual model moves and expresses herself. Many runway models have been booked immediately after shows for other jobs.

Also attending are buyers for major department and specialty stores across the country. From a sales point of view, a good or bad collection can make or break a designer's salability in stores. Hiring recognized models who are outstanding at walking the runway helps the designer show his or her work in the best possible light.

Runway shows take place twice a year: in March for the fall collections and in October for the spring collections. The major cities that host them are Milan, London, Paris, and New York.

Rarely will a young model who is just starting out be asked to work for a top designer on his or her runway. Most newcomers don't have the maturity or sophistication yet. When you are on the runway for a top designer, you must be poised, confident, beautiful, and graceful. You must project the clothes spectacularly.

Designers stake their reputations on their runway shows. They know that they must cater to a demanding, discerning audience full of buyers, editors, and fashion writers. A single show can make or break a designer's season or career. All the elements must be perfect, and designers usually go with the models they know they can trust.

Models who really understand how to make the most of their waltz down the catwalk are in hot demand. There have been wars fought over models among designers, and any agent can tell you of the hectic, crazy time they have in booking popular models for runway shows, juggling the high demand. Designers want runway models with name recognition, and they are willing to pay top dollar for them.

Catalog modeling can also be very lucrative, though it is not as glamorous or prestigious as editorial or runway modeling. A catalog model might be booked for an hour, a day, or even a week on location.

Catalog work may not be high-exposure, but it is an area where models make money most consistently. The better jobs are with the famous companies that send out mail-order catalogs, like Victoria's Secret and J. Crew, and with stores that offer advertising circulars, like Macy's, Ann Taylor, and Bloomingdale's. For starting models, there are lesser-known local companies

whose catalogs can provide entry-level jobs. A small department or specialty store may hire young people locally for a catalog or newspaper ad.

There are also specific cities that models are sent to for catalog work. These include Chicago, Dallas, Miami, Atlanta, Los Angeles, San Francisco, Phoenix, and Seattle.

Abroad, a large market for catalog work is Tokyo. The market is unique in that a model is booked and guaranteed money for a certain amount of time (usually two months) whether she works or not. The Japanese market is particularly good for smaller models (those under 5'9"), since the sample sizes are small and the preference is for girls who are 5'7" to 5'8". Blue-eyed blondes are also in demand in Japan, because the look is so unusual there.

For catalog work, the main objective is to sell the clothes. Unlike editorial, where the goal is to achieve an overall "look," in catalog work it is much more important for the viewer to be able to see every detail of the clothes. Clients go to great lengths to show off the garments in the most flattering light, since they want to be able to sell an item by its photograph alone.

Catalog models are often more mainstream-looking, like the "girl next door." Catalog sponsors want to hire models the audience can relate to, so consumers can imagine themselves wearing the clothes. There is less emphasis on a model's sheer beauty and more on her mass appeal—and on how quickly she can change outfits! On a catalog shoot, it is common to photograph up to twenty outfits in a single day. By comparison, an editorial shoot seldom exceeds eight outfits a day.

Models generally don't put their catalog work in their portfolio. The pictures may be too small, and the models may not look their best. Some pictures are considered too "posed." Many models say they do catalog work to help pay the bills or to put money in the bank. Models and their agents are also quick to point out that they try to limit the amount of catalog work they do to prevent being branded as "catalog queens," although some catalogs are looking more editorial.

On the other hand, some models are quite content with a steady flow of catalog work, and make good money. Some of those models never leave the smaller markets and enjoy great success working for catalogs.

Advertising work can range from catalog style to editorial style—or even television work. We all see advertisements every day—from billboards to newspaper and magazine ads. By examining them more closely than you

might normally, you can get a sense of the range of advertising work that is out there for models.

Sometimes when you flip through a fashion magazine, it's hard to tell the ads from the editorial spreads. You even find entire ad campaigns that are based on the styles or images that have been featured in these spreads.

Advertising work boasts higher rates than catalog work. The fees are also more negotiable, since they take into account "usage" fees—that is, the number of times the ad can be shown and the number of places it appears. Exclusive contracts also pay better, since the model must guarantee that she will only work for a single client and will turn down all other offers from companies selling similar products.

Many big-name advertisers will only work with recognizable, established models. But there are also designers—like Calvin Klein and Guess?—who like to experiment with unknown models to see if they can mold them. It was Guess? jeans' gamble in hiring an unknown model named Claudia Schiffer that propelled her to stardom and put the company on the radar screen of millions of consumers. Similarly, Calvin Klein's exclusive contract with Kate Moss helped launch her to supermodel status.

Advertisers have increasingly acknowledged the public's influence on the success or failure of a product, and have been addressing this by using more "real"-looking models, people the public can relate to more comfortably.

More and more print models are taking the leap to television advertising. Not a day goes by that I don't turn on the television and see one of the models I have worked with. For many models, making a television commercial is a simple extension of the skills they use in front of the camera for editorial work. On the other hand, some models don't like working with a TV camera or aren't good at it. A model who wants to make the transition to television usually has to take acting classes so she can learn to convey her personality and channel her energy toward whatever product is being sold.

Television commercials pay extremely well. Models are paid for the day's work, plus residuals every time the ad airs. For national commercials, this adds up and can be very lucrative for a single day's shooting.

Showroom modeling takes place in the showrooms of fashion houses, where clothing designers do their work. Prospective buyers from retail stores come to see the clothes, and designers need models to show them off in an

informal environment. Most showrooms are in New York and Los Angeles, though there are a few in smaller cities.

For showroom modeling, very specific size requirements are the priority. And, as in runway and catalog work, the ability to change clothes quickly is a must. Designers aren't necessarily looking for the most beautiful girls to work in their showrooms, just models who flatter the clothes well.

Showroom modeling is an excellent opportunity for new models, since there is little emphasis on attracting "name" models to the venue. It's also a good outlet for petite models and plus-size ones, who are in demand there.

Twice a year, the fashion industry holds what it calls fashion market week, when buyers for stores visit showrooms to place orders. Models can be hired for a day or the entire week.

Fit modeling involves trying on a sample piece of clothing for a designer to see how it fits. Fit models must have the ability to stand very still for long periods of time while designers pore over a garment, seeing whether the pockets need to be moved up or down half an inch, or attending to some other detail.

In terms of figure measurements, this is the most exacting sphere of modeling. The model must be the exact size of the sample the designer makes. Each designer's sample sizes vary, some larger and some smaller. There is also fit work available for petite and plus models.

Again, a fit model need not be the most beautiful—and in this case she need not even know how to move gracefully or to play up to a camera. All that matters is that she fit the designer's sample perfectly.

Editorial models may do fittings either to get to know a client better or to pick up extra money.

In-store modeling is one of the best ways for a young model to get work in her hometown. Most major department stores in cities and in malls hold in-store fashion shows of one sort or another.

Models can find work by simply going to a local store and inquiring. On the local level, the requirements can be minimal: a model might just need to be the right size, look presentable, and project confidence. But even at this level, I recommend that a model be signed with a local agency, who can handle fees and give her adequate representation.

In *parts modeling,* a model only shows off a specific part of her body. The most common parts are legs, hands, and feet. For whatever limb is being shown, the skin must be smooth and the body part must photograph well.

Leg models are hired for legwear, socks, and shoes. They can find editorial and advertising work or appear on the sides of product packages. Shapely, well-proportioned, long legs work best. For a foot model, feet should be a size 6 (which is the sample size) and slender. Hand models (who appear in nail ads and the like) must maintain their nails and skin perfectly.

There are times when a parts model is called in to enhance a photo of another model—for instance, an anonymous hand model could reach around another model on a shoot to give the illusion that the hands belong to the model whose face is being featured.

Petite and plus-size modeling still represent small parts of the industry, although the markets—especially for plus sizes—do seem to be growing.

There used to be entire agencies devoted exclusively to petite sizes—that is, models who are under 5'9". Now more agencies are accepting shorter models, but they must be exceptional (Kate Moss is 5'7" and Jaime Rishar is 5'6"). Read about Charlotte Dodds in chapter 3.

The issue of height is the most asked question I get about the requirements for modeling. I do emphasize that there are certain specific height requirements that agencies adhere to because of designer samples, photographability, and so forth. But an agent will sign an unusually qualified model who is under 5'9".

There is a timing factor involved here as well. Agents will sign girls who are shorter than 5'9", but if they find that it's too much trouble to get jobs for these girls, they will stop. Through good management of a shorter girl, it may be possible for an agent to set a trend, opening up the eyes of designers, photographers, and editors to the possibilities of shorter models. But for now, many of the shorter models are used predominantly for "beauty" jobs that feature their face only, like ads for fragrance or cosmetics. Petite models may find work for designers who carry petite lines, or in television commercials.

Like petite modeling, plus-size modeling is a specialty with its own market. There are even entire agencies that represent larger models, as well as divisions in reputable agencies like Ford and Wilhelmina, with more agencies opening plus divisions as the demand for these size models is increasing

as designers and retailers are responding to the need by the plus-size con-sumers. The demand for these models is growing and greatly needed, as more designers make clothes for full-figured women. More catalogs are including larger sizes, and magazines run articles about this figure type with greater frequency. Plus-size models can be anywhere from a size 10 to a size 20.

With both larger and smaller models, the ingredients for success are pro-fessionalism, intelligence, personality, and confidence. You can read stories about plus-size models in chapter 9.

GETTING READY

A workday for a model really begins the day before. You, the model, must call your agent in the late afternoon to get the next day's schedule. By 5 or 6 P.M., the agent will have secured all your appointments and will be able to tell you if you are working (on a booked assignment), or on a go-see (with potential clients or photographers, etc.), or testing (shooting pictures for your portfolio), or having a haircut appointment, a fitting for a client or designer, or the like. It may even be a combination of any of these.

"Ninety percent of modeling when you're at my level—which isn't the top, but isn't the bottom either—is just running around and meeting people," said Nina Kaseburg, sixteen. "You have to be on the Upper East Side [of Man-hattan] for one appointment and on the Lower West Side for the next ap-pointment in fifteen minutes. It's very hard on your feet and it's enough to make you crazy if you're someone like me who doesn't like to be late for any-thing."

Your workday may change as you are actually going through it. You may be on a go-see at a magazine and the editor decides to send you immediately to a photo shoot that is already in progress. Or you could be at a fitting for a designer when he decides he would like to book you for an upcoming runway show if only you had a haircut—and your agent then whisks you to a salon. Or, while you are on a job, your agent may call to tell you to rush off as soon as you are done to another client who requested to see you right away.

Your agent is constantly juggling your schedule, even as you go along with your day. Needless to say, it's important that you are always accessible to her (or him), checking in and returning her messages wherever you may be. Noth-

ing is more frustrating to an agent than not being able to get in touch with a model when schedules and jobs change.

Your agent may even suggest you rest for the day or go for a workout. It is the agent's job to stay abreast of your mood and your mind-set and to sense when you are approaching burnout. But you are ultimately in charge of your well-being and your career, and if you feel you need a day off from appointments or bookings, you must speak up to your agent. Clients want to work with models who are on the job with full force and total enthusiasm.

The major responsibility for a model in her working life is to maintain a healthy attitude, body, mind, and spirit. She must take total care of herself and be attuned to when she is feeling overwhelmed.

IN FRONT OF THE CAMERA

To be a model, you must have innate qualities that enable you to come across for the camera.

That said, there are certain skills you can learn along the way as you start to model—most models describe their careers as learning processes. For example, models have to figure out for themselves what to do at a job or photo shoot, and it can be tough at the beginning.

"Nobody tells you what to do—nobody teaches you anything," said Kim Matulova. "Once you get there, the whole mood sets in: you're sitting in the chair, getting your makeup done. You kind of forget about school and everything else. You're just there and you have to focus."

Moving in front of the camera is a skill most models develop naturally by themselves or with help from photographers. Some learn by watching other models at work or by watching music and fashion videos on television. A lot of models describe themselves as lifelong camera "hams" who liked to pose for family snapshots when they were children.

Some photographers will offer directions to a model, especially if they know that she is just starting out. But more often than not, the photographer says little or nothing about what to do, expecting that the model will do her own thing.

"If they want something specific—like something really happy and teeny-boppery—they usually tell you what they want you to do or give you an

idea, but sometimes they're just like, 'Okay—go,'" said Brittny Starford, an eighteen-year-old model in Dallas.

Gradually, each model discovers her own style of working in front of the camera. She learns her best angles and figures out the ways she likes to move. I often suggest models take some sort of dance class or simply go dancing to help them learn to move freely. Dancing and movement also help you feel comfortable with your body.

Modeling is not always about "posing," which carries with it connotations of stiffness and rigidity. Many of the editorial spreads you see in magazines are about movement. So is runway work and, of course, work in television and movies. The trend toward movement is also migrating into print advertising.

"I think the more times you're in front of the camera, the more you understand how things are supposed to be," observes Marysia Mann, a fifteen-year-old model from Miami. "Also by watching other people. If there are other models on a shoot and they go before me, I watch them to see what the client wants and how they're working."

Heather Lett, who is twenty and lives in New Jersey, said her first experiences in front of the camera were a disaster because of the exaggerated poses she tried. "I was trying to do all of the things I thought a model was supposed to do—pose and be sexy—but I had to learn that that's not what you need to do," she said. Finally, a photographer she was working with advised her to act natural.

The reason models are seldom given strict directions is that what works for one girl may not work for another, and photographers and clients like to give the models license to use their creativity and bring their personality into the work. When a particular shoot isn't tightly controlled by the photographer or director, the model gets to show her own particular flair.

Some models say they cherish the opportunity to go wild on the set.

"I did an editorial for *The Face* that was really wild," recalled Cassie Fitzgerald, seventeen, of Laguna Nigael, California. "Humongous wigs and dramatic makeup. I prefer that, the dramatic thing—it brings more of your personality out."

One of Cassie's trade secrets is that she always tries to work with music playing in the background to get her pumped. "I need music when I work," she said. "It brings out a different side, makes you more loose. Sometimes it's

so quiet and uncomfortable in there with everybody watching you, and music helps you enjoy yourself while you're working."

Danielle Lester, who has appeared in *Seventeen* and in catalogs, says her secret to modeling is to be as "goofy and fun" in front of the camera as she is when she hangs out with her high school friends. "How I am at work is how I am with my friends," she said. "For the camera, I play different roles, but I'm still me."

Getting psyched for the camera is something each model approaches in her own way. The key is to clear your head of any outside baggage and focus closely on the job at hand. I've worked with a lot of models who were extremely professional in this respect: whenever they're on the job, they're enthusiastic and focused.

As with anything you do, from playing the piano to shooting a basketball to writing an essay for history class, practice makes perfect. "In the beginning, when I was in front of a camera, it was scary," said Nina Zuckerman, seventeen, who has been modeling for five years. "You're on, and you have to 'go.' Sometimes you don't know what to do. But then you learn what they are looking for and you get more comfortable."

NAVIGATING THE RUNWAY

Another aspect of work life is runway work, which most models describe as no piece of cake. In fact, most major designers won't use young models for runway, saying they lack the necessary maturity and sophistication.

Most models—even Claudia Schiffer—say they were clumsy at it when they started out, and required loads of coaching and practice.

"I couldn't get the sexy walk down the runway down, because my personality isn't seductive," said Jennifer Davis. "One of my runway teachers said to me, 'You just have to have a different personality, you just have to be Jessica Rabbit.' "

Jennifer describes having to "divorce your internal self" during runway shows, which can be particularly challenging for a teenager. "Modesty is not allowed, basically," she said. "There are dressers—they take the clothes on and off. That was hard for me at the age of fourteen, when you're starting to go through the change."

Being in a runway show is very hectic. Models have to be able to change clothes themselves in a flash, since they can't always be sure that there will be dressers to help them change quickly. A model could be one of fifty girls in a show who appears once, or she could be one of a handful who appears in six different outfits over the course of half an hour!

Walking on the runway is an acquired skill that involves standing very straight, placing your feet quite specifically in front of one another, and mastering a variety of half and full turns. Even when you get some of the technical skills down, the most important piece of the equation is something that can't really be taught: the ability to project personality and attitude. We've all seen videos of runway shows—you can tell when the models are really working it!

Runway work is one aspect of modeling in which most girls *do* need some training or coaching. Some models say their agency offered some help, or even a mini-course in runway work.

Others, like Beverly Peele, say it was videos of fashion shows and practice in their home living room that helped them learn runway etiquette (you can read more about Beverly's development as a model in a later section, "Talking to . . . Beverly Peele"). No matter how she learns, each model must develop her own signature style or walk. Certain models' "walks" are unmistakable, like Beverly's, Naomi Campbell's, and Linda Evangelista's.

Some models find runway work a challenge and a headache. Others adore it because it's live and it's an opportunity to interact with an audience.

I find that the best models on the runway are the ones who seem the most confident and comfortable. Sure, they may be nervous on the inside—everyone feels that way in pressured situations—but the best runway models have a distinctive presence that stands out. Great runway models capture your attention as they walk and show off a designer's creation. These models understand that they must make each outfit look its best.

When a designer hires one of these outstanding runway models, he or she knows that the model will make the outfits come to life. As a model does more and more runway shows, she is better able to engage this skill and develop her own signature walk, one that people come to recognize.

Runway: What's It Like?

▼

Tomiko Fraser, who is now with Ford, has walked runways in major cities for all the top designers—a recent season she did eight or nine shows in Paris alone. She calls runway work "a chance to play."

"You can play for the camera, but with runway you have a live audience," Tomiko said. "It amazes me that they work for months and months for a show, and it's over in twenty minutes!

"Backstage the newer girls like me show up first, usually four or five hours ahead of show time. You get your hair and makeup done. Then about two hours to half an hour before the show, the bigger, famous models start coming in and everyone becomes frantic, rushing to get ready. The press shows up, as well as friends of the designers—including celebrities. It's madness.

"I don't get nervous—I get excited. On the runway, it's my moment to shine. There may be five to fifty girls in the show, but when it's my turn, it's my moment, I make the most of it."

Among Tomiko's most memorable shows have been ones for Chanel, Karl Lagerfeld, Chloé Miu Miu, and Sonia Rykiel.

WHAT IF THE CLOTHES ARE GROSS?

When you are working as a model, your paramount responsibility is to show the client that working on that particular job is the only place on the planet you want to be. You want nothing more in life than to be wearing those particular clothes and working in that particular situation.

Models all say that wearing a really terrific outfit inspires their work. But more often than not, models find themselves geared up in something that doesn't suit their tastes. "If I don't like my outfit, I just think, 'Maybe somebody *will* like it,' " said Tomiko Fraser.

To many young girls, one of the most appealing aspects of modeling is the opportunity to wear fabulous, glamorous, designer clothes. But as all models know—and most other people do not—you *don't* get to keep the clothes (on rare occasions, a designer will let a model take home a piece of clothing she loves), and you don't necessarily have to like them, either.

Kim Matulova says being professional means putting aside any personal feelings you might have about whether the garments are attractive. Though her own tastes run toward baggy pants and sneakers, she is equally comfortable modeling high fashion.

"I never say, 'Ugh, I'm not going to wear that,' " she said. "I'm there, it's my job. I've got to make their clothes look good. Sometimes if a hairstylist needs an idea, I might think, 'This is cool.' Otherwise, I don't really have much say in it."

In general, the models I spoke to said that catalogs—and foreign catalogs in particular—had given them some of their least favorite clothes to model. It can be difficult to feel inspired when you're working hard all day in outfits that make you wince.

Helena Stoddard, a fourteen-year-old from San Francisco, said she confronted this problem in a big way when she went to model in Japan for the summer. The days were long and tedious, and were made worse by the fact that the fashions were—in her opinion—awful.

"In Japan I worked a lot," Helena said. "Up early, working all day, and I didn't like the clothes or the makeup. It was for a catalog, and it was not fun. I would have to smile for five hours in these ugly outfits and ugly makeup. I was just thinking about how much they were paying me—that's how I got through it!"

CONDITIONS CAN BE ROUGH

The set of a modeling shoot is always a crazy, hectic scene. Stylists and assistants are running around setting things up, delivering this and that here and there. The photographer is engrossed in his equipment and the lighting, and other people are also going about their business on the set. It can be distracting and intimidating for the model, who is the center of all the attention: she is the one who is being photographed; she is the one who has to perform.

Every model learns to deal with the spotlight in a different way, so she can do her work.

"My favorite show was Chanel, because of the clothes, the atmosphere. The runway was elevated–it was a conveyor belt–and all we had to do was pose and the runway moved. At the end were the photographers and steps to go down and go back to the start. I had to 'become' each outfit, and it was fun."

A model may go on up to five castings and fittings for a single show. It's a lot of very frantic work.

"Once I went with my friend–at her request–to Chloe, and they hired *me*, not her!" Tomiko said. "She was happy for me. At the fitting was Karl Lagerfeld–the designer–and Niki Taylor and Meghan Douglas. When Karl walked in, he saw me and said, 'Oh my goodness, what's your name? Are you doing my other shows? You must go to Chanel.'"

▲

Tomiko, from New York City, is twenty-three and with Ford Models. Here, she wears black nylon-and-spandex lace sweater by *DKNY*, $125; black cotton-and-Lycra lace bra by *D&G Dolce & Gabbana*, $65; knit drawstring panties by *Joan Vass NY*, $200. For details, see Shopping Guide. Hair, Cessy Lima for Bradley Curry Management; makeup, Robin Schoen for Bradley Curry Management; location, courtesy Charles Sorel Fashion Editor, Ty-Ron Mayes for Jam Arts.

52

TOMIKO FRASER

"When there is a crew standing around all looking, I have to block everyone out and concentrate on the photographer, or I will tend to tense up," said Lindsey Sanders, nineteen, of Dallas.

When shoots take place outside or involve a lot of extra people, the scene can get even hairier. There are passersby stopping to watch what's going on,

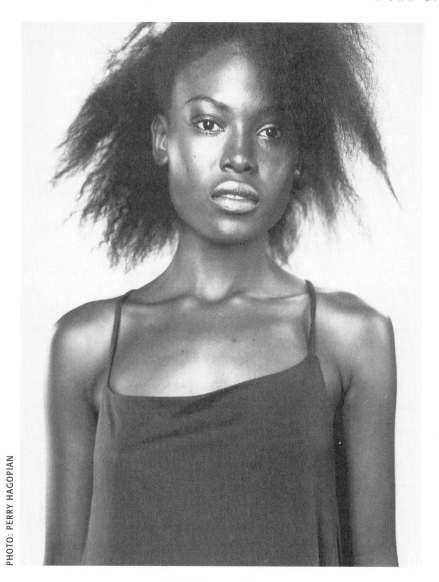

PHOTO: PERRY HAGOPIAN

NICOLA VASSELL

tons of vans parked everywhere, equipment all over the place. A model must stay focused even if she feels like she's in the middle of a madhouse.

On top of all the hysteria, there are often severe time pressures—the client is paying a lot of money for every hour that passes, and it's imperative that everything come together as quickly as possible.

Then again it's also a business of hurry-up-and-wait. Everyone hurries around to get everything prepared—and then you have to wait.

"There's a lot of waiting—you have to be very patient," said Jennifer Davis. "It's standing still to have this pinned, or sitting completely still for your makeup or hair person. People are in your face all the time, touching this or that or smudging this or tugging on your hair. You are the object that is being painted, sculpted, to look good."

Nicola Vassell, an eighteen-year-old model in New York City, describes how important it is to be able to shift gears throughout the workday: "I remember one day my job started at about 9 A.M. Hair, makeup, then being photographed," she said. "Then I got a call from my agent at about twelve or one telling me that I had three very important castings to go to right away, because I was up for an ad for Pepe jeans that was being shot the next day. I was still in the middle of a job, and I had to give that client 100 percent. I remember hanging up the phone and concentrating."

The job Nicola was doing ended at 2 P.M., and she ran downtown to her next appointment, as her agent at Next Management had instructed. "Good thing I was on time," she said. "I got the Pepe jeans job!"

The long, hectic days of a photo shoot aren't the only hazards of a modeling career. Practically every model can tell a story about a job she did in which she spent the day either freezing cold or swelteringly hot. But remember that the entire crew is out there with you suffering!

"They always want you to do the opposite of what you would like to do, like wearing winter boots and sweatshirts and pants on the beach in the heat," observed Marysia Mann. "If it's hot, they want you wearing winter clothes. If it's the one cold day in Miami, they want you in something not warm at all."

Katie Hromada got so overheated once that she fainted on the job. "It was in California—we were shooting winter clothes and it was 110 degrees outside," she said. "We were wearing gloves and hat and ski clothes, and all the models kept fainting. They just said, 'Tell us when you want to stop,' and then we'd go lay down and drink water and put icebags on ourself." But the experience didn't turn her off of modeling. "I'm getting six pages in a ski magazine, so it was worth it," she said.

It seems like every model has a war story. For Holly Barrett, the roughest experience was an advertising campaign for Bold laundry detergent, which

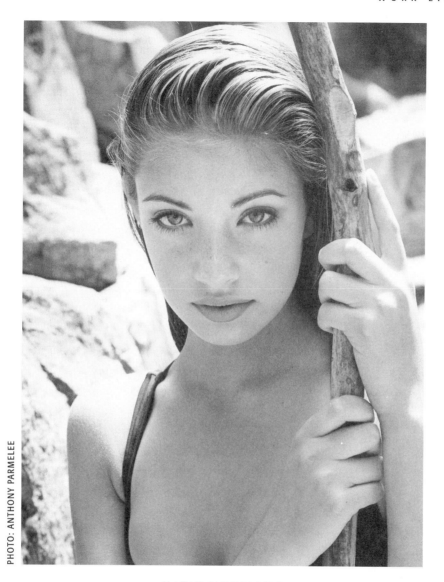

PHOTO: ANTHONY PARMELEE

KATIE HROMADA

was shot on a brisk day in Miami in December. The client was trying to re-create the grungy atmosphere of the Woodstock rock concert, and all the models were practically swimming in mud.

"There was a certain kind of mud that was on the clothes, and a different kind of mud that we were standing in, and the two couldn't touch," Holly

Sticking It Out Under Difficult Circumstances

▼

How rough can the business be? Some models drop out, or at least question whether to stick with it.

Charlene Fournier, a Miami-based model who is twenty-one, said one of her worst experiences was shooting a spread for German *Cosmopolitan* in heavy fall clothes during the high heat of August in New York City. The setting was under the Brooklyn Bridge—and between the warm clothes, the noise of a fog machine, and the smell of chemicals and car exhaust, Charlene and the whole crew were sweaty and miserable. "I had to pull myself out of it, to think about the other people who were also working with me, and how we were all working to help each other."

"You can't be selfish when you're working with other people," Charlene said, reflecting back on that day. "I have to understand that I'm not the only person doing this shoot. There's a makeup person who has to come pat my face because I'm sweating and a photographer who has to wait while that happens. There's the bright light, and I have to keep my eyes open as wide as possible instead of squinting. That's how I've learned to do it, is just not to be selfish."

▲

recalled. "It was really cold but very sunny, so the mud on our clothes was getting all dry and cracking, and they kept hosing us down and getting us wet. So we kept standing there getting hosed down and trying to make sure that the mud on our clothes didn't touch the mud on the ground. The only fun part was pretending we were at Woodstock."

Danielle Bassett, a sixteen-year-old from San Francisco who has been modeling for about two years, says the most strenuous job she ever did was a Korean television commercial that was filmed in Sydney, Australia.

"We had to wake up early in the morning and go running on the beach to catch sunrise, and it was freezing there, because it was winter," Danielle said. "We were in these thin cotton pants, and there were four of us running with dogs, me and three guys. The guys kept having to throw me in the water. We were supposed to be having fun. When they changed the film, we would run to the camper and huddle and have hot chocolate. We finished at one in the afternoon, and I went home and slept."

Long working hours and uncomfortable temperatures are just some of the physical demands of a model's work life. Travel schedules are often very long and very wearing, and models have to be ready to work the minute they hit the ground in a new city.

Traveling for a job may mean taking the red-eye—a plane that, for example, leaves from California at night and arrives in New York in the morning—and spending the day in front of the camera. I've seen lots of girls have to do this. They're groggy, but they manage to pull

themselves together for the camera. (Teenagers are more resilient than most adults, and teenagers who are models are even more so.) If a girl really wants to be there doing the job, you'll never be able to tell she has just stepped off a cross-country airplane flight.

"NOT AS EASY AS I THOUGHT . . ."

Nearly every single one of the more than fifty models I interviewed for this book declared that modeling was not as easy as she had thought it would be, that the whole process was far more strenuous than she had ever imagined. I really don't think that many young girls who decide that they want to be models realize the amount of work that goes into it.

While your friends may think that modeling is all fun and games, you as a working model will find out quickly just how tough the schedules and assignments can be.

Allison Ford, seventeen, an Elite model in Los Angeles, who has been modeling for two years, summed this up nicely: "I never thought it was this much work. It's not as glamorous as everyone thinks. It's harder. It's not like someone sees you and instantly says, 'Oh, I want you for a job.' It takes a lot to get where you want to be, and you have to compete without taking it personally."

Most models said they had the impression that modeling involved no more than breezing in, having a few pictures taken, breezing out, and waiting for the magazine to come out. They

Crowd Scene

▼

Amy Smart recalled a commercial for Union Bay clothing company that had to be completed in only two days. The company was filming both a television commercial and a print advertisement, and hair and makeup started at 6:30 A.M. The setting was Palm Springs, California.

"There was a huge crew and lots of extras, and only a few models," Amy said. "They hired about twenty-five extra people—they wanted people off the street who were more natural and had different personalities and wouldn't 'pose'—so there were people with nose rings, surfers, skateboarders. Such a random mix."

The photographer, Dewey Nicks, started shooting at 9 A.M. "He would shoot print shots and then get a different camera to shoot the commercial, and then would just switch off," Amy recalled. "When I was ready to be photographed—he would call me in—he would always make up a scenario so that we were always doing something, I guess to keep our attention. We shot in a pool, out of a pool. He would always turn it into fun. It felt like a party with all of the different types of people."

While other models were being photographed, Amy had brief breaks, but it was a long day, and she had to do the same thing again the next day. "You go through so much to get a one-minute commercial!" Amy observed.

▲

were surprised to learn how long each photo shoot takes, how much preparation goes into each one, and how physically and emotionally grueling the process is for the model.

"I really like it, but I thought it was going to be more glamorous than it was," said Breann Nelson, summing up the opinions of many girls.

It doesn't take long in the business to find out that the reality doesn't conform to models' idealistic expectations. Of course the pictures look fabulous once they hit print—but what goes into making them is a lot of sweat work.

"I was surprised by how everything works and how it is," said Danielle Lester, who has been modeling for two years. "I thought it was a much quicker process—you go in, get your picture done, then out. But it's not. It's hair, makeup, wait for other girls, shoot your shot, change. It's a lot of sitting and waiting. So always bring a good book!"

Most models said they quickly learned to bring schoolbooks or knitting, a tape player with headsets, or crossword puzzles to cope with the boredom and downtime.

Another shock for many models is the time involved. Shoots can swallow up several full days, and they usually involve getting up brutally early.

"I thought it would be easier—I didn't think you'd have to wake up so early!" said Lindsay Frimodt, fifteen, who has appeared, among other places, in ads for Pantene hair products and Levi's jeans.

It's frustrating for models when outsiders voice ill-informed opinions, guessing that all a model has to do is show up in front of the camera and look good for a few minutes while a smiling photographer snaps away. Lots of models tell stories about friends, family members, and even strangers who make rude and insensitive remarks to them about how simple it must be to be a model.

"Everyone thinks that it's an easy job, and it's not," said Heather Dunn, eighteen, who lives in Atlanta and is represented by Arlene Wilson Model Management. "You have to go see a lot of clients. People say more negative things about you than positive things. Sometimes you have to do a shoot in the dead of winter in a bathing suit all day long. It's just not the fun that everybody thinks it is, and if you can't handle a lot of stress, you shouldn't get involved."

Models quickly learn that this business is more than just having your picture taken.

A CASE OF NERVES

Another universal among the models I spoke to: all of them reported they were nervous at their first job, first test, or first go-see. It's natural to get the jitters under such circumstances.

Kristin Klosterman, nineteen, has been going on go-sees for five years, but now that she is trying to move more into acting, she finds the experience difficult once again. "In the beginning I was nervous going on go-sees, and now they are routine," she said. "But now I'm going on more castings for movies and television, so I'm nervous again, just because I'm not used to it yet. I have to talk and audition with lines now."

Even though a model may have butterflies in her stomach, it is her job not to look terrified. Model Jillian Baker said she literally gets a stomachache sometimes on car rides to test shoots, but she generally gets over it once she meets the people on the job.

Other models say that particular situations trigger their nerves and fears—a go-see for a major job, or a particular type of job, like runway work. But the approval that comes with landing a job or actually performing one can diminish these problems.

"I was more nervous on castings for runway shows, because I didn't know how to walk," said Megan Hoover, sixteen. "But after I got booked for a show—I guess they liked me—I wasn't nervous at the show."

Sometimes making a friend on the set can make all the difference. "My first job was for JC Penney and I was nervous," said Danielle Lester. "But the makeup artist really helped me. She knew it was my first job. I've been real fortunate to work with great people. I always have fun and enjoy it."

Every model has her own way of handling her nerves, and most of them say they get over their initial fears pretty quickly. It is normal to be scared at first—just try to relax, and keep an eye out for people along the way who will try to help you. Remember, even seasoned professionals get nervous—they just try not to look it!

Diary of a Cover Girl Shoot

▼

In 1997, fourteen-year-old Carrie Tivador was one of five new models selected to represent Cover Girl, the cosmetics company. She joined the company's core lineup of all-star models, including Niki Taylor, Tyra Banks, and Rachel Hunter.

The girls' first shoot took place in January 1997 in Miami and New York. It was shot (photographed) by Arthur Elgort, a prominent photographer. After Carrie finished the job, she described her experience to me:

"Each day we would wake up at 5:30 A.M. and start working by 6 A.M. We'd get hair and makeup done, then start shooting. The first few days it was three of us—me, Jua, and Lucy—then the other two came, Sarah and Christina.

"I remember the second day—this was for the commercial. We'd get hair and makeup done, then the crew who were already on the beach would use a walkie-talkie to call another crew person and ask to send us models down to shoot on the beach. On the set, so many people were standing around—it was a crew of about twenty people, including the director, the hairstylist, the makeup artist, and so on.

"First we'd talk to the director. He'd tell us what to do, but just give an outline. Then we could do

LIVING OUT OF A SUITCASE

The two things models cite most frequently as positive aspects of their jobs are (1) the opportunity to travel all over the world and (2) the chance to meet new and interesting people. A model's career can take her to dozens of cities in the course of any given month, and she will meet all kinds of people who are very different from herself.

These aspects of work life actually have bad points, too. On the one hand, many girls say it's thrilling to visit exotic countries they would never have otherwise seen, but on the other hand, the frantic pace of business and travel can be both exhausting and disappointing. Traveling is a physical strain no matter what the conditions are, and it's especially taxing when you're obliged to look your best once you get where you're going. Moreover, models are often so busy on the job—whether it's appointments or actual photo shoots—that they don't get to do much sight-seeing or exploring. On top of that, working in a country where you don't speak the language, getting lost in strange lands, encountering people who are predatory, and feeling homesick can all create intimidation and frustration.

"You have to know about customs, how to get through airports, how to deal with your luggage, the language barriers, dealing with foreigners, the currency and exchange rate," said Catherine McCord Mogull, twenty-three, a New York–based model. "Also you get lonely—you lose touch with your friends from home and

even with your friends in the business." (You can read more about Catherine's modeling career in a later section, "Talking to . . . Catherine McCord Mogull.)

"I love the shooting part and the traveling, but what's hard for me is being away from home," said Bianca Englehart, seventeen, a Miami resident who has spent time modeling in Milan. "If I'm away from home for a month and a half, I need to see my family."

I find that models' experiences working abroad vary—some love it and some hate it. Some models strongly prefer certain cities to others, and some love them all. Some enjoyed traveling from the beginning, while others said it took time.

Kristin Klosterman disliked Europe the first time she went, when she was eighteen. Her month in Milan was a terrible culture shock. "It's dirty, and I didn't like how people there are treated," she said. "I also got sick there—I was sick and exhausted and miserable."

Like many new models who go abroad for the first time, Kristin also found that the work wasn't flowing in as quickly as she had expected, and that most of her time was spent on go-sees. In Italy, "I did do a fashion show for Romeo Gigli, then I went directly to London," Kristin said. "I only stayed one and a half weeks. I was still sick, and going on ten to twelve castings a day. I was also homesick, so I came home."

By contrast, Kristin had a more positive experience on her first trip to New York. Though she was scared about the city's reputation for crime, she came alone for three days and the

whatever we wanted. Since the crew was all watching, I was a little nervous at first, and then I got used to it. After the first half hour of shooting, I thought, 'Yeah, this is cool—even when you do stupid things!'

"The crew would watch a monitor and see what we were doing as we were doing it, to see how it would look on television. If something didn't work, they told us to try something else. We did have a script, but then we were also free to try other things.

"It was *not* what I expected. I had thought it was going to be only me on the shoot, that I'd have to say things, and that everyone would be staring. It was not like that. There were other models, and the director made it fun. I also didn't know that there was so much shooting time for a commercial. I thought it would take one day. Now I know that it takes longer. If something is not right, you have to do it again . . . and again and again and again!

One day, a crew from *Seventeen* magazine came down to do a cover try on all of us. We shot in a studio and did a group shot and then singles on each girl. This was the only print we did—the rest of the week was for the commercial. From that photo shoot all five of us landed on the cover of *Seventeen*'s June 1997 issue.

"On the shoot, we got to meet Niki Taylor and Tyra Banks. For

me, that was the best part. I thought they would be different. They were not stuck-up–they were so sweet. Niki told us to stay in school, and Tyra taught us how to walk down a runway.

"Niki worked with us for the first three days. She would be shot alone, and then do talking for the commercial. Then Tyra came for the last two days. At times the director would pick girls to shoot with Niki and Tyra."

"After one week in Miami on location, shooting on the beach, we flew to New York to shoot more. This time, we shot in a studio and we did more shots of each girl alone. These shots were more 'beauty' shots–close-ups. We were shot in front of a black backdrop in Arthur Elgort's studio, more of the same stuff we did in Miami."

▲

trip was a happy one. "On the last day of the shoot, my agent came up [from Miami]," Kristin recalled. "We went to a party for Jean Paul Gaultier where I got to pick out a dress to wear—I felt like Cinderella."

Coming to New York is a rite of passage for a young model, a chance to find out if her "look" proves popular beyond the market where she may have started. Agents also like to send younger models overseas during school vacations, usually to Europe or Japan, for one or two months during the summer. Europe in particular is a good place for young models to build their skills and portfolios, since there are dozens of European magazines and the competition to gain spots in their editorial pages is less fierce than in the United States.

But travel is a part of life for all models, whether or not they are new to the business. For some working models—those who aren't still in high school or those who have elected for private tutoring—travel is an integral part of the routine.

WORKING ABROAD IS EXHAUSTING!

For lots of girls, traveling to a foreign city to work as a fashion model is a distant dream. When the dream comes true for a young model, the reality can be jarring.

The rigors of working in a foreign country are something that almost every young model has experienced. You may find yourself working in . . .

▲ **Paris**

Jennifer Davis, nineteen, recalls a summer modeling excursion:

"In Paris, I would wake up at about 6 A.M., get on the Métro, and get to my shoot. Usually, my makeup would take about one to one and a half hours, hair another hour to hour and a half. Clothes, set, and lighting would take another two hours, and then shooting starts. Each frame, depending on the photographer and what the magazine wanted, would take an hour, and there would be several outfits, several changes of scenery.

"When I worked for French *Marie Claire,* we would work late, because the photographer needed to get a certain number of outfits done for the story. Then I would get on the Métro and get home late, and get up the next morning and do it again."

▲ **Japan**

At thirteen, Helena Stoddard spent the summer in Japan, modeling mostly for catalogs. She described the experience as the "hardest and most strenuous" of her three-year modeling career. "On go-sees, I would stand in front of huge tables of people, and I couldn't understand what they were saying." The upside was that Helena was escorted to all her appointments by car, so she didn't have to worry about finding her way around foreign turf.

▲ **London**

Before Nina Zuckerman went to London at age sixteen, she had only modeled part-time after school. Though Nina had had a fairly cosmopolitan childhood—she grew up in New York City and Switzerland—she still found it tough to get from place to place in a new city.

"I went around to appointments and jobs by myself—sometimes I would have eight appointments in a day," she said. She worked for magazines *Sugar* and *Bliss.*

Her friends assumed her five-week trip to London with her mother was going to be a vacation, but Nina found otherwise. "It was all very foreign," she said. "I had to learn the Tube [subway] system, and once there was a Tube strike and I had to get to a far part of London for a test. I used maps and figured out what buses to take. It felt like hard work!"

▲ Athens

The first time Nikki Vilella ever traveled by herself was when she spent the summer in Greece. It was lonely and sad to say goodbye to her parents, and everyone cried at the airport, but Nikki ended up having a good time.

"I packed a huge suitcase—I didn't know what to pack—so I'd show up on go-sees in, like, church clothes," she said. "Now I know better. I pack mostly light and black clothes to mix and match."

▲ Milan

When Megan Hoover was fifteen, she spent four weeks in Milan. Her mom went with her. "I didn't work much at all and the castings were exhausting, but I didn't get bummed out," Megan said. "I only worked two times, but I knew the time I put in there would pay off."

I have seen dramatic changes in models who have traveled abroad. Not only have they developed their "look" and brought home tearsheets to show for it, but they also exhibited a new level of maturity and self-confidence. Models have told me that trips abroad can be lonely, scary, and overwhelming. But those who succeed say they thrived on the learning experience.

You can read more stories about working abroad in the next chapter, "Business Life."

ON LOCATION

If a job takes place "on location," it can last anywhere from one or two days to two weeks. In this case, the entire entourage—client, photographers, stylists, models, hair and makeup artists—travels somewhere of the client's choosing: a beach or desert or city street, for instance.

Location shoots can be particularly grueling for a young model, who may be away from home for the first time and among strangers. This is when her personal strengths come into play: she must be cooperative, friendly, helpful, patient, and ready to work hard to create great images.

Location jobs are also filled with long days. You may be up at early to start with hair and makeup, so the photographer can capture your image as

dawn breaks. Photographers say daybreak and sunset provide the perfect light, so you may be called on to work again to use the late afternoon light.

There is usually a break at midday—typically noon to 2 P.M.—when the sun is directly overhead and the light is least flattering.

After work, the crew is expected to have dinner together. This may be a time to discuss the day's work, offer suggestions, and plan for the next day. It's also a time for everyone to get to know one another. As you start to work regularly, you may find that the same people show up again and again.

Amy Owen, who is based in Chicago, said she travels every week. Sounds glamorous? How about a day trip to Dallas, or a trip to the Caribbean on which you aren't allowed to go swimming?

"You're standing on a beach, but you can't even put your toes in the water—it's kind of a tease," Amy says. "You're in full clothes and makeup, and even at lunch you can't go for a dip because the makeup artist isn't going to do it again."

Barbara Stoyanoff, twenty-one, is a six-year modeling veteran whose favorite job was a location shoot for Australian *Elle* in the summer of 1996. "They flew us from New York to an island, Palau, that was six hours north of Australia," she said. "We flew from New York to Los Angeles, to Hawaii, to Guam, to Palau!"

It was a three-week assignment. "We got to swim with the dolphins, go diving. The people on the island were great. They were so proud and protective of their water and told us to watch out not to disturb the coral."

Since that shoot, Barbara has settled in New York and is starting to move into acting and commercials.

Delana Motter, fifteen, said the best job she did was a two-week safari in the wilds of the African jungle. The client was from Brazil, and the pictures that were taken were meant for the covers of a line of school notebooks.

"We were moving from place to place—makeup early in the morning, shooting all day at beautiful resorts and game reserves," Delana said.

Though the scenery was beautiful, the chance to enjoy it was minimal. "We'd arrive at these places so late it would be dark, and we'd leave early in the morning, so we'd never see them."

On a location trip, the crew bonds and you get to know the people you are working with very well, even though you may have just met them. One thing that's particularly hard for young models is saying goodbye at the end of a

trip—it's tough to tear away from people you have been working with so intensely.

TIME OUT: RELAXATION IS A MUST

With the hectic schedules that models carry—especially models who are trying to juggle school and work—finding time to unwind is critical. How a model makes use of her downtime can often determine how well she can then go ahead and do her job during the uptime.

Sometimes when work is slow—jobs few and far between—a professional model can steal time for herself. She can take care of all the things she might have neglected during busy rounds of appointments.

As a matter of course, a model must make sure she is eating right, exercising, and sleeping well. That is part of the job. But when she has spare time, she can also pursue the activities and pastimes that help keep her grounded.

"When I'm not working, I like to cook, do yoga, and paint," said Heather Lett, who is twenty and lives at home with her parents near New York City.

I know models who unwind by taking dance class, biking, attending poetry readings, taking night classes at universities, reading books, writing letters. They use their hours away from the camera to stay in touch with old friends and family members, to stay grounded.

These activities may not seem like a part of "work" life, but they are critical to the holistic life of the model.

"I write a lot of poetry, I do yoga, and get massages," said Cassie Fitzgerald, seventeen. "I go to the gym every morning before school, five o'clock in the morning. I listen to music. If you want to succeed, you have to be powerful, there has to be a spiritual side of you—you have to be in tune with yourself."

Successful models are well-rounded girls. They are fit, intelligent, and emotionally balanced. They take care of themselves, because they know it will dramatically bolster their careers. Since most of them live in large cities, they have ample opportunities for relaxation and self-improvement.

"When I have free time—which isn't that often—I like to meditate," said Nicola Vassell, eighteen. "I also like to work out, run, and read. Since I'm always around people, individual time is very important to me."

For Kristin Klosterman, painting with acrylics and watercolors is a release from the pressures of modeling. She paints every day, and has even exhibited and sold some of her work. To me, Kristin's artistic talent is one of the most intriguing things about her as a model—her eye for beauty enhances her own great looks.

"Art is a huge part of my life, and I have been painting and drawing since eighth grade," she said. "I get my inspirations from emotions. My style involves overlapping and layering. When I go to the beach, I look at the sky and sunset—I can zone out in the colors of the sunset."

Just about every model has some sort of hobby or side interest that helps define who she is. Those special interests also help inform who she is as a model, and can become a critical crutch for her as she goes through new experiences. For instance, let's say a model is visiting a new city—she may feel overwhelmed, confused, and frustrated. Being able to reserve time for herself, to fall back on activities or pastimes that help her relax, is an excellent coping mechanism.

Then again, there may be times when a model feels that her career is dormant—she only has a few bookings or go-sees—and that there is nothing much for her to do. Oh, yes there is! These slow patches are the perfect time for her to take stock of how she's doing and feeling. She can think over the last jobs and go-sees she had. Did she do her best? Was there anything she would do differently?

A Model Who Baby-Sits?

▼

Kim Matulova goes on castings and jobs in New York almost every day. How does she stay grounded?

Believe it or not, even though Kim can make more money as a model, she still enjoys spending her free time baby-sitting for neighbors.

"That's my pocket money. My modeling money goes in the bank," Kim said.

▲

STAYING HEALTHY IS A FULL-TIME JOB

As a new model, even when you're at home—especially when you're at home—you must maintain the same health regimen you would when you're officially on the job.

Here's why: sometimes a client will book you while you're back home. (This is called a direct booking, because the client hires you directly without seeing you in person before the job, on the basis of either your portfolio or a prior meeting.) When I am thinking about doing this, I often ask the agent to have the model take a Polaroid (picture) of herself so I can see if she still looks the way I remember her or the way she does in her pictures. When models are young, their bodies are constantly changing—their hair grows, they get taller, thinner, heavier, their braces come off, and so on. Even if I have just met a girl a month ago, I usually ask to see a fresh photo.

So, if you're back at home and in school, you had better be taking care of yourself. You may be on a plane tomorrow for a major job over the weekend. The unpredictable nature of modeling is why it's very important for models to take care of themselves mentally and physically at all times, to meet the high demands that any day might bring. Eating well, exercising, and sleeping well are steps models can take to ensure that they are alert, composed, self-confident, and beautiful in any situation.

Always keep in mind that if you are not ready for a job that comes in for you, there are dozens of other models out there who are ready. With the competitive nature of the business, it's important to stay ready and one step ahead of the others.

Roundup: What's your favorite—or least favorite—type of modeling work?

▲ Holly Barrett, eighteen

Editorial is so artistic and creative. They experiment a lot more with your makeup and hair and clothes. I enjoy editorial more, because I can get into it and I like the results better.

▲ **Janelle Fishman, sixteen**

I actually think being in front of the camera is more difficult [than runway work]. When you're walking down the runway, it's so fast. You have to look even more perfect because it's live, but you can be more free, in a way. It's fun putting on all those different clothes.

▲ **Megan Hoover, sixteen**

I love all types of work I get—print and runway. You have to have the passion inside to do this.

▲ **Jenny Knight, fifteen**

I like doing television ads. It was fun doing a commercial for Armani jeans—it goes faster than taking pictures. I want to take acting now because of it.

▲ **Breann Nelson, fifteen**

I think editorial is the most fun. Catalog pays more, but everything is kind of generic. Everything is pretty similar with catalogs. With editorial, you get to have fun because it's off-the-wall makeup and hair and clothes.

▲ **Jessica Osekowsky, fourteen**

I don't like modeling bathing suits, that's for sure. It's sort of intimidating.

▲ **Amy Owen, twenty-eight**

Parts modeling was boring. I was a hand model and I liked to play sports, and I had to be so concerned about my nails, my hands, at such a young age. You would have to stand in one position for hours on end—it was really physically painful. So I would have to go to a masseuse and a chiropractor.

▲ **Andrea Pate, fourteen**

I like it when there are funkier clothes, because you can do a lot of different movements and stuff, and create the mood. It's fun when you have really cool clothes that you really like.

▲ **Brittny Starford, eighteen**

Runway is fun because it's live, and they usually have neat clothes. The best part of the job is when you work with people you like—it makes it fun.

▲ **Filippa Von Stackelberg, fifteen**

I love doing runway shows. I am nervous before a show, but I love the music and that it's live. I like runway better than print. I've done shows for Cynthia Rowley, Alberta Feretti, and Jill Stuart.

BUSINESS LIFE

"The price of greatness is responsibility."
–Winston Churchill

THE MODELING INDUSTRY is a business. People in the industry are hired for their looks, talent, and qualifications. Knowing this fact can lead to understanding how you as a model interpret your role and learn to get jobs.

You must have a clear knowledge of how to present yourself—how to put your best face forward and showcase your attributes in the most positive light. You also need to know what your biggest selling point is, whether it's your personality, healthy body, intelligence, or perseverance, or some combination of these qualities.

Because this is a business, a model must also know not to take anything too personally, either setbacks or triumphs. That is easier to accomplish for some models—typically the more mature ones—than for others. For a young girl, the business can be rough indeed, and every job rejection can feel like a slap in the face.

I can't emphasize enough that not getting a job has absolutely nothing to do with who the model is as a person. The client is looking for a specific look, or type, or hair color, or body shape—there are any number of different variables and factors. There are countless reasons why one model gets a job over another, and some may be as simple as having the right shade of brown eyes.

Demand for a model can also vary widely from market to market. A model can find herself in hot demand back home, and totally out in the cold when she goes abroad. The best models take this for granted and don't get rattled.

"I did tons of catalog and editorial work at home in Miami, and then that summer I went to Milan for one month," recalled Bianca Englehart, seventeen. "I did a lot of testing there, but I didn't work at all."

Bianca took the disappointment in stride. Even now, I don't get bummed out about not getting a job. There's always another. I relax about it."

Bianca's attitude was echoed by a lot of the other models I spoke to. Their healthy outlook may be part of the reason they are succeeding in the business.

Success doesn't necessarily translate into fame. Modeling is a diverse business, and many models have successful and lucrative careers without ever leaving their home markets or becoming household names.

On the other hand, a model who seems like a rising star can suddenly find herself not working as much. How fickle is the industry? "You could become something one day, and by the next week, you could be out," said Janelle Fishman. "You could go on ten castings in one day and get one job for that week, or it could be all jobs."

A new model must keep in mind that she may be doing all she can to advance her career, but no jobs come through. That's the nature of the business—there are slow times. A good agent will always be hustling to get her work. If it's slow for a model in a particular city, the agent may send her to another city where opportunities are more abundant or where her "look" might prove more popular. If she and her agent have objectively assessed the situation and have done what they need to, then the problem may lie in the fact that the business is highly unpredictable, and girls often get passed over for inexplicable or intangible reasons.

DON'T TAKE IT PERSONALLY

Most successful models understand the importance of being able to separate themselves from the work they do. They know the rejection is not about them—it's part of the job. But this lesson, one of the most important to learn, is especially hard to accept when you're young.

"No matter how many times I tell myself that it's not about me, it's still there, that someone else got it," said Helena Stoddard, fourteen.

Nina Zuckerman, seventeen, said that the ability to distance yourself

comes gradually. "In the beginning it's hard, but then you get used to accepting rejection and being turned down," Nina said. "Your agent may say, 'Maybe you'll do this cover,' and then you find out they don't want you. You have to know that it's not your fault. After a while you let it not get to you, but you're always a little disappointed."

Jobs are always shifting around—clients change their minds about who they want, what they want, how many models they want. This can bring on a roller coaster of emotions: a girl thinks she has a job, learns she doesn't, then may even get the job back again.

There's also the marketplace to consider. For every job that is available, there may be hundreds of girls trying out—and the client may decide to choose none of them and instead pick someone who walked into his office or whom he saw on the street. So much of it is being in the right place at the right time, and having the right look for a particular job. Clients can be pretty blunt about what they're looking for and whether or not you fit the bill.

Most disappointing, January Jones, nineteen, said, are the times a client will tell her the job is hers during a go-see and then reverse the decision. "If it's not meant to be that you get the job, it's not meant to be," she said. "You have to be strong."

I've seen that happen, too. Sometimes I'll think of a model only to have someone who's even more suitable for the job walk in my door. I'll go with the more appropriate model. It doesn't mean that there's anything wrong with the first model, or that I don't think she's a terrific person! It just means that another model happened to be better for that job. But I'll make sure to discuss the job with the agent.

There are other factors at work. A model who looks great in editorial spreads may not work out on the runway, or a model who does terrific catalog work may not be able to make the transition to editorial. Models generally get to know what types of jobs suit them best.

"You don't take it personally," says Delana Motter. "I'm 5'7½", a bit under standard, so I may be too short for runway work. I have dark hair and light eyes, and they may want a blonde, blue-eyed girl—it just depends what they're looking for."

Melissa Tominac learned that lesson, too, one summer when she came to New York and found her features were not in favor that season.

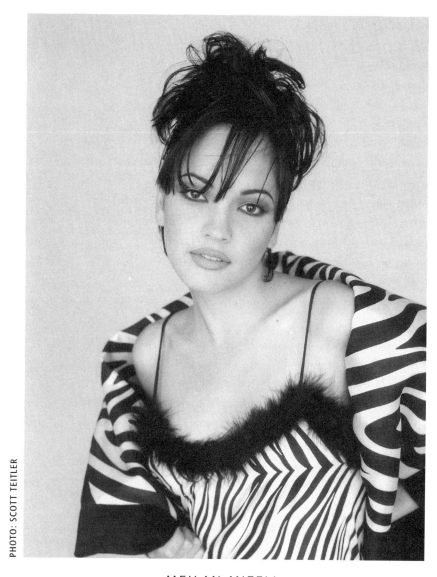

PHOTO: SCOTT TEITLER

MEILAN MIZELL

"I really didn't fit the look that was popular," she said matter-of-factly. "I'm more of a classic kind of look, and they were using more edgy, exotic-looking girls. Maybe my time will come when I'm older and they're more into the classic style. They're always looking for something in particular, and if you don't fit it, it's nothing against you."

Then again, Melissa acknowledges that her "look" may never hit it big. "I do well in school and I keep up my relationships with my friends and do normal things, so, hey, if modeling doesn't work out, I still have all my options open."

"It's hard to separate myself from the work," said Meilan Mizell, eighteen, who graduated from high school in Tampa, Florida, and is now working full-time as a model in New York while she earns money for college. "Modeling is not as easy as it looks, and you go through so many struggles. It's work to keep my ego up, build my self-esteem. I work a lot on myself, and I realize things about myself. It's an emotional struggle."

I have worked with Meilan for several years and have seen her become more successful as her confidence has grown. When she started out at fifteen, school was a priority and the four-hour drive to go-sees in Miami was sometimes too onerous (she occasionally sent Polaroids to clients in lieu of a personal meeting). Meilan says work is best when "I know that the photographer caught who I really am."

She said: "The only time I have a bad day or feel really bad on a shoot is when I feel I'm not doing a good job. I'm always picking up on how everyone is feeling on a shoot. Sometimes it's difficult because, if something goes wrong, I feel 'What did I do to make the shoot go wrong?' "

TIMING IS EVERYTHING

A model's work schedule is serendipitous—she can be crazy in demand for months at a time,

Know Your Best Assets

▼

Some models have a specific feature or attribute that defines the type of jobs they are most likely to get. For Jessica Osekowsky, it is her hair that has defined her young career.

"It's sort of big and frizzy," said Jessica, who is fourteen and lives in Lake Arrowhead, California, a distant suburb of Los Angeles. She is represented by Ford in Los Angeles.

Jessica's first job was for *Teen* magazine, where she was featured in a story about how to condition your hair if it is frizzy. It took two hours to prepare her hair for the shoot. She then did print and television advertisements for a product called Frizzies, which—you guessed it—is a hair detangler.

Ironically, the worst part about modeling, Jessica finds, is having her hair done. "It hurts a lot," she said. "They pull and stuff—they put in tons of hair spray and knot it all up. You always have to comb it out and wash it when you get home."

Sometimes the hair torture is unbearably time-consuming. "When they curl it with a curling iron, that takes about two hours," Jessica said. "It takes about that same time to straighten it. Most of the time, they make it really big, which only takes them about half an hour."

▲

PHOTO: TODD VITTI

JESSICA OSEKOWSKY

then her work flow inexplicably dries up. She is still the same person with the same look, but she may no longer be the type of model clients are seeking. The reverse may also be true. Models tell stories of slow work periods followed by an avalanche of jobs.

There is no secret to being in the right place at the right time. I know

from my own work picking models for *Seventeen* that there are so many models out there, it's mostly a matter of timing and logistics that determines which ones I am able to see (or use) when I am casting a particular job. The perfect model may be out there, but she may be unavailable. Someone who was perfect for the last job we did may not be suitable for this one.

One strategy that has worked well for some models—and one that agents recommend—is to try out several markets, large and small, to see which is the most suitable for a girl at a given time.

An example of a model who followed what was happening at the moment and went where there was work for her is Nikki Vilella. First she went to Greece and got no work. Then, on her agent's advice, she went to Miami and had better luck.

"Miami was an easier market than New York or Paris—for me," Nikki said. She stayed for five months, building her book with catalog work. "I remember my first go-see there," she said. "It was for a Swedish catalog, and I got the job. I remember my jaw hitting the floor when they told me my rate for the day!"

But the bigger markets proved harder for Nikki to penetrate. She came to New York and found it scary: "I thought, 'I'm not a New York model.'" She got a trickle of work. Then her agent sent her to Paris, and she got no work at all.

"There were ten of us girls the agency sent who had never been to Paris," she said. "I was there for a month and a half, and I had go-sees every day. I was a little disappointed that I didn't work. None of the ten of us new girls worked. But it wasn't heartbreaking—I was in a beautiful city, I had great experiences, and I had the money I had made in Miami to spend."

Nikki's travels took her to Los Angeles next (in between each city, she made sure to go home for a while to Michigan to relax and regroup). She didn't like the city, but the work was good, and she got jobs four or five days a week.

Often the big, exciting jobs are punctuated by a more steady flow of smaller jobs—or of no work at all. It's hard for the model to deal with the uneven work flow, or with the fact that every job she gets may be her last.

It's made even more difficult when friends and schoolmates are keeping an eye on your work. Most models say their family members and friends ask

them all the time about when they're going to appear in magazines, and it adds an extra layer of pressure.

Melissa Tominac tells the story of doing a shoot for *Teen* magazine, which was a big thrill, and then moving on to another job for *YM* magazine. The *YM* job, shot in Miami, was meant to be a cover shoot, but at the last minute the magazine decided to use another model. "I was like, 'Oh no, I told all my friends I was going to be on the cover,' " Melissa said.

Sometimes timing can work in your favor. Nina Kaseburg got her first modeling job even before the agency that signed her, Seattle Models Guild, had written down her telephone number.

The story goes that Nina's photo was floating around the agency on a day when a client came in looking to fill a particular job. The client saw the picture of Nina and said, "She's the one." The agency began searching for Nina's number to contact her, and at that very moment, Nina happened to walk into the agency. She has gone on to work for department store catalogs—Nordstrom's and Bon Marché—and has appeared in *20Ans* about top new girls to watch.

Rarely can a model have any control over whether she gets a job or loses it. Sometimes a model can lose a job for the strangest of reasons. For Charlotte Dodds, it was a blemish. "I had a catalog job in Miami, and I had come directly from a job in Cuba with a mosquito bite on my face," she said. "They saw my face and said, 'We are canceling you.' I was like, what? Then I had to laugh. How funny is that? Because I have a mosquito bite on my face? What can you do? It wasn't my fault, it wasn't the client's fault. It was a freak of nature!"

On the other hand, Charlotte also got one of her favorite assignments through timing. In chapter 1, I discussed how getting discovered as a model can be a matter of good timing—being seen by the right person at the right time. Well, as it turns out, getting jobs once you are already a model can work exactly the same way.

Charlotte was modeling in Milan for a stint and happened to be waiting in the lobby of a building where a designer, Versace, was casting a runway show. Even though Charlotte didn't have an appointment, the Versace people saw her standing there and asked her to be in the show. "I was the shortest model on the runway," marveled Charlotte, who is only 5'6".

THE YOUTH FACTOR

Most models start out when they are in their teens. People in the industry are attracted by the models' youth, but have to draw boundaries: clients know they shouldn't throw a young girl into a high-pressure environment too soon.

"I was on hold for a job to go to Australia, for a magazine, for ten days," says Andrea Pate, fourteen. "They canceled when they found out my age. A lot of times my age is a problem, because the clients don't like it that I am so young. But a lot of times the photographers love it."

It is this paradox that dogs the fashion industry: photographers say they make the best images using models who are extremely young and slender. Magazine editors and other clients can be torn, worried about the concept of promoting girls at such a tender age. Parents are also torn, wanting their daughters to fulfill their ambitions but worrying about their missing school.

A lot of models in their early teens find that, when they get dressed up, they easily look twenty years old or beyond—but inside they're still just kids. Their youth is a huge issue in their working life.

Part of the issue is emotional maturity. Starting models may never have been exposed to the types of situations the modeling world offers, working with all sorts of adults who have nothing in common with them and who may not know how to relate to them. Even their agents,

5'6" Is Short?

▼

The average American woman stands well under 5'6"—but not the average model.

At 5'6", Charlotte Dodds once won the Overall Petite category at a modeling convention. Though most models of her height find they can only work in the niche market of petite modeling, Charlotte was a rare exception. She has broken into the mainstream model market but finds that her height constantly works against her.

"It has been harder for me," she said. "I am up against models who are 5'9" and 5'10". But I have gotten a lot of work, so I'm not complaining."

Jaime Rishar, a rising superstar who is also 5'6", talks about the problems of being on the short side. You can read about her in a later section, "Talking to . . . Jaime Rishar."

▲

who are their links to the working world, are grown-ups who aren't always sensitive to a model's youth and development.

So, although the industry thrives on the youth of the models, it can also overlook girls' needs. Models who have the strength and support necessary to work in an adult world are the ones who can stick it out.

Adjusting to the schedule of a working person can be the biggest shock for a schoolgirl. The working day usually involves spending a lot of time with adults. Many younger models describe feeling uncomfortable at being the only teenager in a sea of grown-ups.

"Sometimes I feel strange on the set, like I don't fit in," said Filippa Von Stackelberg, a ninth grader. "I am usually so much younger than everyone else."

Marysia Mann, who is fifteen, has had the same experience. "I try to do homework during castings," she said. "It's pretty funny. Everybody else is like eighteen, twenty, and I'm sitting there doing my workbooks for school."

Another common problem is the culture shock that comes from switching back and forth between friends and school—normal teenage activities—and work life as a model.

Jo Stoddard, whose daughter Helena began modeling at eleven, put it this way: "Helena lives in two worlds. In one, she is treated like a kid, and in the other, she is treated like an adult. It's awkward to flip between the two. But she has matured and gotten a broad perspective on the world."

Helena, who is now fourteen, has been modeling for three years. Her mother took pictures of her and sent them to two local agencies in San Francisco, where they live. One agency sent a rejection letter; the other, Stars, The Agency, called for an interview and eventually signed her.

Working at such a young age has had its ups and downs; Helena looks back with humor at how little she appreciated the prestige of one of her first jobs—for an Esprit catalog.

"It was hard in the beginning," said Helena, who has modeled in San Francisco, Japan, Italy, and New York. "It is a very adult world, an adult business. As children, we have to learn how to talk with adults and be able to have a conversation. I can't feel self-conscious or it will show in pictures."

Working in the adult market often means being placed in adult scenarios. Some very young models say the sexy or romantic content of the shoots they do is hard to handle.

Janelle Fishman recalls an uncomfortable shoot she did for *Self* magazine with a male model. "I was in a nightgown and he was in boxers, we were sitting on a bed, and we had to pretend that we were making out," she said. "He was much older than I was, and I felt really weird pretending that we were kissing."

Another time, when Janelle was only thirteen, she was sent on a shoot in Italy. "No one spoke English and I couldn't understand anybody," she said. After a difficult day of shooting, "They said, 'You look too young, so we're going to send you back.'"

Depending on how mature a young teenager looks, she may be able to start her modeling career right away—or she may have to wait. Lindsay Frimodt, of San Francisco, got signed by an agency when she was thirteen, but she didn't get her first job for a year. At 5'6", Lindsay was considered too young and small to begin working right away. Her agent at Mitchell Agency told her from the get-go that she wasn't likely to work much for the first two years, as she grew and developed.

"I tested and I just waited," said Lindsay, who is fifteen.

Her patience paid off after a year, when she landed a spot in an ad for the *San Francisco Chronicle*.

"I wore a Jessica McClintock dress and was photographed in a pumpkin patch," she said. "I didn't know what to do. I had only done two other shoots before, and the photographer had helped me and told me what to do. But on this job, the photographer didn't say anything or give any directions. It was so scary."

Six months later, Lindsay took her first trip—to Korea to do catalog work for two months. It was there that she learned the ropes. "I learned how to pose and then how to move," she said.

Remember, clients want to work with models who are ready, not ones who are going to behave immaturely or get freaked out by the responsibilities of working in an adult world.

SETTING LIMITS

Models have to know where to set limits: on how many jobs they will do, what types of jobs they will do, and how much of their bodies they will expose.

Modeling is an industry that requires girls to show off their bodies, often during a time of life when they're feeling self-conscious about the changes that are a part of adolescence.

Being in a runway show can mean having to change clothes in front of strangers. So can being on an editorial shoot. Crews try to be as sensitive as possible to the modesty of models on the set, but getting undressed and changing clothes is a fact of life in the business.

Cassie Fitzgerald, seventeen, said her most memorable job was one in which she was naked, covered only by flowers. Cassie wasn't bothered by the situation—and neither was her mother—but she said her brother flipped out when he saw the pictures, which were for a story for *Detour* magazine. Cassie brushed off his objections.

"You couldn't see anything," she said. "There were roses on a vine, and they went all around my body. There were only the amount of people that needed to be there on the set—just the photographer and the stylist—and I didn't feel too uncomfortable. Nobody should really be self-conscious in the business."

Other models agreed that they had grown accustomed to people seeing them in various states of undress, and that people they worked with made them feel comfortable by not making a big deal out it.

But some models said they *did* feel uncomfortable about certain types of jobs. A lot of girls say they don't particularly like modeling bathing suits, and some will refuse to model lingerie.

Beth Pate, the mother of fourteen-year-old Andrea, forbids her daughter to model in lingerie, and Andrea supports this rule.

"Once when she was in New York, there was a photographer who tried to get her to do a lingerie shot, and she was very firm in telling him that she was not going to do it," Beth recalled.

In another situation, Andrea gave up the cover and a six-to-eight-page spread in a foreign magazine because the client requested her to model with her torso unclothed.

"We traveled to Atlanta, she did the entire job—and it was taken away because she refused to do a body shot," Beth said. "I let her make the decision—it was totally hers. I was there, and she chose 'no.' I was so proud of her for being able to give up something that was very important to her."

Jillian Baker, a fifteen-year-old New Jersey model, felt compelled to turn down what would have been her first job—for a major magazine.

"My agent called one day and told me they wanted to use me for a story, but I would have to wear a sheer top," Jillian said. "My mom turned the job down. I didn't want to do it either. I was just starting out, so I thought, 'Maybe I have to do it,' but I knew it was going against my morals. If I was older, it might have been different. It was very hard to turn it down, since it was the first job that came in for me, but I knew there would be more."

Always remember, you have a voice in what jobs you feel comfortable doing and can turn down any job that doesn't sit right with you. Always be true to yourself and communicate with your agent.

REALITY CHECK

The media often portray the fashion industry through a sugar-coated lens: models being photographed at exotic locations in front of an admiring crew, models at movie premieres, models with their rock star boyfriends. There are tons of television shows about fashion and people who work in the business. There are countless news and magazine articles about models on runways, models at charity benefits.

Of course, the industry has this exciting side to it. But I know—and the working models know—that a majority of the life of a model is not like that. What goes on behind the scenes is not at all what the public imagines. Even TV programs on the "making of" a fashion show or music video or advertising spread go only so far. Models tell me that the public still doesn't get it. People tell them sarcastically, "Aww, poor you—traveling around the world with people fawning all over you!"

Also know that the pictures you see represent a single captured moment, precisely orchestrated with lights, hairstyling, and makeup, and that the models you see don't go around looking like that twenty-four hours a day!

This is a very tough business, not only on the physical level of having to rush from place to place and use your appearance in your work but also on an emotional level. Setbacks, disappointments, are a daily truth. A model must work hard at not getting discouraged or insulted by what goes on.

The underside of the glamorous images is scrambling around in a foreign city and getting no work, or being told to your face that you're not good enough, or working exhausting hours for a job that falls through.

Nina Kaseburg, a sixteen-year-old model from Seattle, was sent to Paris for the summer by her agency. After spending the entire summer on go-sees and castings and test shoots, she knew the geography of the city perfectly but still had landed no jobs. The tourism end of the experience was pleasant, but the lessons she learned were hard.

"In Paris, I was doing an audition for a body soap or detergent," Nina said. "The man in charge went over the entire thing in the beginning, and I did the first part, and I thought I did it pretty well, and then I stopped and I said, 'Now what do I do?' And he told me, 'You're not a professional, you're not a model, you're not an actress, so what *are* you?' He was going off. I told my agency."

What did Nina take away from that incident? A lesson that so many models know so well: you need to be strong-willed and to stand up for yourself—and don't take anything personally.

THE COLOR LINE

More and more, the fashion industry is taking notice of the growing ethnic diversity of our country. It's great to see a more global and ethnic mix of people being reflected in clients' choice of models.

There were days when only blue-eyed blondes were in demand. Today, the demand for such models tends to be somewhat cyclical. But the popularity of supermodels like Tyra Banks, Naomi Campbell, Beverly Peele, and Navia Nguyen speaks to the changes that have come about.

It's obvious from looking at the pages of mainstream magazines that minorities tend to be underrepresented. And minority models say they still face many obstacles.

"There have been times that I have been the only black girl on a show, or the only black girl in a shoot with six girls," said Tomiko Fraser. "Unfortunately, I'm sure that there are a lot of jobs that I'm not even considered for because I'm black."

But Tomiko says that "things have definitely progressed" and that mod-

els like Iman and Beverly Johnson had a far more difficult time breaking in than people who came to the industry more recently. Tomiko is doing quite well and has worked for German *Vogue, Mademoiselle, Glamour,* a commercial for Dove soap, and appeared on runways for Chanel, Karl Lagerfeld, and Chloé. Read about her runway experiences in chapter 2.

"People will accept what you put in front of them," Tomiko said. "I think somebody has to be the one to take that first step, to put Asians, blacks, and Hispanics out there, to make it more acceptable."

Charlene Fournier said she believes her exotic looks have helped her. Her ancestry is a mix of Canadian and American Indian blood— among the tribes she is descended from are the Mohawk, Cree, Algonquin, and Ojibwa. In addition to her dark skin, dark eyes, dark hair, and high cheekbones, she has a tattoo of a frog on her leg that represents an Indian clan.

"I think being Native American, I get further," she said. "People are very interested in that. They usually think that I'm Spanish or Hawaiian or Polynesian, and when I tell them, they are totally intrigued."

We in the fashion industry strive to make the images we capture signs of the times, reflections of the society we live in and its diversity. It's great to see changes occurring that recognize the ethnic mix in American life, the blending of cultures that makes us unique as a country.

An Ethnic Model Changes Her Look

▼

Charlene Fournier has had a great modeling career, but she has also encountered plenty of bumps along the way. Charlene nearly quit modeling several times when things didn't work out in New York—there was no demand for exotic models there at the time, she found.

She debated whether or not to quit and return to her rural hometown. Fearful that she would end up "in central Canada in the prairie," Charlene decided to move to Miami to model, hoping that her ethnic look would find greater favor there.

The move was a success, and Charlene began working steadily with clients, including catalogs for Sears and JC Penney, German catalogs, and a campaign for Iman cosmetics. Even so, she recently cut her super-long hair to ear length, to distinguish herself from other ethnic-looking girls in her market.

She explained. "They have the long hair. I wanted to be more sexy. I thought I would have more of a chance of getting work. I looked around and there were lots of girls in my category—long hair, wavy, tall and dark. My agent at Ford and I had been talking about getting my hair cut for two years, and then I showed them a photograph of a model who had the look I was striving for, and we did it."

▲

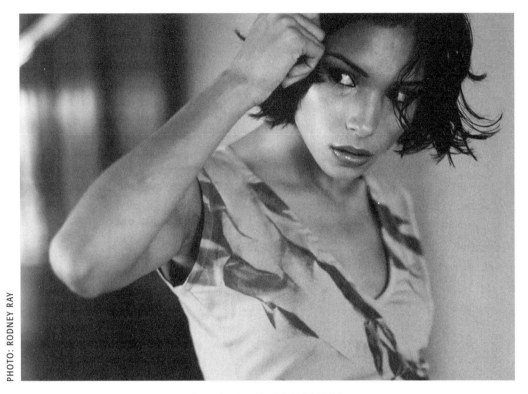

PHOTO: RODNEY RAY

CHARLENE FOURNIER

GUY MODELS

A lot of the models in this book talk about working with male models and actors—of course, guys model, too!

Most of the same rules apply to male models as to female ones. They break into the business in the same ways, and their work, business, home, and social lives are all pretty much parallel to those of their female counterparts.

Just as with the female side of the fashion industry, certain "looks" come and go. There are times when the industry is seeking rugged and masculine-looking models, and other times when tastes run toward male models who are delicate and almost effeminate.

The one major difference between male modeling and female modeling,

perhaps, is the level of competition. Male modeling is a competitive field, to be sure, but most little boys don't grow up wanting to be models. Not so with girls!

Another difference is that male models usually start out modeling at a later age. Most start in their late teens or early twenties, and their careers usually last longer than those of female models. A lot of male models can find themselves working well into their thirties, which is much less typical for female models.

Over the past few years, the male model industry has grown. The demand for male models—not as accessories to the female models, but as models in their own right—has increased, along with the exposure and rates.

Still, the modeling industry is female-driven, and rates for women models are much higher than for males. That is changing slightly. With increasing interest in male models, there are more opportunities for them and their agents are negotiating greater exposure and higher fees.

A few have even gained supermodel status, like Marcus Schenkenberg, Mark Vanderloo, Jason Lewis, Alex Lindquist, and Tyson Beckford. Their popularity is due in part to their looks and talent, and in part to the promotion and marketing done by their agents.

THE NEW YORK EXPERIENCE

For many girls, modeling in New York is the biggest goal. New York is the modeling and fashion capital of America, if not the world. All the major clients are here—magazines, advertising agencies, fashion designers and their runways. All the best opportunities are here.

But the wonderful benefits of New York can also be a disadvantage for less experienced models. Because of the concentration of great agencies and their tremendous rosters of models, New York is the toughest market in America for models to get jobs. Making it in New York is not just a career in itself; it also sets the stage for an international career.

Many models get their first taste of the fast pace of the industry on their first trip to New York. If a girl is from a small town—or even a not-so-small city—coming to New York can be overwhelming and frightening. It's a nec-

essary step, since gaining representation by a reputable agent in New York is the surest and most direct route to a modeling career.

When a model gets to New York, she can know that she is at the very center of the fast-paced, high-stakes world of fashion modeling. If she's fortunate enough to already live in New York City, that's great, but if not, she will have to go through various channels to get here—local agencies, conventions, contests, or schools. Unless a model wants to work exclusively in a smaller market, she's going to have to adjust to working in New York.

MODELS WHO ALREADY LIVE IN NEW YORK

Some models are fortunate enough to live with their familes in New York, or just outside. For them, being able to work in the most major of all markets and still live at home is an enviable situation. They have the luxury of working in the top model market, having access to the world's best agencies, and staying close to friends and family.

Filippa Von Stackelberg, fifteen, lives in New York City with her family and was spotted by a photographer on the street. It was the third time someone had stopped her! She has been working nonstop since signing with Next Management.

Kim Matulova, sixteen, has been modeling since she was six years old. She lives with her family on Long Island, about two hours outside New York City. After a long day's work, it's nice for her to be able to go back home to familiar surroundings instead of retiring to a hotel room or model apartment.

A model who hasn't started working yet but lives right outside New York is Jillian Baker, fifteen. Her hometown in New Jersey is close enough to the city that she has been able to start the testing process right away through Elite. "I live an hour outside New York, so I go on go-sees after school," said Jillian.

School is important to Jillian, and so is ballet—she does about eight to ten hours a week. For now, modeling is an after-school activity, but her proximity to the major market will make it easy for her to progress if she is ready.

These girls were all fortunate to grow up near the best market for their work as models. This gives them the ability to keep their lives as close to "normal"—the way they were before modeling—as possible.

MODELS WHO MOVE TO NEW YORK

Models who move to New York have usually been working in other markets first, to gain experience.

Barbara Stoyanoff, twenty-one, has been modeling since she was twelve. At the beginning of her career, Barbara stayed in school and modeled part-time in the Houston area. She worked her modeling schedule around school. One summer she went to Paris and another to Japan. Her senior year, she went to Miami and New York during extended school breaks. "I've settled in New York this past year," she said. "Here I do editorial and am starting to do more commercials."

Barbara was glad she went this route. By gaining experience, she was well prepared to model full-time in New York, and she's doing very well.

Another model who waited to finish high school before moving to New York is Meilan Mizell, eighteen, who is from Tampa, Florida. She has been modeling since she was fifteen. Now she enjoys big-city life.

Meilan is busy with go-sees, tests, and jobs for clients like *Seventeen, Glamour,* Delia's catalog, and department stores Nordstrom's and Macy's. She plans to live in New York at least one more year before starting college. With such an active modeling schedule, she says, "I wish I had more time to enjoy New York!"

Charlotte Dodds, nineteen, moved to New York to model full-time even though she only had a few test shots and a smattering of editorial work in her book. From here, her agent from Next sent her on modeling trips to France and Italy, where she appeared in Italian *Glamour.*

"I love living in New York," said Charlotte, who has appeared in major magazines like German *Vogue, Marie Claire, Mademoiselle, Seventeen,* and *Harper's Bazaar* and has done advertising work for Revlon. "Here I am from a small town in Tennessee, and now I'm in New York—wow! I appreciate that modeling has gotten me out of my small town. I never really fit in there."

Most models who move to New York and who are successful are girls who have already finished high school. Also keep in mind that some of them view their time in New York as temporary—they may move on to go back to school or to try a different market where there may be more opportunities.

NEW YORK ON SCHOOL BREAKS

At one time or another, nearly every model who wants her career to advance must spend some time in New York, whether she moves here or not. If it's at the beginning of her career, she's usually in high school and has to make these trips during a school break or summer vacation.

Typically, a new model will come to New York for a week or two, accompanied by a parent. If it's longer—say, one or two months during the summer—a parent may come in the beginning to get her settled and then go home. The model and her parents always discuss the living arrangements in advance with their agent. (For more on this, see the "Living Arrangements" section in chapter 5.)

Megan Hoover, sixteen, of Houston, has made a few trips to New York during school breaks. The first two were to secure an agent. The third was to start the testing process. "It was spring break that I came to New York to meet with agents," said Megan. "That summer my mom came back with me to New York. I did testings to start my new book, and I went on go-sees."

New York was an exciting change for Megan. When she worked for *YM* magazine, she said, "I felt like, here I am from a little place, I came to New York, and I'm going to be in a magazine!" After the shoot, Megan went back home to school, and she has been shuttling back and forth ever since.

Delana Motter has also spent a lot of school breaks in New York, where she has worked for *Seventeen,* Delia's, and Finesse hair-care products. New York is not the only city where Delana works—she has agents in Los Angeles, Seattle, Chicago, and Miami as well as in Phoenix, her hometown.

Despite gaining such ample representation, things haven't always been so easy for Delana. The first time she came to New York, it wasn't a great week. "I had only one or two photos and was told to lose weight," she recalled. She went back to Phoenix and through Ford/Robert Black work picked up. Now that she is more seasoned, she has been embraced by the New York market, and a more recent trip here was more fruitful.

Some models may not get work in New York the first or even second time. Many come to test, meet clients for the first time, or get an agent. Helena Stoddard, for instance, came to New York for two weeks to look for an agency.

PHOTO: RODNEY RAY

DELANA MOTTER

She and her mother stayed at a hotel, then returned home with an agent—but still no jobs.

The following spring break, when Helena and her mother returned, the situation was quite different. Helena worked for *Seventeen,* Australian *Vogue,* and Quebec *Elle.*

A Day in the Life

▼

To illustrate how modeling on the local level can be a satisfying and enriching career, here is Lindsey Sanders's description of a rough day on the Dallas modeling circuit. She had three jobs in one day.

"I got up in time to get to the studio by 9 A.M., making sure I had clean hair and a clean face," she said. "I got makeup and hair done and started to shoot. It was a job for JC Penney, and at 11 A.M., it was done and I drove to my next job.

"The next job was for Palais Royal, another catalog, and it went from 1 to 3 P.M. I rushed in with makeup on from the earlier job, said, 'I'll be right back!' and ran to the bathroom to wash off the makeup. Then they started over with new hair and makeup for this job—a whole new routine.

"When that job was over, I grabbed my shoes and a bite to eat and rushed off to my final job, which was supposed to be from 5 P.M. to about 8:30 P.M. This was a runway show for Chanel. I had new hair and makeup done—the third time that day!—then had a rehearsal and the show started at 8 P.M. It only lasted about twenty minutes."

Though Lindsey was exhausted, the runway show itself was worth waiting for. "It was a taste of a Paris runway show," she

There are many other models who try New York on their school breaks and then return later to work. Sometimes the process takes a while. Again, it's a matter of timing. If, for example, you are in New York for only a week and the clients have no job for you, then you won't work, no matter how well suited you are to modeling.

The opposite can also happen. See Carrie Tivador's story of landing a job at *Seventeen* during her first quick trip to New York in chapter 1.

MODELING OUTSIDE NEW YORK

Not every model can work in New York. Not all of them want to. Plenty of models profiled in this book enjoy steady work in their hometowns near major market cities where they choose to live. Although the high-profile jobs come from New York, there is work for models on other levels in cities across the United States.

Lindsey Sanders, who is nineteen, has never been to New York to model at all, but works full-time in Dallas. She's been modeling for four years and has become well known locally. Because she is a familiar face on the modeling scene in Texas, she typically lands three or four jobs a week and rarely has to go on go-sees.

Her first job, at fifteen, was a runway show at a local department store. After that she started testing through her agency, Kim Dawson. Now Lindsey is able to experience all the thrills of big-time modeling—meeting famous

designers and celebrities, working hard in glamorous settings—without having to travel far from home.

Another model who is based outside New York and does most of her work in smaller markets is Amy Owen, of Chicago. She is also a college student.

"I go to school one day a week and every other evening, then I'll work the other four days," Amy said. "I travel quite a bit, one day a week in a different city, mostly in the Midwest—Chicago, Dallas—but also Atlanta."

Amy does catalog work and is happy with it. She made the editorial rounds when she was younger and has concluded that, in the end, "I would much rather have a long career in catalog than in editorial. With the money I'm making, I'm putting myself through school and I own my own home."

TO GET TO NEW YORK

Many models use their time working in markets outside New York to gain the experience necessary to get them here. Some models need to grow and develop in their early career stages, to gain maturity and skill for the Big Apple.

Nicole Blackmon, twenty-five, has moved back and forth between New York and her hometown, San Francisco. At times it seems her "look" is more popular among her established clients on the West Coast. "It seemed like I was a new face here in New York, with my dreadlocks and all," she said. "Plus, I feel

said. "The New York models had come to town, Stella Tenant was there. They chose four or five of us local girls from Dallas to be in the show. There was a tent set up at the airport, and it was a major production. It was great to have the experience of doing a major designer show right here in Dallas."

▲

it's important to work near your home, have a home base, before you leave for a larger market like New York."

Danielle Lester, seventeen, lives near Dallas, a few hours' drive from her agency. She is a high school student and has been modeling for about two years, for clients like JC Penney. She goes on castings and has test shots taken, all with the hope of working in New York.

"Now I am concentrating on finishing high school, because it's important to me," Danielle said. "After I graduate, I plan to work more and maybe go to New York."

Another model who is starting close to home is Shaundra Hyre, eighteen, who lives in Indiana and models in Chicago. It's not that far for her—about a forty-five-minute drive.

When Shaundra was still in high school, she modeled after school and on days off. Now that she has graduated, she works full-time in Chicago—mostly catalog work—with the explicit goal of saving money to go to New York. Shaundra was in New York once for Elite's contest, but it didn't quite work out for her here the first time.

Another model, Allison Ford, seventeen, has been modeling for two years. She lives and works in Los Angeles, modeling part-time while still in high school. She's done editorial work for *Teen, Sassy,* and *YM* and modeled for B.U.M. Equipment and the Robinson-May catalog.

Allison has gained experience through her local work, but says, "After high school, I'd like to travel more for work—maybe go to New York."

What all these girls understand is that for them, at this point in their lives, they can model part-time near home, get more seasoned, and still keep their modeling sights set on New York. They also recognize that this is a business and that their "look" may be better suited to one market, where they can work while preparing for the big time in New York City.

GOING ABROAD BEFORE (OR INSTEAD OF) NEW YORK

Some models start out working and then go to markets abroad—like Europe or Japan—before hitting New York. The idea is that the work experience abroad can better prepare them for New York, if they do end up here.

Brittny Starford, eighteen, who lives in Dallas and goes to high school there, has been modeling for two years, working for clients like JC Penney and Dillard's department store. She has not modeled in New York yet, but one recent summer her agent at Page Parkes sent her to Paris for two months.

"I worked on my book a lot [testing] and did go-sees," she said. "My roommate and I took the train and went to London, and I had a job in Germany."

Is Brittny setting her modeling sights on New York? Not necessarily. "Why I'm modeling, basically, is to earn money for college," she said. "If it's convenient to model and go to college, I'll continue to model." Brittny has done quite well in the Dallas market and did some work in Paris.

Another model who went directly from one market to a foreign country is Katie Hromada, fourteen, a high school student in Seattle. She started testing and modeling about a year ago and has worked for Nordstrom, Bon Marché, and *Teen* magazine.

One recent summer, she got a money contract to spend two months in Japan. "My mom came with me, and it was really a lot of work," Katie said. "I worked every day, sometimes two times a day, and did a lot of different magazines, ads, catalogs, and posters. It was really fun. I learned about the business. Here, they want a natural look, and in Japan, they like funny faces and different facial expressions. They also work you a lot harder!"

Katie learned a lot about the Japanese people, but found it was "pretty lonely. It was too expensive to call my friends, and I worked so much that I didn't have a lot of time to do fun things kids my age do."

Katie has not yet worked in New York, but she did recently sign with an agency here, Ford. Based on her experiences in Seattle and Japan as well as her looks and talent, I think she is ready to try New York.

Another girl who went straight overseas after working one market is Lindsay Frimodt, fifteen, of San Francisco. She's been modeling for about two years, but six months after she signed with the agency, they sent her to Korea.

Later, she flew to London for two months, where she did editorial work, went on lots of go-sees, and lived in a model apartment with lots of other girls (who shared her turmoil at having to find their way through the city using maps and subways and buses).

Lindsay's next foreign stint, after returning home, was in Australia. "My favorite!" she said. Lindsay admits that traveling is lonely and that she's afraid of flying, but she has had great success in three foreign markets, and the experience has helped her personally and professionally. Lindsay has signed with Company Management in New York and feels ready to tackle the biggest market of them all.

What I am illustrating with these examples is that in each market (or city) there are specific "looks" that are in favor at any given time, and some models fit the look better than others. If work dries up in one city or if a model is looking to work more, it's wise for her to check out another city that may be better suited for her at that time.

Another key point is that while traveling may be difficult, it is a valuable experience no matter what. Models who go abroad say that on a personal level, they learn to take care of themselves, and on a professional level, they gain camera time and tearsheets.

THE TRANSITION TO ACTING

Modeling can open other career opportunities.

Since modeling and acting are related skills, it's not surprising that a lot of models try to make the transition from one industry to another. Liv Tyler, Cameron Diaz, and Brooke Shields are great examples of models who made the switch.

Some make it, and some don't. Just as some people aren't cut out to be models, some models aren't cut out to be actors. But many models say their work has given them a taste of what it's like to act in films and television shows, and that they would like to sample more.

One model who is in the midst of making the switch is Amy Smart. Amy had a great modeling career—she appeared on lots of major magazine covers and in television commercials for Union Bay and Bongo jeans. Now she only wants to act. Amy has appeared on MTV and has had small parts in five movies. She's been studying acting for four years and is still taking classes. She works with a prominent acting coach and reads many scripts.

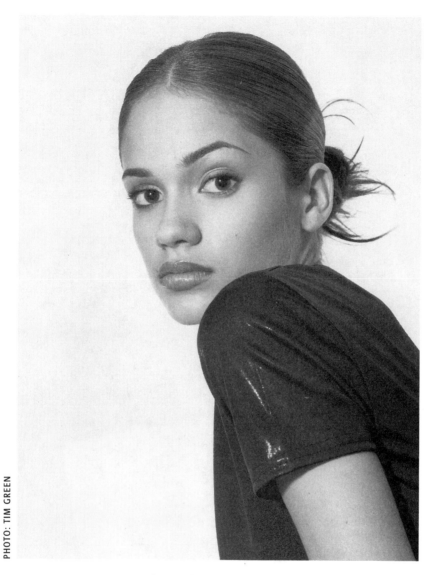

LINDSAY FRIMODT

Amy says modeling is more spontaneous than acting—there is less time waiting around, more time spent in front of the camera doing your thing. It's also more absorbing.

"Modeling to me is a kick in the pants—it's fun," Amy said. "But acting takes everything of you—it's all of you."

JESSICA BIEL

Barbara Stoyanoff is also trying to make the switch into acting. So far, she has done a Maybelline television ad with Christy Turlington.

"A go-see for a commercial is different than a go-see for print," Barbara observed. "You are giving emotions, not just a face. You have to show your inner self."

THE CAST OF *7TH HEAVEN*

Jessica Biel has successfully made the transition from modeling to acting: she plays Mary Camden on the television show *Seventh Heaven*. Jessica is fourteen now, but as early as age eight, her dream was to act on Broadway and in television and films. She started taking acting classes at eleven and continues to take them even as she works on the series.

Jessica's Story: Landing a Part on a Major TV Series

▼

When Jessica Biel, who is fourteen, first auditioned for a role in the Warner Brothers television series *Seventh Heaven,* she was psyched that the part she was trying for was a girl who shared her interests. "She likes basketball and I like basketball, so I thought, 'If I get this, it's perfect. She's an athlete, and so am I.'"

Jessica was called back for three separate auditions—each of which she describes as "fun"—and then a final callback in front of Aaron Spelling, the producer. "It was nerve-racking," she said. "There was this huge couch, about fifteen to twenty feet long, loaded with people looking at me. It was so funny. When I walked in, they all smiled, so I felt good.

"In the last part of the audition, there were four of us kids—the other three who are on the show, and me—and they stared at us together for five minutes, all smiling and taking notes. You don't know what they're thinking. 'Is she too tall? Too short?' So I just kept on smiling. I got the part."

Jessica's father has moved with her to Los Angeles, where she has a six-year contract for the television series. She has breaks from shooting at Christmas and from April to August, when she goes home to Boulder, Colorado. "When

"For me, modeling is fun," Jessica said. "If it's a good opportunity, I'll do it, but for now, acting is my priority. My favorite part about acting is that you get to be somebody that you're not. The character I play now is similar to me, but for one film, I played someone completely different. I was a punk, a rebel. I had spiked short hair. That's not me. I'm more like T-shirt, jeans, big shoes."

STICKING IT OUT IN LOS ANGELES . . . AND SUCCEEDING

Amy Smart is twenty now, and after a highly successful modeling career in which she never left her hometown of Los Angeles, she is making the transition to acting.

But things weren't always easy for Amy, who started at thirteen and said she only got one or two jobs in the first two and a half years of her career.

Amy said: "I just kept with it. I was in school, and I stuck through the slow parts. I was fortunate living in Los Angeles, near a major agency.

"My first job was for a magazine called *Moda.* Then I worked for *Vogue Bambini.* I felt nervous and excited—I couldn't believe it, because I had always dreamed about being in a magazine. Then I would just go to castings and go to school. I'd do a few catalogs.

"I worked for *Sassy* magazine when I was fifteen and a half. Then it started to pick up. I would work after school and go to castings after

school—my mom would drive me until I was sixteen. But I didn't get a ton of work—I was told I was too big to be a child model and too young to be a teen model. But I stuck through it. I was in school, I had my friends. Modeling was like a hobby. If it happened that I got jobs, great, and if not, I wouldn't get upset."

At a certain point, after Amy had matured physically and emotionally, her career took off and jobs started pouring in. After high school, she modeled full-time and went to Milan for three months. She did runway shows and catalogs and traveled the world.

"I remember a job for *Sassy* magazine where I played a young Axl Rose and we shot at a club in LA," Amy said. "We pretended to perform—we were rock stars for a day! Then I started working with *Seventeen*. The first was a prom shot. We went to Santa Barbara—it was a big crew. I did another prom shot a few years later again, this time in San Diego.

"Another job was for an ad for Dolce & Gabbana. I was sixteen. I remember other models like Jaime Rishar and Bridget Hall were there, too. We were all sitting there in the location van waiting for the photographer, Steven Meisel, to show up. Everyone was nervous. But I wasn't, because, being from LA, I didn't realize who he was and how great a photographer he is and what a big deal this job was!"

Amy's work has also included magazines— Italian *Glamour*, *Marie Claire*, Italian *Vogue*, and catalogs for Macy's and Nordstrom's.

I'm in LA working, I call my friends back home because I'm on the set every day," she said. "I have a tutor and I home-school. But I miss out on the whole social part of high school, all of the new kids you get to meet."

Jessica maintains a schedule that would be busy even for a working grown-up. "For me, it's pretty amazing at fourteen to be working all day at a job," she said. "I'd like to do a film one day, but if it doesn't happen, it's not meant to be. If I keep working, that's awesome, but if it doesn't happen, there are so many other things that I want to try."

▲

PHOTO: KEVIN HEES

AMY SMART

I first saw photographs of Tyra Banks in the fall of 1990. I had been calling agencies in Los Angeles to look for new models. Her agent at the time was LA Models, and they sent me about four photocopied pictures of her.

When I saw them, I was impressed; not only was this girl tall and beautiful, but she looked like she was tons of fun and having a great time in each shot. The next job we were doing was in Los Angeles, and I hired Tyra without meeting her in person.

When I met her, she was just the way I had imagined her to be from the photos: beautiful, free-spirited, and energetic. We photographed her for the March 1991 issue.

At the time, Tyra was in high school. She likes to tell the story of when the pictures came out, and how the teachers at her school put a sign on the bulletin board saying, "Congratulations on being in *Seventeen* magazine!"

Since then, of course, her career has taken off, and she has become a model of "firsts." In 1996, she became the first black woman—and first model—to be featured on the cover of *GQ,* and the first black woman to appear on the cover of *Sports Illustrated*'s super-popular swimsuit issue (the first time she appeared, she was with another model, and in 1997, she appeared on the cover solo). She also became the first black model to grace the cover of the Victoria's Secret catalog. She became the third black woman to receive a major cosmetics contract (she has an exclusive, multiyear contract with Cover Girl).

When Tyra started modeling her senior year in high school, she fully expected to go to college. She was accepted at several colleges and planned to attend, but her plans were derailed when her agent at the time, Elite, introduced her to a scout from a Paris agency, who suggested she postpone college and try modeling in Europe.

Tyra's mother, Carolyn, supported her decision to test the waters in Paris for a year. To prepare for the runway shows she would encounter there, Tyra rented videotapes from the Fashion Design Institute's library to study international fashion shows. She endlessly watched MTV's *House of Style* and CNN's *Style* to pick up tips. She practiced walking back and forth in the fam-

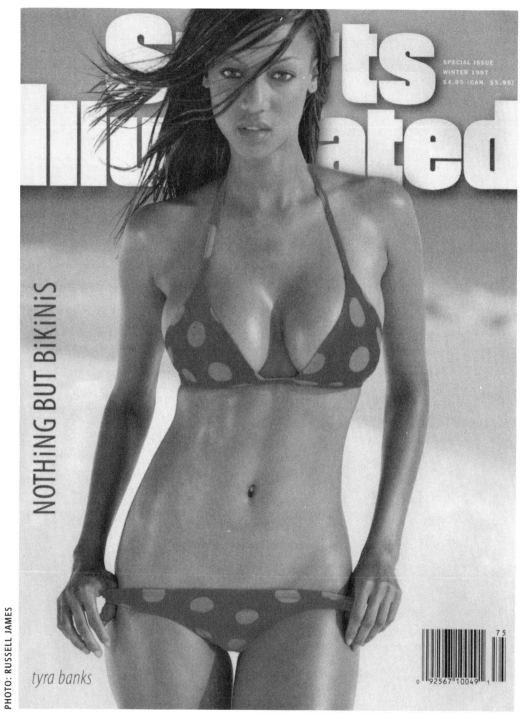

TYRA BANKS

ily living room in her mother's highest-heeled shoes and long, flowing night-gowns. Her mother coached her.

Tyra left for Paris in September 1991. It was her first trip away from home alone, and she was only seventeen. Two weeks after she arrived, Tyra got her first magazine cover, then the runway work started pouring in. Tyra was booked for an unprecedented total of twenty-five shows her first time out, and appeared on runways for Karl Lagerfeld, Yves Saint Laurent, Oscar de la Renta, and Chanel. She has a very distinctive walk that inspires many young models.

Tyra is now represented by IMG Models. Her résumé includes ad campaigns for Pepsi, McDonald's, and Nike, a top-selling calendar, and editorial and cover photos on domestic and international magazines as diverse as *Elle*, *Vogue*, and *Harper's Bazaar*. She has also added acting to her résumé, playing roles on NBC-TV's *The Fresh Prince of Bel Air*, *New York Undercover*, and in John Singleton's film *Higher Learning*. She has also starred in music videos, including George Michaels' "Too Funky," Michael Jackson's "Black and White," and Tina Turner's "Love Thing." One of her goals is to become a film and television director; another is to change the media's portrayal of African-American women.

When I approached Tyra about talking to me for this book, she was very busy—the 1997 *Sports Illustrated* issue had just come out with her on the cover—but she did spare a little time to answer a few questions.

What are your earliest memories about your modeling experiences?
Being lonely in a Paris model's apartment the size of a breadbox and being extremely homesick with no friends or family around.

How did you juggle school, jobs, friends?
My education always came first, so I only worked after school or on weekends. My friends have always looked at me as the same ol' Tyra—they are not affected at all by my job. Of course, there are the few people who can't handle my success, but then that only makes me realize who my true friends are.

What is your advice for girls who are starting out?

New models should be aware that modeling is a business, not just fun and games. They should learn everything they can about the industry and develop a good business sense. Always be professional and responsible.

What role did your parents play at the beginning of your career?

My parents were very supportive from the beginning. They respected my choice to give modeling a try, and have been there for me during the rough periods. My mother is my manager and my best friend.

What is the hardest part about modeling?

The endless traveling is hard sometimes. Being alone in hotel rooms all over the world can be very lonely—thank God for the telephone! Most people would faint if they saw my phone bill.

What's your favorite part about modeling?

I enjoy being self-employed and totally in control of my own schedule.

When you see photographs of yourself, is it the same person you see in the mirror?

It takes hours to create an image (hair, makeup, lighting, etc.). When I model, I feel like I wear a mask. What I see in the mirror when I wash off all the goop is the real me.

Tell us about your charities and social causes.

I established the Tyra Banks scholarship for African-American girls who have good grade-point averages but who would not be able to attend my alma mater high school [Immaculate Heart High School in Los Angeles] due to financial difficulties. I am also spokesperson for the Center for Children & Families in New York City.

How does it feel to be a model of "firsts," like being the first black model on the cover of Sports Illustrated, GQ, *and the Victoria's Secret catalog?*

I have been fortunate in my career to be able to transcend long-standing barriers. I hope and realize that my success as a model of "firsts" is paving the way for other "firsts" to be achieved until there is no longer a need for the distinction.

SCHOOL AND HOME LIFE

"If you want your children to keep their feet on the ground,
put some responsibility on their shoulders."
—Abigail Van Buren

OST PEOPLE ARE really surprised when I say that one of the most important career elements for a girl who is starting out in modeling is a good family life.

This is something I feel very strongly about, and I have seen it reinforced over and over again with the young models I have known. The most successful girls are the ones whose parents and other family members have fully supported their decision to model and have taken active supervisory roles.

Starting models are typically between fourteen and seventeen years old—in other words, they are young. They may think they are grown-up and sophisticated, but in reality they are teenagers who are at a critical stage in their emotional development. As models, they are plunged into a heavy-duty competitive work environment that even some grown-ups find intimidating.

The girls I meet are very impressionable. They are at a time in their lives when every setback is a crisis and every triumph is the most awesome thing ever to happen to them. They are also greatly influenced by other people's opinions of them—particularly their friends'. Moods can swing at the drop of a hat.

Girls at this age can be fickle, anxious, and very insecure. At the same time, they can also be decisive and calm. There are so many conflicting things going on in their lives—they want to have fun and hang out, but they are starting to wonder about what they want to do in the future. College? Ca-

reer? Family? Athletics? For a girl who has modeling potential, these pressures are magnified by the immediate opportunities unfolding before her—the tantalizing prospect of wealth, success, international travel, and intense public recognition.

It's paramount for a model to keep everything in perspective, and that's why I encourage them to latch on to their support system of family and friends. I always tell models to remember that these are the people who love you for who you are, the people who will be there for you in good times and bad, and the *only* people who have your best interests at heart. They love you just the same whether you score the cover of a magazine or a major ad campaign, or if you bobble on the runway and never get another modeling job.

SCHOOL LIFE

This is my rule number one for a girl who is starting as a model: stay in school.

Nothing can replace a high school education. Most models start out working part-time, and nobody in the industry—agents, editors, photographers—expects them to drop out of school the moment that success seems tangible. Everyone recognizes that the best models are those who are mature, intelligent, educated, and well rounded, and only a decent education and a good grounding at home can infuse those qualities.

By staying in school, a young girl can develop the interests, talents, and hobbies that will enrich her life whether or not she ultimately pursues a full-time professional modeling career. School is not just a "fallback" in case modeling doesn't work out—it's also a strategic career-enhancing move.

A girl who has successfully balanced a modeling career with high school is Melissa Tominac, who lives in Phoenix and will not take jobs out of state while school is in session. A junior at a top private school, Melissa is so committed to her education that she turns down more than half of the jobs she is considered for because they conflict with her academic schedule. She makes rare exceptions; once, she missed a few days of school to shoot the cover of *Teen* magazine. She has also worked for catalogs for department stores Dillard's and Saks Fifth Avenue.

PHOTO: PHYLLIS LANE

MELISSA TOMINAC

Melissa says she enjoys physics and art history, writing for the school newspaper, and working with a community service club. She also does peer tutoring.

"I would maybe like to be in the fashion industry when I'm older," Melissa says. "I'm interested in advertising or possibly being an editor at a

magazine, and those are things that I credit modeling for getting me interested in."

As a highly intellectual person, Melissa finds that modeling has its limits, that it's not an attractive long-term option. "There are all different ages—I'm sixteen, and I'm with all these thirty-year-olds, so you don't necessarily fit in. You kind of have to find a more intellectual way to look at it. I like to look at it as I'll be able to use it for my future."

A lot of smart and successful models can't understand why anyone would be foolish enough to drop out of school to pursue something as risky as modeling, where a girl can be "in" one day and "out" the next.

Nina Zuckerman, seventeen, is a model who is definitely college-bound. She attends a private school in New York City, where she sings in the glee club and plays on the basketball team. "I enjoy modeling—it's fun—but I love to learn and use my brain," says Nina. "I like to be challenged, and I work hard in school. I met girls in London who quit school with the idea of becoming supermodels. I don't think anyone should quit school."

Nina's policy of refusing to miss school on account of modeling is a tough one to live by, just because it's exhausting to go to school all day, model a few hours after school, and do homework as well. But it's a dilemma lots of young models can relate to.

"It wasn't so much a problem before when I wasn't modeling so much, but this year it's harder," said Breann Nelson, a fifteen-year-old sophomore in Long Beach, California. Breann tried to cope with her overladen schedule—school, swim team, and modeling—by doing homework in the car on the way to modeling jobs and during the waiting times.

Jenny Filler, fourteen, said she constantly feels torn between school and modeling. "It's hard to turn down jobs because of school, but I do," she sighed.

Other girls have cut back their modeling because of school. Danielle Bassett was "modeling nonstop" for clients, including *Dolly*, department stores Macy's, Kmart, and Mervyn's, her freshman year of high school—three or four days a week—and saw her grades plummet. When her mother took her to task for her report card, Danielle said, "I told her with modeling so much I couldn't focus on my schoolwork. She told me, 'From now on, tell me how this is affecting you.' "

For now, school is Danielle's number one priority, soccer number two. She

plays for the state soccer team and plans to curtail modeling if clients object to her increasingly muscular physique.

"I have girls who come up to me and say, 'Get out of school, school is boring, go model full-time,' " Danielle said. "That's the *last* thing I would do. I don't know how I would keep my sanity modeling without my friends. A lot of these girls have just lost their childhood because they dropped out of school at a really young age. They don't know how to be fun anymore. They act like they're too sophisticated, they don't think the things my friends and I do are fun. Someday they'll say, 'What happened to my high school years?' "

Those models who stay in school say they are far richer for having done so. "I definitely had a normal high school experience," said Jennifer Davis, a former model who is now a full-time college student. "The only thing different was in the summer, I jetted off to Italy instead of getting on the bus to go to Camp Longhorn."

Jennifer said she was grateful that her public school allowed her a flexible schedule. "I essentially did have my cake and eat it, too," she said. "After school, when most kids would typically go home and watch television and do their homework, I would go do a shoot and then do my homework. I went to the prom. I did all the normal things."

What is special about these girls, besides their beauty, is their intelligence and the fact that they keep education as a top priority and view modeling as a secondary interest. No matter what happens to them in modeling, they always have their education.

SWITCHING SCHOOLS

When modeling and school intersect, there are gray areas: some schools are more flexible than others, and girls have to decide with their parents how much tolerance to have for missing class. One model said her school was willing to fax homework assignments to Paris for the two weeks she spent there; another model said her school was so strict about missed classes that she had to switch in order to keep modeling.

Andrea Pate, fourteen, who has been modeling for a year and a half for clients, including Abercrombie & Fitch and Bloomingdale's, switched from public to private school to gain the flexibility necessary for work. "I have to

be on honor roll to continue modeling—it's my parents' rule—so I have to work extra hard, but it's worth it," says Andrea, a ninth grader who lives in Greensboro, South Carolina.

Andrea's mother, Beth, says the increased demands on Andrea's schedule—and the fact that her career is really taking off—have posed some tough choices. "Our number one goal is to make sure she comes out of this as a balanced person," she said. "We really hope that she can stay in school and have the normal socialization with peers, but she's having some opportunities that are increasing her number of days missed."

Andrea said she wants to stay in school. "I love the modeling and everything, but it's not going to be there forever," she said. "I'm definitely planning on going to college. I don't want to just be a model. I want to also have something to fall back on."

Lindsey Sanders, who started modeling at age fifteen and is now nineteen, switched from a regular public high school in Dallas to a special high school for professionals—artists, actors, and athletes—to help solve her scheduling conflicts. In her special school, Lindsey said, she was just as diligent about schoolwork but didn't have to worry about taking time off for assignments. Lindsey has worked for catalogs, and has done regional television commercials.

"When I graduated from high school, I was torn between going to college and modeling," Lindsey said. "I wanted to do both, but I wanted to give 100 percent to each, and I was spreading myself thin." She attended Southern Methodist University for one semester, then decided to take a break and model full-time. She plans to return to college eventually.

HOME SCHOOLING

I don't recommend it, but it does happen: some young models whose careers are taking off arrange some kind of tutoring program that works around their heavy modeling schedules. At least, home schooling is a better option than dropping out.

When girls home-school, however, they miss out on the social aspects of high school, the interaction with kids their own age. As a model, it is this nor-

PHOTO: RODNEY RAY

JANELLE FISHMAN

mal fraternization that helps keep you centered and balanced—especially since you're working with adults.

After Janelle Fishman, who is sixteen, found her modeling skills in demand, she decided the academic pressure was too great. "I was having trouble because I was missing so many days of school," said Janelle, who lives in

New Jersey. "I was given all my work, but I wouldn't understand half of it. So they just told me I had the choice, that either I fail, or I could go on home instruction."

Janelle finds home instruction a lot easier. "I've been getting straight As now, and I get five hours of school at night. It's nice to have instruction on a one-on-one basis."

But other models who have taken time off from regular schools say they regret the decision.

Kim Matulova, a sixteen-year-old who has been modeling since she was six, said she did home schooling from grades six through eight, went back to school for ninth and tenth grades, then returned to home schooling for her junior year.

For the most part, Kim's mother is her teacher. But Kim also has a correspondence teacher in California who works with her by telephone and computer. "I really miss my friends," Kim said. "I usually get to see my friends only two days a week, on the weekends, because they're in school all week and I'm busy."

Kim's one piece of advice for girls starting out? "I would tell girls to finish school," she said. "I always meet really young girls who want to quit school and I'm always like, no, finish school."

Kim plans to return to school for her senior year but anticipates that the heavy academic workload and conflicts with her modeling schedule will be a severe strain. Right now, she said, she does her course work while commuting into New York City every day, which takes about two hours each way. "I usually just bring my books on the bus. You don't have to do schoolwork every day. I can do it all in one day if I feel like it."

Delana Motter, fifteen, began taking a correspondence course in order to model full-time. "I missed a lot of important things—graduations, homecoming, and proms," she said.

While former schoolmates were going through these rites of passage, Delana was learning maturity in a far different way: alone on a job in Brazil. "I found myself in a different country and didn't speak the language, and I got scared and called home and cried to Daddy. He said, 'Get a backbone.' Actually, it was wonderful, because I came home totally strong."

Jessica Osekowsky, a ninth grader, reduced her school commitment after only six months of modeling. "I'm on sort of an independent study thing,

where I go for two periods a day and the rest of the classes I have to do on my own," she said. "It's not really that much fun, because I don't get to see everybody in school."

She goes to about three or four castings a week and has maybe one job a week.

MODELING VS. COLLEGE

While no one can dispute the value of a high school education, some models decide that college is less of a priority, or at least that it can wait.

After much agonizing, Barbara Stoyanoff, twenty-one, turned down a scholarship to the University of Texas in favor of full-time modeling in New York City. One day, she said, she may try to earn her degree through a correspondence school, but for now, things are really working out and modeling as an "adult" has proved more rewarding than it was as a teenager.

"I never thought I'd be this successful," said Barbara, whose credits include appearances in *Seventeen, Harper's Bazaar, Allure, Glamour,* and *Self.* She has also been in catalogs for Coca-Cola, Neiman-Marcus, J. Crew, and Macy's. "I thought I'd just go to the university, but I realized that modeling was really happening for me when my agent recommended I wait for a year," she said. "I had changed. In high school, you are deciding what to wear to school or whether to go to the prom—not about a career. So I finished school and then made the decision."

As it turned out, Barbara's one-year sabbatical was so successful that college became a distant wish. "Things are going really well for me now, maybe because I am older," she said. "I've learned so much. You change and learn how to work with the camera, what looks best, how to work and be professional. I have a more active role with my agent now, deciding what to do about my career and how far I'd like to go, and that's changed a lot since when I was in school."

Other models with a more academic bent decide the opposite—that modeling can wait or that it can be combined successfully with college. These decisions are hard to make and often involve a lot of soul-searching.

For example, Nikki Vilella was valedictorian of her high school in Lansing, Michigan, a serious student and basketball player who had earned a scholarship to the University of Chicago. Even as a high school student,

school was so important to her that she once was late to a modeling convention because a basketball game ran overtime!

The summer between high school and college, she went abroad, tried different markets, and started tasting success as a model. She deferred college for a year. After that she was still enjoying modeling, but knew she couldn't defer college again. What to do?

"I talked it over with my parents," she said.

Six days before college was to begin, Nikki made the choice—based on her gut instinct—to do "a 180-degree turn." "I had to go back to school," she recalled. "So I went back to Michigan. I put all my modeling stuff away, packed my sweaters and stuff for school, all in five days. I had been working up to the day I enrolled in school."

Nikki ended up going to college *and* retaining her modeling career. She signed with Elite in Chicago and told her agent she would work around her college schedule. Sometimes she finishes classes on a Monday afternoon, flies to New York or Los Angeles for a job on Tuesday, then returns home for class on Wednesday. It's not easy.

"School is so important to me," Nikki explained. "But modeling is a hard business to walk away from. It's great money—better than the wages of the other students—and I have learned so much about myself."

Nikki says her experiences traveling and taking care of herself have given her a leg up on college classmates whose lives have been more sheltered.

"People may think I'm crazy to do both college and modeling, but to me it's very responsible," she said. "I've had to turn down jobs because of school, and that's okay. I say to my agent, 'This is when I'm available.' It's not that I'm trying to be difficult, but it's what works for me. School is my priority."

Nikki has achieved success on both fronts. Her modeling credits include photos in *YM, Sassy, Vogue, Elle, Self,* and *Shape.* She has appeared in ads for Secret deodorant and BCBG clothing and in catalogs for Dayton Hudson, Montgomery Ward, and Target.

MISSING OUT

Whether or not they have actually stopped attending a regular school, most models say that work interferes with their ability to lead normal teenage lives.

Even though models always have veto power over jobs—a model can always tell her agent to turn down a job if it conflicts with school or something else she wants to do—models say their work hours and crazy schedules often require them to skip extracurricular activities and other types of fun.

"The hardest part is missing stuff at school, like a rally, when I have a job after school," said Allison Ford, seventeen.

"Last year I completely missed my whole summer with my friends because I was away modeling," said Danielle Bassett. "We wrote to each other, and they wrote about the fun times they were having, their beach trips and stuff. It got kind of depressing. I felt I was missing out."

On the other hand, Danielle found value in her summer experience in Australia, where she made new friends and got great jobs. "I have friends who work in the shoe store and in McDonald's and the mall and stuff, and they don't learn half the stuff you do traveling around the world. I have five friends in Australia I met there, and we write back and forth."

The models all know it is their choice to miss something—whether it's a rally or a school dance or even an exam—but that knowledge doesn't necessarily make the reality any easier. A lot of teenage models talk about how hard it is to spend the summer working abroad while friends at home are having relaxed vacations. While the friends may think that a summer of magazine shoots in Paris sounds glamorous, the model may be wishing she were hanging out with her classmates.

Going Back to School After Modeling

▼

Amy Owen deferred college until she was twenty-four. What would have been her college years were consumed by modeling.

Junior year of high school, Amy won a contest sponsored by *YM* magazine and earned a college scholarship. But she turned down the scholarship and decided instead to tour the world as a model. "I loved Europe so much and I loved traveling so much that I didn't go back to school at first," she said. "What's been nice now is I've been able to go to school full-time and pay for it."

The working world also gave Amy the maturity to appreciate her education. "I realize that school doesn't just offer an education—it's a very important time of life for an adolescent or girl, and she should be in a protected environment. I would recommend that models go to school."

Over her lengthy career, Amy has done ad campaigns for Maybelline, Aveeno, Suave, and Sears. She has modeled summers in Japan and worked designer runways in Milan and Paris. Today she lives in Chicago, where she balances modeling and college. Amy is married and plans to become a teacher.

▲

KEEPING A LOW PROFILE

Those of us who work with young models find ourselves very proud of their successes—we're eager to boast of the cover shoots, editorials, and ad campaigns earned by the young people we know. But sometimes we lose sight of the fact that the models themselves would prefer to keep these achievements quiet, in order to better fit in with their classmates.

How should a model handle the delicate feelings that bubble up when friends and classmates find out about her career?

When Helena Stoddard, fourteen, was missing school to go to a job or casting, she used to tell friends that she had a doctor's appointment. After her friends caught on, they begged her not to be shy about it, but she is still ambivalent about how much to disclose. "When you are not different from everyone, you want to be, and when you have something that *is* different, you don't want people to know," Helena observed.

When Nina Zuckerman needs to bring her modeling portfolio to go-sees after school, she hides it in her locker. "If girls see my portfolio, they make remarks and roll their eyes," she said. "It's hard to brag, and it's also hard to share my happiness. It's hard to talk at all about what I do. Maybe the girls I would want to tell about it also wanted to be models but didn't make it. I don't want them to be jealous, but I would like to share my happiness."

Not everybody at school sneers at Nina's success. "When the first pictures came out in *Seventeen,* my friends and I ran to the deli around the corner and they screamed, 'Nina! It's you!' It was so exciting."

Meilan Mizell, eighteen, says she tries to keep quiet even though her friends are always enthusiastic about the jobs she gets. "They say stuff like, 'Hey, that's cool.' Mostly I say, 'Thanks,' and blow it off, so we don't have to talk about it."

Models say that if you treat modeling matter-of-factly, as just another normal activity that you do, you'll have the best chance of continuing to fit in. No matter how proud you are of your accomplishments, models say you should try to act nonchalant around your peers.

JEALOUSY

Many models find that classmates—even some friends—are jealous of them. The hard feelings can mount along with a girl's success.

When a girl starts modeling, the word can get out at school, and soon it seems like everybody in the world knows. The other kids turn a shred of knowledge into a rumor or false information about the model and her work. All kinds of bad situations can develop, not the least of which is when a model has to face going to school with classmates who assume she's stuck-up.

"At school, I've been called every name in the book," said Heather Dunn, eighteen. "But it doesn't bother me because I know who I am. My close friends didn't change their opinion of me at all. Most of the time, everybody just wants to know how much money I make."

Jealousy is a problem that lots of models have to face on top of academic pressure. When the atmosphere at school is unpleasant and keeping up with classes is difficult, it's tempting for young models to seek an alternative.

"The girls in my school did not like me at all," said Janelle Fishman. "When I first entered ninth grade, I had already been modeling for one or two years, and I just got totally harassed by the people who didn't know me. They called me a snob because I'm a model. If they did know me, they would know I'm not like that."

Kim Matulova reported similarly painful encounters. "When I first started going to public school, girls would come up to me and say stuff like, 'Don't think you're better than me because you're a model.' I was like, 'What? I've never even seen you before.' Those people are not my friends—those are people who don't know me."

Kim said her real friends "get the magazines and call me up really late all excited. My friends don't give me a hard time—they've known me since before I did it. They don't even think about it. And when I'm not working, I try to put it away. That's my time to be home with my friends and my family."

Like Kim and Janelle, Jenny Knight takes correspondence classes now. But when she attended school back home in Utah, "it was hard," she said. "Kids at school were snobby. Someone would run up to me and say, 'You're a model,' and I'd say, 'Yes,' and then they would run away."

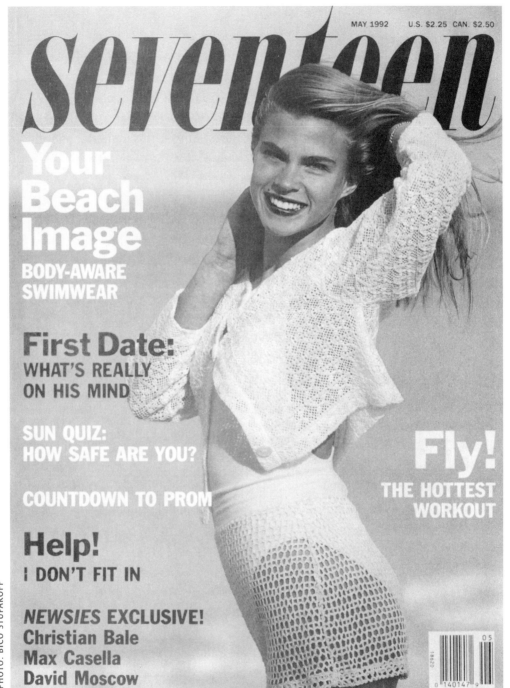

KRISTIN KLOSTERMAN

Needless to say, dropping out is not a good solution to the jealousy problem. Lots of models say they've encountered nastiness from classmates and have stuck it out.

"When I was in high school and got my first cover—it was for *Seventeen* in 1992—I did lose some friends," said Kristin Klosterman, nineteen. "I guess they weren't my real friends. I got attention, and even though I'm not an attention freak, these friends didn't like it. Maybe they were jealous."

In one example of harassment, Cassie Fitzgerald, a high school junior in Orange County, California, started getting a lot of obscene phone calls and has had to change her telephone number more than once. Girls come up to me and confront me and say nasty things," she said. "I have, like, five really good girlfriends and then the rest are guys, because they don't really get carried along with that whole thing, that attitude."

Most models learn to ignore nasty comments and be appreciative of their family and friends who support them.

MISUNDERSTANDING

Part of the reason for jealousy, of course, is the fame and prestige associated with being a model and having your picture appear prominently in public. But another reason, models say, is that friends, family, and even strangers don't understand the industry and can't see behind its glamorous image. Every day, young models have to confront the misperceptions people have about the fashion business and what a model's role is.

Other models report strikingly similar experiences. "A lot of people don't understand about how you go about getting a job and the whole agency thing," said Breann Nelson, fifteen. "Because I've been in *Seventeen,* the people at school all thought, okay, she works for them, and they expected me to show up in each issue. I had to explain, 'No, you go on castings and you get jobs.' "

Breann said her friends were "wowed" when she started out—they bombarded her with questions about what it was like. But now her eagerness to set the record straight about modeling has diminished a little—it can be a nuisance to have to explain yourself all the time. "When I meet people and

they find out, they give me their opinion of how it is, and it's totally different from the truth," Breann said.

Marysia Mann, who is fifteen, agreed. "It's frustrating that people don't understand the business," she said. "It's frustrating to have to explain to them all the time what a casting is. And if they haven't seen you in a magazine recently, they'll say, 'Oh, you're not a model' or 'Oh, you're not working.' "

What Marysia's friends don't know is what people like me in the business take for granted: that a job we're working on today is for a magazine that may appear four months from now. The same is true for advertising campaigns, television commercials, and other places models appear.

Another problem: models say their friends often want to know how they can get into modeling, too. It's hard to tell a pal that you won't refer her to your agency or that she's not tall enough.

"I have a few friends I've sent to the agency because they're like, 'Oh, I can model,' but they're only 5'6" or 5'7"," said Danielle Bassett, sixteen. "I'm almost 5'11"."

Most of Danielle's friends are understanding and enthusiastic—one even has all her modeling clips taped to a bedroom wall. For a firsthand glimpse of the modeling life, Danielle once took a friend along on a job. "My friend said it was the funniest thing she'd ever seen," Danielle recalled. "It was first thing in the morning and everybody was in a mellow mood, drinking coffee and being quiet, and I was up there smiling and being peppy. My friend was in the back laughing her head off."

Girls who have worked in the business for a while uniformly report that it is friends and family who help keep them grounded and centered. But at the same time, they say, there is a level of frustration that develops: models often feel that even the people closest to them fail to recognize the pressures they are coping with.

"Even my sisters seem to think that I just walk through this dreamworld, and it's just not the case," said Amy Owen.

A college senior who is trying to balance school and modeling, Amy is still dogged by the repetitive questions from classmates: "Do you get to keep the clothes?" and "When am I going to see you on the cover of *Vogue*?"

The culture gap between models and their friends widens as a girl's career takes off. January Jones, nineteen, of Sioux Falls, South Dakota, said her friends at home reacted negatively when she returned from a modeling stint

in New York. "They just don't know or understand," she said. "I felt forced to explain and defend what I do. I tell them it's my job. When I go home, I talk about modeling, because that's what I'm doing now. I work all day long, and it's what I know and love."

Though January loves her work, it has driven a wedge between her and the community that raised her. "I'm from a small town, and the people are uncomfortable around me," she said. "When I'm home, the local news always interviews me and treats me like a star. It's at these times that I realize who my true friends are."

MODELING AND SELF-CONFIDENCE

Some observers may perceive that modeling saps young girls of self-confidence, but most models say the opposite is true. I also feel that working in an adult environment helps the girls become more independent and thus more self-confident.

Many girls tell stories of how modeling helped them grow in emotional maturity and banish some of the negative feelings they had formed about themselves growing up. Models say their work has given them a renewed sense of pride that carries over into their home life.

"I've changed quite a bit through modeling," said Delana Motter, fifteen. "I've become so self-reliant and so self-sufficient. I've learned to take care of myself, and I've become much more open—I think that's something I've acquired just through meeting a lot of people."

Seeing Your Face All Over the City

▼

"When I first saw my ad for The Gap on the side of a bus in New York, I was like, 'Oh my God,' said Filippa Von Stackelberg. "I was very amazed. It then got hard when everyone kept coming up to me and saying, 'I saw you on the bus ad.' My close friends at school are like, 'It's so cool.' There were others who thought that I would be conceited, and they turned their backs on me. Everybody thinks it's so great—they say to me, 'Oh, you will make lots of money and be famous.' What they don't think about is the work part of it."

▲

Nina Kaseburg, a sixteen-year-old in Seattle who has been modeling less than a year, says modeling has cleared up a lot of problems she had in school as a child and has boosted her ego, which had been beaten down by a lifetime of teasing over her height and looks.

"In elementary school, I used to cry myself to sleep every night because everyone insisted I was ugly," Nina said. "I think in the long run, that was very good for me. I don't tend to judge people on the way they look. I have a very diverse group of friends now."

High school is a time for adolescents to find themselves. They learn what kinds of people they like and what kind of person they want to be. Girls like Nina say modeling has helped guide them in the right direction. "It's given me an incredible sense of self-esteem," Nina said. "Every time I go in to my agency, they tell me how much they value me. It's really been a blessing because I love my job so much."

Nina doesn't cry herself to sleep anymore, and school has become a much more pleasant place to go to. She takes pictures for the school yearbook and hopes to become photo editor in her senior year.

Other girls tell similar stories of how modeling bolstered their courage and made them believe in themselves. Some models spoke of their pride in learning to travel alone, to take care of themselves, and to behave professionally in a business setting.

Certainly, there are lots of blows to the ego that come along in the modeling field—it's always tough to get passed over for a job or be told that something about your "look" is wrong for a particular assignment. The self-confidence models gain from their positive work experiences is what helps them work through these disappointments.

"I've changed because of modeling," said Helena Stoddard. "I am really shy and modeling has helped. When I entered high school, it was easier for me, because I was used to talking to adults."

FRIENDS

A model's friends play a key role in her career decisions. You know who your friends are—they're the ones who comfort you when you flunk a test or lose a boyfriend, and who are genuinely excited for you when you win class pres-

ident or ace an exam. Having great friends is important to all the models I know, since friends are an extra support system.

Most models find that somewhere along the line they lose some friends—whether it is when they land on the cover of a magazine or even when they appear in a small ad in a local paper. Some people the model thought were friends turn out not to be, and she learns to treasure the ones who stick by her.

"Your friends are so important—you need them to talk to," said Lindsay Frimodt, fifteen. "At work I'm with older people, so I need my friends."

"I did lose some friends because of modeling," Lindsay said. "The ones that got jealous aren't my friends. Some of them surprised me—ones I thought were my friends turned out not to be."

If anyone is going to tell you that modeling is going to your head and making you stuck-up, it is your best friends—your true friends. They will notice if you start to change in bad ways. It's good if you change by becoming more mature and independent, but not if modeling turns you into a conceited prima donna. It does happen!

But girls who have remained humble say their friends don't always appreciate it. Some friends get really sensitive, start misinterpreting the normal things a model says, and assume that she's getting stuck-up.

Nicole Blackmon, twenty-five, said her longtime best friend has been a little bit less than understanding. "Sometimes she acts weird," Nicole said. "If I say something like, 'I need to get some blush for work,' she thinks that I needed to announce to everyone that I am a model. I'm like, 'No, this is what I do, it's my job. It's just like you talking about classes you're taking, or whatever.' "

In general, models who have grown up with their schoolmates say they have an easier time being accepted in their new roles as models.

"I've known my friends ever since I was young, and they have been with me throughout it all," said Melissa Tominac, sixteen. "Sometimes it can be kind of confusing to them, because it's a confusing business. They always ask me about the male models—they'll ask me what it's like, how long does it really take. A lot of the guys want to know how much I get paid."

On the other hand, models who switch schools or move to a new city find that it's just that much harder to gain acceptance and get people to know you for who you are.

"I started a new school this year, and when I started, everybody knew me as 'the Model,' " said Andrea Pate, fourteen. "People ask me about it a lot, but people don't treat me any differently. They come over to my house, want to see my portfolio and stuff. A lot of times people ask me about the money involved. I'm just always like, 'I don't want to discuss it' or 'I'm not sure.' If you say how much you're really making, that can cause some problems. I do not brag about it at all."

As a working model, you'll also make new friends within the business. A lot of them may be older than you, and those who are your age are likely to be fellow models. It's important to develop these new friendships, since they can provide invaluable support when you are away from home, but new friends should in no way replace old ones.

Friends in the industry may also be competitors, or may have ulterior motives for cultivating your company. The modeling world is a breeding ground for jealousies, insecurities, and one-upmanship, and young girls must be careful about whom they trust with confidences and whom they choose to associate with.

With that caution, I should also emphasize that there's no reason to be paranoid. Lasting friendships *can* be made in this industry.

PARENTS

Parents need to instill values in their children, to help them evaluate situations and make judgments. Parents must also make their children know that they are ultimately responsible for their own decisions and actions.

Of course, these are important lessons for all aspects of their children's lives, but they become particularly valuable when a child decides to go into modeling. A teenager who does stray cannot blame her own irresponsibility on modeling.

Parental monitoring is critical even when a model is far away. Whether it's spending two weeks in New York during a school break or going to Paris for the summer, a young model needs to know that her parents are only a phone call away and that they are checking up to make sure she stays out of trouble. In the beginning it is wise for a parent to accompany her daughter.

My view is that parents, agents, and clients must work together to give a

model the support she needs to do the best she can. A girl may have modeling potential—even star potential—but may need to develop the emotional stability necessary to function productively. As teenagers, most models don't have a well-developed sense of self yet.

Parents know that these are turbulent years for their children, and they must help their daughters decide if they are ready for the pressure of a career—in what we already know is a very intense industry. Parents must help their daughters with the anxiety of not knowing whom to trust and must emphasize that modeling is something you do (a job) and not who you are (your identity).

Before a girl begins modeling, the very first step she should take is to sit down with the grown-ups she trusts and talk extensively about her motivations and what she expects to accomplish. She must make sure her reasons for trying to model are mature, valid ones.

At the beginning of a model's career, it's crucial that her home life be kept as close to normal as possible, however it was before modeling entered the picture. Parents of models tell me that they see their daughters struggling to handle the trials and tribulations, successes and failures, that are by definition associated with a modeling career. Maintaining an atmosphere of normalcy is a big help to the girls.

Parents must work with agents and agencies, ask questions constantly, and do research about what standard practices are in the field to make sure that their daughters are not being duped or taken advantage of. They must be perpetually vigilant. If a girl is a hot modeling prospect, she is likely to be showered with attention by agents, scouts, photographers, makeup artists, and other people from different ends of the business—all of whom have their own best interests in mind, not the model's. No one will take as good care of a child as her parents or guardians.

Most models who are young and starting out travel with at least one parent. While some teenagers may not think it's "cool" to have a parent around, most of the models I spoke to said they were really glad when their parents came with them—it showed how much concern their parents had for them and for their careers. Those girls also said that other models on the set who didn't have parents with them were jealous of those who did—a sure sign that having your parents along is definitely "cool."

Staying in Touch

▼

Before sixteen-year-old Megan Hoover ever started modeling, her parents were enthusiastic about it. After she started, their delight in her decision translated into strong support for every aspect of her career.

"My parents think this is unbelievable," Megan said. "They see my pictures and they say, 'This is Megan?' They have always looked at me as a person, who I am on the inside, not necessarily the exterior."

Megan said that as much as her parents like the fact that she is modeling, they have also told her that they would be equally happy if she decided to quit modeling—it's her decision.

"They have always said, 'We are 110 percent behind you. If you ever need support—mental, physical, or financial—we're here. You can call us anytime, and in a second we would jump on a train or plane to get to you if you need us.'"

Megan said she has heard stories from other models about parents who are less supportive, and it has made her grateful for what she has. In return, she tries to treat her parents with the same respect they give her.

"When I worked for *Harper's Bazaar*, we worked late one night," she recalled. "We were still at the studio when I announced all of a sudden, 'I have to call my mom!' I did, and she was crying—she was scared because she hadn't heard from me."

▲

PARENTS TALK

"It put us in a tizzy," said Jo Stoddard, whose daughter, Helena, started modeling at age eleven. "We didn't sleep at night because of the rumors about the industry."

Jo and her husband were worried that their daughter—who, at eleven, looked like an eighteen- or nineteen-year-old when she put on an evening gown—would grow up too fast or fall victim to bad influences.

Jo said the job of being a "stage parent" is rough, both emotionally and logistically. On shoots, she tries to stay in the background and not get in the way, as she has seen other mothers do. And sometimes she goes to extraordinary lengths to help Helena attend jobs and go-sees.

"At times we would drive for an hour, find a parking space, and meet the client for only about two seconds," Jo said. "They'd flip through the book, look at Helena, then we would be out of there."

Jo's parental duties also fall especially hard when Helena is turned down for jobs. "I tell her, 'If you don't get the job, you don't have the look they are going after—it has nothing to do with you,'" Jo said. "I like to focus on the positive side of modeling. It has increased her self-confidence. I tell Helena, 'Don't accept a job unless your whole heart is in it. This is a business.'"

Jo's role has been to monitor each work-related situation and offer comfort when things aren't going well. Sometimes she has to inter-

vene: Jo recalled one job Helena did that went smoothly for two days, then turned sour when a second model arrived.

"Helena started to feel insecure because of the way the people were falling all over the other model and making a big to-do about her," Jo said. "Helena was intimidated by that. On the last day, she became sick and was replaced. The photographer even came over to me and said, 'Something seems to be bothering Helena.' She was feeling she couldn't measure up to the other girl. Now she's more able to recognize what's happening."

Despite Jo's reservations about modeling, she has let her daughter pursue it because she felt it was Helena's destiny. At age ten, Helena told her mother she had dreamed she was a model. Her parents sent her to self-esteem classes, where she was told that pursuing something you want with all your heart would make it happen. After that, her mother said, Helena put notes all over the house—on the refrigerator, mirrors, doors—that read, "Make model appointment." Jo called an agency and brought her in, and they signed her.

Beth Pate said her fourteen-year-old daughter, Andrea, has not taken jobs with clients who made stipulations that made her feel uncomfortable, and has meticulously monitored her daughter's career. Andrea begged for two years before Beth would allow her to try modeling. "There are so many negative images with the industry, and that's why I didn't want her to do this," she explained.

Living in Greensboro, South Carolina, the Pates don't have too many friends nearby with whom they can discuss the situation. So whenever Beth Pate travels with her daughter to different cities for jobs, she makes a point of learning more about the industry from people with more experience.

"I try to talk to as many adult models or people who have been through what we're trying to go through," Beth said.

Bill Dodds said he and his wife were supportive of their daughter Charlotte's decision to attend modeling school—but not of her later decision to move to New York and model full-time at age seventeen.

The Doddses—like most parents who have never encountered the modeling industry before—said they spent a lot of money to help launch Charlotte's career. In hindsight, they would have done things differently.

"Each family has to decide for themselves about the expense," said Bill Dodds. "I know now that for Charlotte to make it, we only had to send Polaroids to an agent in New York, but we didn't know that then, when she was

going to modeling school. It was the same thing when we went with Charlotte to Chicago after her first convention and stayed for six weeks. It was a big expense for us, and Charlotte didn't get much work—just a few catalogs."

Once Charlotte determined what her "look" was, she got better test pictures and her career began to improve. Her parents were still wary. "You can't go into this unless you understand the high failure rate," her father said. "We had to understand that getting work in one market doesn't mean you will get work in other cities."

Even though Charlotte is on her own and doing well in New York, she still talks to her parents on the telephone once or twice a day, no matter where she goes. The Doddses visit her in New York occasionally, and once Charlotte took her mother and sister to a shoot on Grand Cayman Island.

For Bill Dodds, his daughter's modeling success has been a bittersweet adjustment. "As a parent who used to have total control, you move to having a strong influence and then to having little influence over your child," he said. "It's a part of parenting, but when you add to it the modeling part, all of this comes a lot sooner."

A model's home life is what helps her stay focused and balanced as she pursues her career. Her home life—including her family, friends, school activities, and hobbies—all work together to shape who she is as a person. It is that well-rounded person who steps in front of the camera and who comes across better in film because of the richness of her life. Living a complete and three-dimensional life helps keep the sparkle in a model's eyes—it helps her hold on to those unique qualities that made her stand out when she was first spotted by the agent who signed her.

Roundup: What do your friends/family think about your modeling career?

▲ Holly Barrett, eighteen

My sister is in eighth grade and she is very proud of me. She loves to tell people everything. She brags a lot, and people get sick of it. Whenever I'm home, she likes me to come out for lunch so she can show her little boyfriend.

▲ **Jessica Blier, twelve**

I have two younger brothers, and they like to brag to all their friends about it. All their friends like me. *Hard Copy* did a thing about supermodels in South Beach, and they chose me to do an interview. My littlest brother showed it to all his classmates at school. They both want me to buy something when I get enough money.

▲ **Tomiko Fraser, twenty-two**

My siblings and cousins tease me: they say my grandmother has a shrine to me. It can be a Sears catalog, it can be *Vogue,* it doesn't matter—she wants it.

▲ **Melanie Hansen, nineteen**

My parents have been great—they are totally supportive of my decision to put college on hold. I want to see if this is going to work for me. I fully intend to go to college, but I need to try this while I am still young.

▲ **Meilan Mizell, eighteen**

My parents have always been integrated in everything I do concerning modeling, and I'm very glad.

▲ **Brittny Starford, eighteen**

With my parents, it's okay as long as my grades stay up. But they always worry—they're my parents. They wouldn't let me do it any earlier than I got started. The first time I went to Paris, my dad went with me and showed me how to get around. Now they trust me and know I can make good decisions.

▲ **Barbara Stoyanoff, twenty-one**

When I started, most of my friends at school were happy and collected stuff I'd done in the newspapers. But some passed rumors about me, which I ignored.

Talking to . . . Jaime Rishar

Jaime Rishar, twenty, is a rising superstar in the modeling industry. As of this writing, Jaime is in hot demand by designers and magazine editors, despite the fact that, at 5'6", she is unusually short for a model.

Another interesting thing about Jaime is the fact that she got discovered at a modeling convention. At the event, there were about a thousand girls lined up to be seen by agents for a few seconds each. An agent from Company Management saw Jaime and signed her up instantly, and she is still with them.

Even though Jaime was short for a model, she entered the convention at a time when her waiflike look was "in"—it was a good time for her to be going into the business. And after she began working with some of the top photographers, everyone became convinced that her height was not an issue.

Jaime grew up in a small town in Pennsylvania. She lives in New York City now and models full-time. She has appeared in runway shows worldwide—for Prada, Miu Miu, Calvin Klein, Donna Karan, Todd Oldham, Anna Sui, and Givenchy, among others. She's done ad campaigns for Armani Exchange and Allure fragrance by Chanel. And her magazine credits include the covers of *Harper's Bazaar,* German and Italian *Vogue, Elle, Seventeen,* and *Mademoiselle.*

I might point out that Jaime is also versatile, which I consider to be one of the key attributes for a model. As the market has migrated away from the boyish and waiflike look, Jaime, too, has developed a new style. She looks very feminine now. I talked to Jaime about her career.

Tell me about your start in modeling.

I never thought about becoming a model. When I was sixteen, my mom and I were driving home from the mall and on the radio we heard an ad for a model search. At that moment, we were driving past the hotel where the search was, so we turned around and went in.

We listened, and as the scout was talking and giving us the "height" speech about having to be 5'9", we got up to leave. Since I was only 5'6", we thought we didn't want to pay our money for nothing.

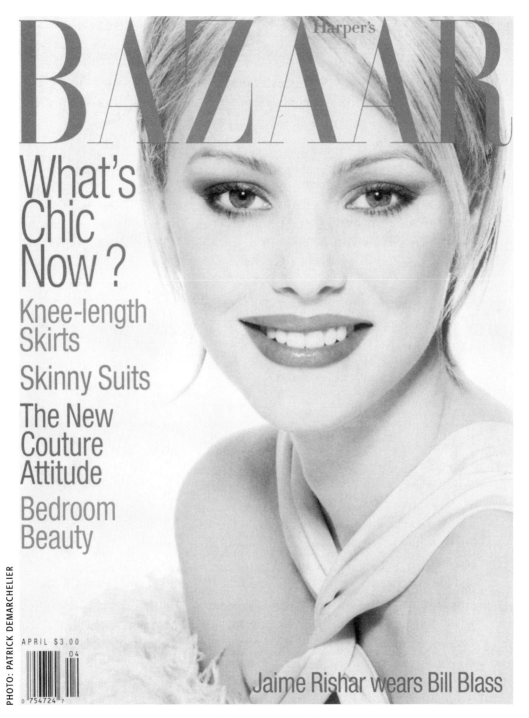

Harper's

BAZAAR

What's Chic Now?

Knee-length Skirts

Skinny Suits

The New Couture Attitude

Bedroom Beauty

APRIL $3.00

Jaime Rishar wears Bill Blass

JAIME RISHAR

As we were leaving, a scout stopped us and convinced me to go to the convention. At the convention, I got thirteen callbacks. I was thinking, how am I going to choose one agency? But in New York, on the second round, only one agency, Company Management, was interested. The others said I was too little. I'm glad only one agency was interested—it made my choice easier, and even now with all I know about the business, I'm glad I'm with them.

Do you feel your height is an issue?

I didn't in the beginning—I was getting jobs. But now I pray and wish I would grow two inches! I would be making more money if I was taller. I've been turned down for jobs straight to my face. I do understand that the clothes look better on people who are bigger than me.

How do designers react to your height?

It is more complicated for designers to make outfits for me. It's limiting. I always get the worst outfits in the show—the ones that will not be used in the magazine, the outfits that aren't the hot thing. But, hey, at least I'm in the shows.

When I did a show for Anna Sui, she gave me some of the outfits. One of them had to be used for a cover, worn by Helena Christensen, and they had to rip open the back to fit it on her. Then *I* got it!

What do you know now that you wish you had known when you were starting out?

I wish I had known more about the business side. Not that anyone was lying to me, but I just wish I had known more about how to handle the money.

I hear the same story from other models. In the first two years you work, you have no idea what to do about money, then you get smart and learn what to do. So advise anyone starting out about the money aspect.

Also, if you have a good relationship with your parents, do not let anyone push that away. For me, in the beginning, I forbade my parents from getting involved in my money matters. If I would have included them in the money aspect, I would have more money now from my beginnings. Just know that everyone else has their own agenda.

Unfortunately for some girls, even their parents have their own agenda! I've seen some parents live off their daughter's money, and some girls haven't even spoken to their parents about it.

What happened after you signed with Company Management?

My agent suggested I get a short haircut, and I did my first test right after I got my hair cut short. I was still in junior high school, and nobody had short hair. Then when I started to work, they hated me at school. My mom still lives there and the people still talk—it's a small town.

My first job was for *Interview* magazine. I was so happy I got a job. I remember not what the story was about, only that they had twine wrapped around me, my neck. I was paranoid, because I had a thing around my neck, and I remember going to the window, opening it, and throwing up.

I felt so bad. I wanted to please everyone—it was my first job. I said I was sorry, and I was crying. They also felt bad, knowing that it was my first job. I remember looking at the photos when the magazine came out and thinking that I looked so ill.

Did you ever think you would achieve this level of success?

I hadn't ever thought it consciously. It was not what I was expecting. I did not think this was all I would do. I guess I never verbalized my level of success, fearing it might come to an end. I thought, "I can handle this."

What are the best parts of the job?

I like doing runway shows. I also like the days when you are working with a photographer, doing print work, and it feels like a show—I enjoy that. Maybe there's one day in a month like that.

I also am excited that I am able to afford things that a twenty-year-old usually wouldn't. It's nice to know I can have and do what I want.

How do you handle the unpredictable nature of the work?

Sometimes it's good because you can have a week off. But then again, you could schedule other things, and then they tell you that you're working. Once I had to cancel three other things because I found out I was working the next day. So sometimes you can't really plan anything.

It would be great to know about jobs a week in advance, but that's not usually how this business works. I usually find out the day before, and sometimes even the day of the job.

Have you seen the industry change?

When I started, it seemed that anyone could be a model for five minutes. There were models that worked straight for one month, and then you'd never see them again. Now at least you see the same girls for at least one or two seasons.

When I started, the look was the "little girl" thing. Models were girls who didn't normally get to be models. A few of those girls have been able to stay by having something people liked. [Note: I think Jaime is an example of this!]

Today, there are a few girls who come and go, but there seems to be more stability. The first season I worked there were so many girls who had hardly taken any pictures before who were doing the shows.

Also, now I notice that for the major campaigns, the models that are hired are either the established girls like Linda Evangelista, or they are the new crop of fourteen-year-olds.

Has modeling changed you?

Modeling has made me grow up fast, but I'm still the same sort of person I was before I started modeling.

For example, on a day off, I'd rather sit home. I'm the same person from Pennsylvania—I never went out then, and I still don't. I'd hang out home with my friends. Now I'd rather be home with my two dogs, my sister, and watch TV than run around. Sometimes I say no to traveling jobs so I can stay home. For me, work is always second.

What's the hardest part of modeling?

For me, the hardest part is that I hate traveling. I have a phobia about flying. There was a time I didn't travel for a while, but now it's picking up again. Now I miss my dogs if I'm gone even for an hour!

Traveling is okay if it's a few days at a time. It's hard when you are away and are in hotels and sit there at night—what to do? I bring a CD player, and recently learned cross-stitching and crochet. This past Christmas, I

made everyone scarves and baked cookies. Everyone was making fun of me. But for me, learning to crochet and stuff was a way to pass the time when I traveled.

I remember times when I'd travel and call home and tell my mom, "They made me go!" and she'd say, "I'm coming to get you!"

Aside from the traveling, sometimes I get bummed out if I don't get a job. If it's editorial, I know another one will come along, but if it's a big job like a beauty contract, it's harder.

Tell me what your work schedule is like.

Well, tomorrow (Note: the day after I interviewed her) I leave for Miami to do a cover for *Mademoiselle,* then back to New York. Two days later, I go to Palm Beach to work for a German magazine, then two days after that I go straight to the Caribbean to shoot for British *Elle.* Then back to New York.

The next day I leave for Kenya for a week to do a job for *Marie Claire* magazine. Then straight to London to do runway shows. I think I'm scheduled to go on to Milan and then to Paris for more runway shows. That's a long stretch of time. It's okay, because I'm not in any one place for too long.

How do you keep your look up-to-date?

One way is with my hair. It was short and bleached blond, then grew longer. For three years it was blond, and now I've colored it chestnut brown. When I was blond, it seemed like I didn't have hair—you hardly saw it. Now I see my brown hair.

At times when I was blond, people would ask me when I was getting rid of it. I said when I didn't like it anymore, I would change it. One day at work my hair was put in rollers and I thought I looked like an old grandma—they were styling my hair big—so I thought it was time to change the color.

How have you stayed working for so long?

There are certain models that photographers use, that are popular at the moment. I've stayed working in spite of my height, I think, because I'm a nice person. On jobs sometimes I'd feel guilty if I'd ask a hairstylist to

compromise his creativity. There are some girls who'd say, "Don't do my hair like that."

For me, I'm nice, I show up to my jobs. I have only canceled one job in four years—all other times I've canceled, I've been sick. One time I wrote a fax to the photographer because I was sick and had to cancel. It was so hard for me.

I also think it's important to be honest. One time I wanted to use some Polaroids a photographer took of me with my new hair for a card. Since these Polaroids hadn't been published yet, I wanted to make sure if it was okay with the photographer to use them. You know what? They remember that. I felt if I misused the gift, they wouldn't use me again.

SOCIAL LIFE

"I can't make people like me,
but if I wasn't me, I would like me."
—Third-grader

QUICK QUIZ: Most successful young fashion models spend their Saturday nights: (a) nightclub hopping; (b) at the movies with a group of friends; or (c) spending time at home with their families.

What's the public perception? Answer *a,* to be sure. What's more of a reality? Answers *b* and *c.* Let me explain:

Everybody thinks of models as beautiful people who are constantly in the public eye. The media just love to show images of models at popular hot spots—trendy new restaurants, clubs, museums—enjoying the scene and being worshiped by a fawning public. Because supermodels have captured the public imagination, newspapers, magazines, and television programs delight in reporting hyped-up stories about models on heroin, models on cocaine, models with eating disorders, models who are emotionally troubled, models who are abused by their boyfriends, and so on and so on.

Let me say at the start: This industry is not alone. There are also similar stories about people in other industries, like music, television, and even high finance. Unfortunately, people in the modeling industry are much more visible than, say, someone in banking, and the public loves to read and hear things about people they recognize.

But it doesn't have to be that way. Every model is faced with distractions that could lead her astray, but it is ultimately her choice how she will conduct herself. A model can have an active and wholesome social life both in and out

of the business, and never needs to associate with people who want to steer her down the wrong path.

There are lots of models whose idea of a great time is to go out to dinner with friends or people in the business, then go home and get a good night's sleep. Some models like to spend the evening at poetry readings. Some do charity work or go shopping. Some—like Jaime Rishar—even like to stay home and bake cookies and knit. All of these are healthy, normal social activities.

And in my experience, successful models lead clean lives. It stands to reason that if you've got to be in front of the camera early looking your best, there's no way you can be out partying all night. If you stay out too late, you look hung over. If you look hung over, you're not going to get another modeling assignment. And they might just send you home.

I've had a jarring experience when I wanted to hire a model. I called her agency to arrange the job and found that they had dropped her—no longer represented her—because she had a drug problem. It was extremely disturbing—but also very much of an exception. I have spent years working with young models under very close conditions. In many cases, I serve as a chaperon for the models. Every day, I'm on the phone with or meeting with a model, working on a shoot, or talking to a model about a career. If one of these girls were acting strangely, I would know something was up. So would the agents, who are also in daily contact with their models and whose best interests are served when the models keep level heads. Agents are also now working together to unite the industry to get help for the models who may have drug problems.

LIVING ARRANGEMENTS

Some models are fortunate—they can live with their family and work nearby in a major market city. But the others must travel away from home to get to the places they need to be for their careers.

There are always several living options for models coming to a new city, and a model should discuss them with her parents and agent to figure out what best suits the situation. Options include a model apartment, a hotel room rented by the week, or living in an extra room at an agent's apartment or house. And arrangements can be made, if needed, for a parent.

Living arrangements are tremendously important, because they can have a big impact on the model and her well-being. If she's not happy where she's staying or with whom she's staying, it's going to be reflected in her attitude and her work.

MODEL APARTMENTS

In most major cities, the top agencies maintain apartments that are shared by whatever models are in town. The dwellings are usually supervised by someone from the agency. The models pay rent and are responsible for their share of the bills: electric, cable TV, telephone, food, etc. If the agency does not have such an apartment, they usually provide a new model with a discount hotel room, usually shared with other models.

These arrangements are meant to provide new models with comfort and support. They are living with girls their age in the same situation, and the idea is that the fledgling models can help one another find their way around town and relieve one another's stress by talking things out. The young models are away from home, often for the first time, and may be feeling confused and overwhelmed by the vast array of temptations and distractions being presented all the time.

The chaperon from the agency at the apartment is there for advice, support, and guidance. She is not there to serve as disciplinarian or to play the role of a parent. The models are expected to be mature and responsible enough to conduct themselves in a professional way, on and off the job.

Models themselves have conflicting views of model apartments: some love them and some don't. Nina Kaseburg said she "wouldn't be caught dead" living in one, because she has seen apartments where the models used their freedom to behave irresponsibly.

But Holly Barrett, eighteen, of Orlando, has had a different experience. After graduating from high school, she moved into a model apartment maintained by Ford near the beach in Miami. "We do have a lot of freedom, but they give us a list of rules that we have to live by," Holly said. "I live mostly with twenty-one-year-olds—four or five of them—and I think if we were irresponsible or couldn't control ourselves, they would be more hard on us. They come by to check up on us."

Holly describes life in the model apartment by the beach as fun and relaxed. The apartment was furnished by the agency and includes a swimming pool. The models talk together regularly about jobs they've done, which, for Holly, has included work for German catalogs. They share their ups and downs and make observations about the industry.

Keeping your social life in check is also a must, the models agreed. Holly—who goes to church every weekend and won't take modeling jobs on Fridays and Saturdays for religious reasons—says the opportunities to stay out late are plentiful and that new models must learn to stay grounded.

"When they first get here, everybody finds there's so many parties all the time," she said. "You kind of get caught up in it, and you have to get your priorities straight. You could go out every night if you wanted to. You have to remember that you have a job and modeling is your priority. If you stay out late, you don't want to get out of bed in the morning."

Nikki Vilella's experiences in model apartments have also been good. The summer she went to Greece—her first time away from home—group living was a comfort. "I stayed in a complex with other models and photographers from all over the world," said Nikki, who is twenty. "We were all out of our environment, so we were like a family. It was a great experience."

Nikki lives in Chicago now. But whenever she goes to New York to work, she makes a point of staying in the model apartment maintained by her agency in that city, IMG Models—even though she doesn't have to, and even though the apartment has only one bathroom for six or seven people!

When Meilan Mizell moved to New York, she lived in a model apartment for the first three months, but found the instability jarring. "I was in shock," she said. "I enjoy being around people, but it was hard when girls moved in and out. There weren't many steady friendships. You could lose yourself in that. So I moved out and got my own place."

Meilan's mother spent the first two weeks in New York with her, to help ease her transition. I generally think that the involvement of parents in ways like this is extremely helpful. Since the models who live in these apartments or shared hotel rooms tend to be teenagers who are gaining their first taste of the world of work, extra supervision is always a good idea.

LIVING WITH YOUR AGENT:
THE FORD MODELS SYSTEM

At the Ford agency, they take the clean-living principle so seriously that executives literally take girls into their own homes and show them how to behave. Living in Eileen Ford's apartment in New York City is a rite of passage for many Ford models. Since Eileen's daughter, Katie, has taken the reins at the agency, she also has numerous models stay in her downtown loft.

Holly Barrett spent a month at Eileen's when she was sixteen. "She loves to teach the models proper dining etiquette. She would show us the right diet to use, the right exercise. She would take us down to the gym. I didn't see her too much, but I did like her."

What was Eileen Ford's advice? Holly explained: "She told us how to take care of our bodies, to eat a big breakfast and drink lots of water, get a lot of exercise, a lot of sleep. They had curfews for us—eleven o'clock. She likes to tell you the picture is not there unless it's in your eyes. Think about things that you love, or, if it's an angry picture, think about something you hate."

Breann Nelson also lived at Eileen Ford's for part of one summer. "I had a lot of fun—it's a good experience," she said. "We had really good dinners every night."

Mrs. Ford was a stickler for table manners, Breann said. "We had to be really good at the table—also really good about keeping your room clean."

Holly Barrett remembers that, too: "Every evening was a formal dinner. You had to use the right fork and cut everything properly."

All reputable agencies make sure that their girls are well chaperoned and cared for; the Ford system is a great example.

MODEL FRIENDSHIPS

Sharing living quarters is a good bonding experience for models, who often complain that their busy travel schedules prevent them from keeping up with all the nice-seeming people they meet.

Two hot young models, Kim Matulova and Janelle Fishman, became instant best friends when they both showed up at a *Seventeen* shoot with skate-

boards. Now they skateboard—and snowboard—together, and talk on the phone constantly.

Two other models who became best friends through the business are Helena Stoddard and Nicole Rawlings. Helena is from California and Nicole is from Texas, but the two had a bonding experience while working a grueling summer in Italy. As Helena describes it, the summer was filled with impossible schedules—days where she had seven castings scheduled but was only able to make it to four because she got lost in the Italian subway—and meeting Nicole was a bright spot. They even did a job together for Italian *Elle*.

Some models describe striking up easy friendships with the people they meet through jobs, and how those fellow models become the confidantes they can share secrets with. But other models say it's extremely difficult to find friendship on the set. It can be hit-or-miss.

"I'm a very friendly person, and many times I've been shot down," said Charlene Fournier. "I smile at people and say hello, and sometimes they don't choose to do it back."

She explains: "When you're working, you're in a weird state. You're trying to be confident, and when there are other girls around, there is friction, there is attitude. I think by the end of the day you exchange some views or you try to have some conversation. When it does happen, you're very relieved that there are other human beings in the business. There are lots of walls that are put up in this business among models."

Some models prefer to keep their private lives away from modeling. But other models find that their closest friends tend to be fellow models. After all, who else understands the social pressure, the demanding work requirements, and the obligation to look your best all the time?

KEEP IT IN PERSPECTIVE

Modeling is a business that concerns itself with looking good, and those who succeed know the importance of taking good care of themselves both physically and emotionally. This means keeping a "social life" in perspective.

Any girl who is interested in a modeling career because she thinks it will gain her access to the high life and lots of boyfriends will be in for a rude sur-

prise. She may find jet-set "friends," but she may also find that her new career as a model ends abruptly.

Agents and clients do not have the time or patience to put up with unprofessional behavior or with models who show up to a job looking horrible from lack of sleep. Never forget: you're expendable. There's always someone else looking over your shoulder who is ready and eager to do the job.

In terms of socializing, some models are more naturally outgoing than others. "There are some models who have the happy social-butterfly life and others would rather be at home painting their nails or watching a movie," observed Charlene Fournier.

Anyone who is considering modeling should spend some time beforehand evaluating her reasons for entering the business. If a girl is focused on the social aspects of the business—going out to parties and trying to meet guys—then that is what she will find. Models don't have to look hard to find parties and events that welcome them.

If, however, a girl is interested in modeling because she wants to build a long career, work hard, make money, and meet new people, she should try it out and see if she has what it takes. If her priorities are right, she can put the social aspect of the business in the proper perspective. Her top priorities must be work, taking care of herself, staying healthy, and getting rest.

Socializing is fine in moderation. It can even help a model's career, as when her agents set up dinners with clients, photographers, editors, and others in the business.

Jenny Knight, who is fifteen, learned the hard way how important it is to keep a social life in perspective. She moved to New York from Utah. It was then that she got carried away with the high life.

"Basically, I did whatever I wanted," Jenny said. "I got caught up in the social scene of the industry. I knew it was a problem. My career was going down the drain. I recognized that, then also my agent got worried."

Jenny's agent at Click alerted her family to the problems she was having. "My mom got on the next plane," Jenny said. Now her mother lives with her in New York and accompanies her everywhere. "It's so much better with my mom around. I don't go out anymore, and my career is taking off."

SOCIAL LIFE: THE DARK SIDE

Just about every model you talk to can tell seedy stories about the industry—improper relationships, wild parties. Whether it's firsthand experience or word of mouth, most models say they know something about this side of the fashion world, the side that tends to grab headlines in the media.

Please know that most successful models steer clear of the dark side and lead healthy, clean, vibrant lives.

Most of the models interviewed for this book said they had seen some evidence of the sleaziness that sometimes tarnishes the fashion industry, but all of them said they themselves avoided it. Some girls said they had heard about wild parties for models that had spun out of control.

Since this is a social industry, there are many invitations extended to models. In cities like New York, Los Angeles, and Miami—as well as Chicago, San Francisco, Seattle, Atlanta, and Dallas—there are parties thrown for models at the hottest clubs. The club owners and party promoters know that having models seen at their clubs, bars, and restaurants is good for business. It improves their image and attracts a curious clientele. Models are usually given preferential treatment, whisked behind velvet ropes and treated to free food and drinks.

All this seems very new and exciting to a young model, who may be in a new city and away from home for the first time. It is dizzying, head-spinning, and seems like the culmination of a dream. But it's important not to get caught up in the breathless social swirl. The solution: take part in the festivities in moderation, then go home and get some sleep.

LONELINESS

The hidden truth behind all the thrilling party myths is that modeling can be lonely and isolating. This is especially true for models who travel a lot, or for models who have left home for the first time. Hectic schedules prevent you from getting together with old friends, and a lot of the people back home often assume that you've grown stuck-up and unapproachable because of your suc-

cess. Models who return home expecting a warm welcome from classmates are sometimes surprised by the number of cold shoulders.

There's also a lot of solitary time on the job, time spent with adults who may not even speak English. It's important to be flexible, easygoing, open to learning, and very strong. Because even when a model is surrounded by people—on the set or on a casting interview—she can feel isolated. This is especially true if a model is staying in a new city by herself. No matter how much her agency tries to lend a helping hand, it's tough to learn to be on your own when familiar faces are far away.

"If you don't make friends when you work abroad, you're lonely," said Barbara Stoyanoff, who has modeled in France, Italy, Japan, and Australia. "You get your appointments and a map, and you may have to go to ten or twelve places in one day. You have to make friends who will help you get around, who will keep you busy in the off-hours so you don't get lonely."

To fend off the blues, Barbara brings pictures of her family, favorite books, and her own blanket with her on location—plus she calls home a lot.

Charlotte Dodds, nineteen, found herself most lonely during a week in London, when she was doing an ad campaign and some editorial work. "It's fine when you're working, but it's hard on weekends," she said. "You don't know anyone, you don't know where anything is, and you don't know how to get what you want. Sometimes you feel trapped." Charlotte calls home, or friends in New York, or curls up with a book.

Fortunately for most young models, starting out means traveling with your parents, who can ward off loneliness and talk through any difficult feelings you're having.

Of course, some models don't want their parents around—and that can be fine, too. Just know that they are only a phone call away.

While models almost universally cite travel and the opportunity to meet new people as the most exciting parts of their jobs, those aspects of the industry are not without their downsides. Living abroad can be lonely and isolating, and the new people you meet aren't always kind.

Lindsay Frimodt, fifteen, said her fear of flying and her isolation in a model apartment contributed to the loneliness and homesickness she felt while working in London and Australia on her own for months at a time. "They give you a map and you have to take subways and buses and find your way around," she said. "You get very lonely. Since I do home study, I'd do my

schoolwork, hang out with the other models, sightsee. But at night I got so lonely that sometimes I would cry. I'd phone everyone—I bought tons of phone cards and called my friends and my family."

For one model, it was the transience of a model apartment—where people are constantly moving in and out—that brought this message home. Nikki Vilella recalled her first stay in New York: "When I first walked in there, I was alone, and there was a girl walking out with her suitcase—she was leaving. It was so quiet—nobody was there. I had a sinking feeling. I sat down and thought, 'What do I do?' Loneliness set in, and it was overwhelming."

Nikki later learned to enjoy the camaraderie of living in shared quarters, and she has developed coping mechanisms. Each time she goes to model in a new market for a few months (Miami, New York, or Europe), she makes sure to go home to Michigan for a while to see her family and get grounded.

These first experiences in unfamiliar circumstances can be difficult for adolescents to handle. Most of the girls I know who have come through the social adjustments most gracefully have found ways to stay in close touch with their best friends and their family, whether on the phone or through notes and letters. By staying in touch at home, a new model can ensure that she has a strong support system of old friends who help her stay strong as she develops new friendships within the industry. This helps her both personally and professionally.

THE CHARITY FACTOR

One of the key social aspects of the modeling industry is charity work. Models are in hot demand at charity benefits and in other kinds of volunteer work, since they never fail to draw a crowd.

Not all models have an interest in pitching in for humanitarian causes—everyone has his or her own natural inclinations. But models who naturally gravitate toward social service commitments say the visibility of their modeling work helps them make a difference.

"I have been so fortunate to have done what I have done, so I like to give back," said Amy Smart. "I'm an environmentalist, so I volunteer. One of my projects is for Heal the Bay, to educate people about ocean pollution. I go to

classes and talk to school kids. It's the best feeling to inspire people. It's from my heart."

A lot of the top models do charity benefits. Some of them have even formed their own organizations, for causes like animal rights and AIDS. But models in any market say they have been able to blend their paid work with volunteer work.

"In school, I do peer counseling, and outside of school I like to volunteer for AIDS and support any kind of pro-choice cause," said Cassie Fitzgerald. "I do walkathons and send money to charities. I've done three fashion shows for AIDS things, including one for Isaac Mizraahi. I've always wanted to get involved in helping other people, and this was kind of a good way for me to start. When my agency brought it up and said, 'Would you volunteer? They don't pay,' I didn't hesitate."

Supermodels do a lot of charity work as well. You can read about the involvement of Tyra Banks and Navia Nguyen in the interviews with them in this book.

HAVE FUN!

With charity benefits and the like, it's nice to note that modeling is a very social industry.

Most of the professionals you will meet as a model are friendly, interesting, and talented people who enjoy using their artistic expression and spending time with people who share their interests. Fashion professionals like to work with young people and usually enjoy rubbing elbows with others in the industry even when they aren't working.

Socializing can take place on the set or off. Some models describe their best experiences as being with a group of people who are all on the same wavelength and who can feel the spark of something beautiful and creative coming together. I've seen this happen myself.

"One of the best parts of modeling is when you do a job and do well and have so much fun with the crew—the hairstylist, makeup artist, and everyone else," said Megan Hoover. "When the crew is clicking together, it's great. It makes me feel comfortable. I like people who make me laugh."

During all these away-from-home excursions, models are invited to tons of social events—breakfasts, lunches, dinners, after-hours parties. Some are valuable business and career opportunities that a model should take advantage of, like ones hosted by their agencies. In the best cases, these gatherings can help turn the agency into an extended family. They can help models meet new friends and feel safe and comfortable in a strange city.

But other events to which models are invited are potential trouble spots or "bad scenes" that they should avoid. Good grounding and values from home can help a model use her judgment, but even mature girls can't help being naive at first. Parents should play an active role, ask questions all the time, and stay in close touch with agents and chaperons from the agency.

Roundup: What's your social life like?

▲ Heather Dunn, eighteen

When I was in Japan, I went out two times the whole time I was there. I could have gone out a whole lot more, but I just never wanted to. A lot of the models are really disciplined.

▲ Tomiko Fraser, twenty-two

I am not the typical model who is shown to the public in terms of partying. It's really a business to me. If I have to go to a party, maybe it's because a certain photographer will be there or a client had requested me to go.

▲ Kim Matulova, sixteen

I haven't been to a party in so long. Sometimes I have to get up so early in the morning. Girls come up to me and they'll be like, "What clubs do you go to?" and I'm like, "I don't have time for clubs." Sometimes if they have a model party or something, I'll go. I know some models who are total club kids, but they're not going to have a very long career that way, looking tired all the time.

▲ Meilan Mizell, eighteen

I don't go out. I've never been to a club. I have no desire to go. I'll go to museums, the park, walk around and look. I like to paint, draw, play the cello.

▲ **Andrea Pate, fourteen**

I have a horse, so I ride a lot. I run track. I get together with friends a lot and we go to parties. I do basically what the average teen would.

▲ **Melissa Tominac, sixteen**

I have a pretty normal high school social life. I just hang out with my friends. My school is very small and I'm really close to all the kids in my class—we hang out at each other's houses or go to coffeehouses, go to the movies, go shopping.

International supermodel Beverly Peele has been on the cover of virtually every major fashion magazine, including *Allure*, the American, French, Italian, or Spanish editions of *Elle*, *Vogue*, *Harper's Bazaar*, and *Marie Claire*.

She has walked the runway of every leading fashion designer—Chanel, Versace, Giorgio Armani, Ralph Lauren, Donna Karan, and Calvin Klein—and she has worked with such prominent photographers as Steven Meisel, Herb Ritts, Arthur Elgort, and Peter Lindbergh.

Beverly, who is six feet tall, began modeling at age twelve. She was discovered at an IMTA (International Modeling and Talent Association) convention, and by fourteen, she had already appeared on the covers of *Mademoiselle* and *Seventeen*, and was represented by Zoli Model Management. By sixteen, she had become one of the youngest girls ever to achieve supermodel stature! Beverly was also one of the first black models to achieve that status.

Beverly has returned to modeling after having her first baby. I talked to Beverly about her experiences and career. She is now represented by I'M NY.

Has the industry changed much over the years you've been modeling?

The industry has changed so much. Even in the one year I took off from modeling, it changed: the people, the emphasis on money, the girls [other models], the styles. Now I just came back, and sometimes I think, "Oh, do I want to do this?"

I think the industry wants to use models who are not well developed and to try to forget about puberty. I remember when I hit twenty-one, work for me slowed down. I got curves. I was wondering, "What's happening? What am I doing? Why isn't anything happening for me, workwise?" The industry was used to skinny girls. I had to cope, and it was very, very hard. I am still coping.

The industry has changed for models in some good ways. Models are speaking more, having a voice. To be a good photographic model, she needs to be able to present herself as well to the company as she does to the camera.

VOGUE

ITALIA

APR.
1994
N. 524
L. 7.500

mai
così

stylée

sofisticata e elegante!

ABITO GIORGIO GRATI

PHOTO: STEVEN MEISEL

BEVERLY PEELE

What has modeling done for you?

It has broadened my horizons. I am able to look at life, respect life more. It depends on the individual as to what modeling can do for you. A modeling career can go by so fast.

I have learned respect. I have loved the travel. And I have learned to take everything for what it is, and not to take anything for granted. Now I'm modeling for *me,* and I enjoy it more. It's fun. If I don't get a job, I say "whatever," because I know I have other things in my life—especially my three-year-old baby girl, Cairo.

If a girl doesn't have a life and interests outside of modeling, she is bound for disaster. She won't be able to handle the disappointments—for example, if she doesn't get a job.

Did you ever dream you would become a supermodel?

I never thought I'd reach this level of success. It happened so fast. In the beginning, it was just an after-school activity. Soon people were calling me "Supermodel Beverly Peele"! It didn't hit me until right before my baby was born, because at that time, there was a lot of press about me because I was pregnant. There were TV interviews, magazine articles. Then, for the first time, I looked at what I had done and said, "Wow! I did do that—that's incredible!"

It did seem like just yesterday I was thirteen and in Italy doing nineteen runway shows. I was still in junior high!

What was it like when you started out?

Modeling was an after-school activity. I never thought about becoming a model when I was younger. I remember in eighth grade, I wanted to be a plumber and to go to college to study business. I also wanted to be a dancer. But modeling came to me, and that's what I did.

I remember when I was starting out, my mom kept close watch and was very much involved with what I was doing. I was glad—I was definitely well watched. Even when I went to Italy and I stayed in the home of the owner of the agency, I was well looked after.

Now young models are in this industry that has become a "supermodel factory." There's really no specific look. When I was doing runway, there

was an air of sophistication. It was like theater. Now it's changed. There's no fun anymore.

It is a cycle, though—the business is one of repetition. You only see a few of the old faces that were successful. There's room now for new people, which is cool.

But you did take a break from modeling?
I did take one year off. I didn't want to stop, but I had to. I had put on weight from having my baby, Cairo. I enjoyed being a mom and sitting around and cooking. So I did need a year to have time off and lose the weight. Now I'm ready to model again.

I also have other plans, maybe to open a modeling school or to publish a book of my poetry that I've written over the years.

What do you know now that you wish you had known when you started?
I wish I had saved money. I wish I had taken a course on how to manage money. Also, I wish I had known to watch out for people stealing my money. Not knowing how to save money was bad—I was spending ridiculously. It wasn't until after I had my baby that I realized how important it is to save money. But for me, it was too late. I remember getting a letter saying I owed back taxes—my parents and I thought it was being taken care of. As a young teenager, model, I didn't think about taxes. I wish I had.

What's your advice to young girls starting out modeling?
Don't [*laughing*]! Wait until you can handle the responsibility yourself—specifically until you can handle the money side, unless you have people you trust to help you and watch your back.

What do you think about when you're on the runway?
When I'm on the runway, I think about what I'm wearing and listen and go with the music. When I was sixteen, I got great advice from photographer Gilles Bensimon. He said I was great on the runway but told me not to zone out to the cameras at the end of the runway. But to me, the photographers at the end of the runway loved me to look and pose right at

them. So I changed and started to play more to the audience. I got bolder, and it was more fun.

What's the hardest part of modeling?

Waking up early. It puts me in a grouchy mood. Some girls I've worked with, when they first meet me, would say, "Oh, I thought you were a bitch." I'm like, "No, I'm a nice person, I'm just not a morning person."

What I'd like people to know about me is that I'm down-to-earth. The only things I care about are my love life, my daughter, my happiness. When I look at pictures of myself—and I like to—I like to remember what I was thinking at that moment, to make me look that way, have that expression.

Have you found it harder getting work as a minority?

There is racism everywhere, in every industry. For me, in the industry, it is not a problem. There have been times when I've been one of three black models in a runway show, but it never bothered me. As one person, I can't fight racism in an industry. I did attend a meeting of the Black Women's Coalition, but I thought that they wanted publicity rather than to deal with the real issues.

Is it easy to get caught up in the glamorous side of modeling?

The modeling industry is a fantasy world. It's like you get everything you want, whenever you want. But you know that in the real world, it's not going to be that way. My fiancé has really helped me to get grounded. Sometimes I take him and my baby, Cairo, to a job.

On the job, you really do get caught up in it all. You can't help it, and it's not a bad thing. I even find my attitude changes a little. Then when I'm done working, I have to get back to being the normal person that I am. For young girls, that's hard to understand unless they are in touch with their inner self or have someone who is able to help them understand. My fiancé has done that for me.

CAN YOU BE A MODEL?

IS MODELING FOR YOU?

"I don't know the key to success, but the key
to failure is to try to please everyone."
—Bill Cosby

NOT EVERYONE CAN be a model, just as not everyone can be a writer or a singer or a professional athlete. Everyone is different, and possesses unique skills and attributes. If you're not cut out to be a model, it doesn't mean there's anything wrong with you or that you aren't a beautiful and wonderful person. Remember, most people *aren't* models and can't be no matter how hard they try.

Even though a person may be beautiful on the outside, it is her inner complexity—not just her surface beauty—that makes her special. And those qualities that make up her character may also be ones that are well suited to modeling—or they may not be. It doesn't really matter either way. What does matter is that a person values herself for who she is—inside and out.

Why do so many girls want to be models? Each has her own reasons. It's not just the glamour and prestige associated with the profession, or the implication that being a model means you are beautiful. Think about the word "model." One definition that comes to mind for most people is that a model is a perfect example, someone or something worthy of being copied or emulated, as in the phrase "a model citizen." If fashion models were called something else—"posers" or "live mannequins," for example—there might be less prestige associated with the profession.

The modeling industry is a fickle one, and it is based on intangible and ever-changing standards. A model who has been working a lot may find her-

self with fewer bookings all of a sudden, or a model who hasn't gotten work in a while may suddenly find herself working every day. Clients' and agents' tastes change as to what they consider "in" at the moment—blond hair, short hair, thin bodies, ethnic looks, strong features, "all-American" looks, and so forth. Anyone wanting to get into modeling must understand this and be able to separate her personal self from her working self.

Sometimes there is no concrete explanation for why one model gets more work than another or why a model stops getting work. This is especially true when a model first starts out. A girl may have all the physical requirements, be emotionally ready, have photos, have an agent—basically the right ingredients—and it may still take a long time for her to get a job. Or she may never get a job.

On the flip side, a girl may have never considered being a model, let alone having an agent, and she may be spotted by someone in the industry and—boom—a career is started. It happens all the time. The point is that it's critical in this business to take everything in stride, keep everything in perspective, and have concrete reasons for pursuing the career.

Bad reasons to pursue modeling? A desire to run away from home, drop out of school, or meet a lot of guys. Don't go into modeling because you think it's a ticket to the high life.

Don't do it to please your parents, if they are the ones who are pushing you toward modeling. I've seen parents put pressure on their daughters to try to model because of the money associated with it, or because they are trying to live out their own dreams through their daughters. I've even seen families who looked to their daughters' modeling careers as the chief source of family income. A girl's career is usually not a long and successful one unless it is *her* personal decision to pursue modeling, and she has good reasons to back her up.

Good reasons to model might include the fact that modeling (while staying in school) can be a good source of extra money to pay for a continuing education. It's also a way for girls who might not otherwise be exposed to foreign travel to have that opportunity. Girls who lead relatively sheltered lives—and even those who don't—can view modeling as a way to meet interesting people and catch a glimpse of what it's like to be a working adult. Yet the best reason of all is that a girl genuinely enjoys the experience of working as a model.

MATURITY COUNTS

In general, the type of person I've seen thrive as a model is someone who behaves maturely, takes things in stride, and appreciates how modeling enriches her life. She's someone who knows who she is, knows what works for her, and is able to show that. She understands the qualities that make her unique and can project that self-awareness.

Some models say, when they look back on their experiences, that they wish they had started when they were a little older. Their early immaturity left them less equipped to handle the business side of modeling. I always stress that, yes, there is a lot of money to be made in this business, but it's important to know how to take care of it. Some models mishandled their money, spent too much of it, or let other people take too much from them. Some remember feeling childish on the set or behaving in silly ways that they regret now. But those who have stuck it out say that strong support from parents and agents helped them learn to treat modeling as a business and to take control of their finances.

Kristin Klosterman's great attitude has enabled her to pursue a flourishing five-year career. Among others, she has worked for magazines French *Glamour, Seventeen, Mademoiselle* and ad campaigns for Esprit, Replay, Abercrombie & Fitch, and Ellen Tracy. Kristin grew up in a small town in Florida and describes her background as modest. As a kid, she said, she was a tomboy, and as a young teenager, she was "not a social butterfly." She has the ability to separate herself—as a person, an artist, and a friend to many people—from the craziness of her work.

"I am not a model—I model," Kristin explained. "I don't get caught up in the business. I sit back and relax and watch everyone go. If you worry, you will burn out. So on a shoot, I bring at least three books. I just do my job. My goal is not just to work, but to be happy."

Another model who always seems to have a great understanding of how modeling fits into her life is Nicole Blackmon, who had a leg up in this respect because she didn't start out until she was twenty-two. Like Kristin, who draws and paints religiously, Nicole uses her free time to write. She has written screenplays, a one-woman show, and essays on meditation and self-help. "About ten years ago, I started writing consistently and each week would

work on my sitcoms, adding characters," she said. "When I'm modeling, I think of writing about it all—the setting, the lights, the crew."

Nicole's well-grounded attitude and her strong interests outside modeling are key to her success and longevity as a model. "I define success as self-love, self-empowerment, and self-respect," she said. "Having a happy relationship and home life, having my writing, are important, but not money necessarily. I do like buying things, but it's not just about that. I could have tons of money and be miserable, so I want to be happy with myself."

Maturity also means having the ability to set your own priorities, not to let other people dictate what you should be doing. For Nikki Vilella, this meant deciding when to go back to school and what responsibilities to take on in addition to her college work.

"I have always looked at situations and choices," Nikki explained. "An agent may say, 'Go here, go here.' I look at it not from a modeling point of view, but as a human judgment that I make with my parents." Nikki has learned to balance modeling and college and to arrange her priorities. She is fortunate to have agents who support her decisions.

A girl with a clear definition of who she is and what she is about will succeed at modeling—or whatever she chooses.

ARE YOU READY?

I've talked about timing being a major factor in launching girls' careers. But timing doesn't just refer to being in the right place at the right time to get a job. It also refers to whether or not now is the right time in your life for you to be modeling. Some models must wait until they're ready—emotionally, physically, and intellectually—before they begin. Some take breaks in their career to pursue other interests or do some growing up.

If you've read the stories working models tell in the earlier chapters of this book, it's likely you have a pretty realistic sense of what it's like to work as a model. If some of these tales sound somewhat frightening, it may mean that you should wait to try modeling until you are more mature.

Heather Lett, who is twenty, said that as a young teenager she was constantly approached by scouts and agents in shopping malls in New Jersey,

where she lives at home with her parents. But at age thirteen or fourteen, she did not view modeling as a priority and did not consider herself ready.

"People were always asking me if I was a model or if I would try it," Heather said. "But I knew in my heart it was not right for me. I wanted to be with my friends. I was in high school, I was in the Honor Society, and I wanted to go to cooking school."

Heather finally changed her mind after a photographer coaxed her into having some test shots done in New York. "It was the right time for me," said Heather, who is represented by Next Management. Read more about Heather in chapter 10.

Nicola Vassell, a native of Jamaica, was fifteen when she won a Miss Jamaica Fashion Model Pageant. One of the judges was a Miami agent who expressed great enthusiasm over Nicola and brought her to test in Miami and New York. But the experiences frightened Nicola, who decided she wasn't ready for modeling yet.

"Being from the island of Jamaica, even Miami seemed overwhelming," Nicola said. "I said to myself, 'I can't do this right now. I need to focus and regroup.' So I went home to Jamaica."

Back at home, Nicola continued her education. She learned languages and took computer courses, to prepare herself for the working world. She gained maturity and confidence.

The next year, the summer when she was sixteen, Nicola went back to New York and stayed in a model apartment. This time she was ready.

"It was a good experience," she said. "I only had about three pictures in my book, and I was hired to do a television commercial. It was great!"

Now Nicola is eighteen and lives full-time in New York, where she models through Next Management. She has done work for *Mademoiselle, Marie Claire, Harper's Bazaar,* Pepe jeans, and Guess?.

"The first time I went to see an agent, I was sixteen, I was with my mom, and they told me to lose ten pounds," recalls Shaundra Hyre, an eighteen-year-old model from Indiana.

Once Shaundra learned about the rigors of modeling and realized the difficulty she would have meeting the demands, she decided to wait a year. She has since graduated from high school and pursued modeling full-time.

Other times a girl with modeling potential will simply have to wait until

she is physically mature enough. She may need to grow taller or develop in other ways.

"When I was twelve and thirteen, I had braces, so that really limited what I could do," said Melissa Tominac, who is sixteen. "When I got my braces off, the agency I was with had grown and they were really interested in my doing more adult work."

Megan Hoover, who is sixteen and modeling part-time while attending school in Houston, agrees that being "mentally ready" is key. "You have to travel a lot, sometimes by yourself," she said. "I'd be at home and think, 'Yeah, I could do that,' but it wasn't easy. At home my mom would cook my food, my parents were always there. In New York, I've got responsibility—I've got to keep my clothes clean, be on time for everything, without my mom there pushing me. It was the first time I had to wake myself up in the morning! It's all part of the job."

For Meilan Mizell, modeling serves as a pleasant interlude between high school and college. While in high school, she only modeled on weekends and vacations. "For me, modeling wasn't worth doing all the time," she explained. After graduation, she moved to New York to work full-time. She plans to attend college and says modeling has helped her amass not just the tuition but the necessary personal strength.

"After high school I wasn't ready to go directly to college," she said. "Modeling has been a great savior. If I had gone directly to college, I would have dropped out. I feel I'll get more out of college now, due to my modeling experiences."

So, before you begin to pursue modeling, make sure you are comfortable and confident about who you are. Make sure it's the right time in your life. Make sure it works for you!

DECIDING THAT MODELING'S NOT FOR YOU

The flip side of knowing when you're ready to begin modeling is knowing when you're ready to quit. Time and again, I have seen models at different points in their careers decide that they have done all they want to do with modeling and that they want to take their lives in new directions. Remember, this is not only okay, it is normal and healthy. To be a successful model, you

must plunge into it wholeheartedly. But nobody says that once you do start modeling, you must do it forever or for longer than you want to.

In fact, it is the very nature of the industry—which values the "new" and the "fresh"—that would prevent anyone from modeling forever. And as you grow, learn, and experience life (and modeling), you change. Your priorities, interests, goals, and desires evolve. It is ultimately your decision—not that of your friends, boyfriend, family, or agent—how long you should model or whether you should try it at all.

I often hear models say that they want to quit the business before the business no longer wants them—in other words, before jobs become scarce for them—or until they save enough money, get their first acting job, or whatever other goal they have set for themselves. Sometimes a model has the luxury of deciding for herself, and sometimes it is decided for her.

Some lucky girls stop modeling to pursue related careers. Two whom I've worked with, Liv Tyler and Cameron Diaz, went on to become actresses, and there are many other examples, from Brooke Shields to Cybill Shepard. Another model I know, Milla Jovovich, stopped modeling to become a professional singer and actress—and now is working as a model again, appearing on designer runways and in ad campaigns.

Many models pursue careers related to modeling—like becoming photographers, makeup artists, and even agents. Those who become agents have a personal understanding of the wants and needs of the models they represent—they've been there themselves!

Some models have dropped out of the business to finish their education, to move back home with their family and friends, or for other personal reasons. These are all perfectly valid reasons. Even more models stop because they get discouraged—by the competition, the difficulty of the field, the demanding schedule, or the fact that they just don't enjoy modeling.

This last reason—because they don't enjoy modeling—always reminds me to emphasize the importance of sizing up your own goals and expectations. You must understand your motivations and have a grasp of what the industry will expect of you.

One good strategy to figure out whether modeling is for you is to take a good look at your life and your priorities. Do you like to play on the basketball team? Ride horses? Do photography? How would modeling fit in? Think about what types of demands modeling would place on your schedule and

One Model Gives Up
Her Career

▼

Jennifer Davis once had a fabulous modeling career. She spent summers in Paris and Milan working for the best photographers and the best magazines.

Jennifer, a nineteen-year-old Dallas native, appeared in dozens of magazines, including *Seventeen, Marie Claire* and *Elle*. She did a print advertisement for Chanel, a television commercial for Lancôme and a runway show for Romeo Gigli. In the summer of 1995, she was chosen as one of *Top Model* magazine's ten up-and-coming girls.

One day she stopped modeling completely, with no plans to return.

"I was in Paris with my mom and I was working so hard," she explained. "I looked at all my friends and they were going to college and having fun, and it really made me feel like I was missing out on a time of my life that I didn't want to miss out on."

Jennifer described the circumstances of her decision: "One night I had gotten home from a job in Paris—I had been there for three months—and I got a call from a friend who had started school back home. She was saying, 'I met all these people and went to this party and that party, and my roommate is so great,' and I said,

your psyche. Try to imagine how modeling would fit into your life as you lead it today.

If you have the talent, the opportunities are out there—but keep in mind that it's your choice and your life, and your decisions must be consistent with who you are and what you like to do. For many girls, becoming a model is unrealistic for a variety of reasons, both logistical and personal. Thank goodness modeling is just one of many careers!

Throughout this book, there are stories of models starting their careers and the steps they've had to take. But keep in mind as you read them that not everyone who embarks on a modeling career actually goes very far. Models and their agents may set goals, but for one reason or another, the model may not meet them. Lots of models drop out, are rejected by the industry, or decide that modeling isn't for them.

On the whole, whether they dropped out early or pursued a lengthy career, most models say they wouldn't trade their modeling experiences for anything in the world. What they learn about themselves and about the world stays with them for their whole lives and infuses everything that lies ahead, professionally and personally.

Roundup: How has modeling enriched your life?

▲ **Lindsay Frimodt, fifteen**

I never thought I'd be doing so well. All I wanted was to have a photo shoot and say I model. I did not expect to travel or be in a mag-

azine or on the cover. But I have been able to meet a lot of new people and make a lot of new friends through modeling.

▲ **January Jones, nineteen**

Modeling has made me grow up real fast. I do feel old compared to friends at home. I see how I've changed and they haven't.

▲ **Kristin Klosterman, nineteen**

I'm completely different from modeling—I'm more worldly, smarter, more open-minded, and I'm happy about that. I come from a small town and I've never met so many different types of people. It has helped me as a person. I learned things about life that I could not have learned any other way. I traveled, which I never would have done if it were not for modeling, and I have great people supporting me.

▲ **Danielle Lester, seventeen**

My life hasn't changed much, except that I've gotten into better shape. At first, I didn't understand the whole modeling thing, concerning getting in shape. I know now that it's something you need to do, because there can be fifty other girls waiting to take your place.

▲ **Meilan Mizell, eighteen**

Modeling has really given me a great opportunity not to follow the usual path: high school, college, job. Modeling has opened a totally different doorway to do amazing things and go great places.

'Gee, I haven't talked to another person my age in three days. Let's look at who's happy and who's not.' That's when I wanted to get on the next plane home."

Jennifer packed her bags shortly after and hasn't had a single regret. "I never look back and think, 'Oh, I wish I was still modeling,' " she said. "I'm very happy where I am right now." She is a student at the University of Texas at Austin and plans to pursue a career in broadcast journalism.

Though Jennifer appreciates what she learned through modeling, she feels she has graduated to something more meaningful to her. "Being in a layout or on a cover or a runway, or a picture that someone might look at for five seconds and then throw the magazine away—it wasn't worth it to give up the whole college experience," Jennifer said.

▲

▲ Amy Owen, twenty-eight

Modeling gives you such street smarts. It's made me really flexible and easygoing. The positive side of the business is you get an education that you can't get in school—I went to India and Nepal by myself, and I didn't really think twice about it.

▲ Carrie Tivador, fourteen

It has made me more talkative!

▲ Nicola Vassell, eighteen

I think modeling has helped give me a healthy and positive attitude. Modeling is a lot harder than I thought—it's so much more involved than just having your picture taken. It can be physically and emotionally draining. You have to be strong.

▲ Nina Zuckerman, seventeen

Modeling has been a good experience for me, something I will carry with me as I go to college. I was a shy person, and I had to deal with it. It has made me more independent. I've learned about what it's like to be in the working world—and I'm only a teenager. When you're young and you see the pictures, you don't understand how much work it takes.

WHAT I LOOK FOR IN A MODEL

"Zest is the secret of all beauty. There is
no beauty that is attractive without zest."
—Christian Dior

T O ME, a model is not a specific person, but a person who engages in a particular job or career—modeling.

There are certain circumstances and personal characteristics that make one person a better model than another. Some things that make someone a better model can be learned through training, and others cannot. The elusive personal qualities and physical attributes that separate an obviously attractive girl from someone who has that intangible "it" that is necessary for modeling are impossible to define in words, but easy to identify with a trained eye.

The industry's definition of what makes a great model changes, so there is no one standard to judge whether a girl has "it" or not. People like me who scout for models can generally tell in an instant whether a girl is ripe for modeling at a particular moment.

You might think, "Well, how can anyone judge so quickly? No one can get a fair shake in such a short time." But actually, I find that you *can* tell. It may sound brutal, but anyone who is going to make it in modeling has got to get accustomed to acceptance or quick rejection.

From the time they were young, all that many girls have ever wanted to be is a model. That's fine, but know that the best models are well-rounded— meaning that they have lots of other interests that define who they are. You can see in their photos that they are unique, smart, beautiful individuals with

style and substance. You don't see someone who is posing, trying to be "a model." There's no set way that a model should look, and the variety of models' personalities and looks is what makes the fashion world so interesting and lively.

As I've said, there is no prescription for becoming a model, and the "in" looks change from season to season. Sometimes magazines, designers, advertisers, and photographers are looking for ethnic girls; sometimes they tend toward the blondes with blue eyes. Sometimes they want more full-bodied girls, and sometimes the "waif" look is considered chic.

That said, there are certain physical guidelines that most models must meet. Not meeting them does not necessarily disqualify you from modeling, but it does dampen your chances significantly, because you will be competing with many models who *do* meet the physical requirements.

I've identified seven attributes I look for in models, and I think almost all successful models exhibit them to some degree.

1. BEING PHOTOGENIC

Being photogenic is the single most important quality to have for a model. This is a business based on how you photograph!

The way the camera sees you can be totally different from how you look in person—this is why many people are surprised when they see models on the street who don't look at all the way they do in magazines.

You may be beautiful in person and your friends and family may tell you you look like a model, but you may not photograph well. Conversely, there are people whose beauty may not be apparent every day but whose looks come alive on film. Certain physical characteristics are picked up by film that the naked eye cannot see.

Often I notice among successful models that there is a chemistry between the model and the camera or photographer—a kind of spark.

Whether your beauty is obvious or not, the key to being photogenic is the ability to convey a range of emotions in front of the camera and to project whatever image or mood is being called for on a specific shoot. You must feel easy and comfortable in front of the camera, not self-conscious. You may be asked at times to change your "look" or attitude from one picture to the next.

I think of Niki Taylor, who was somewhat shy in person when I first met her but who radiated grace, beauty, charm, intelligence, and personality the moment she stepped in front of a lens.

2. THE PHYSICAL REQUIREMENTS: A HEALTHY BODY, A CLEAR FACE

A model must have a healthy body. To me, that means staying within one's own natural body shape and exercising to keep fit. Some girls are naturally thin. For those who are not, it is extremely unwise to starve down to an unnatural weight. For most models, all that is necessary is to eat a healthful, well-balanced diet, to exercise, and to get sufficient rest. Most of the models interviewed for this book said their figures came to them naturally.

To me and many others in the industry, Cindy Crawford is a great example of a model with a healthy, strong body—not a super-thin one, but one of the most attractive in the business. Cindy has built a career around her healthy body, and the public has responded to the pride she takes in herself. Cindy's two exercise videos have sold very well, and she makes the point in both tapes that it's important to exercise and stay fit no matter what profession you pursue.

Besides a healthy body, a key physical attribute I look for in a model is clear skin. This means skin, particularly on the face, that is free of scars and blemishes. Sure, most teenagers have breakouts, which go away or can be covered up. But clear skin with invisible pores and a healthy glow is certainly a great plus. Makeup artists always tell me what a pleasure it is to work on a model who has great skin. Think of your skin as a blank canvas before a painter applies the paint—it is always best to start with a clear, smooth foundation.

Photographers also report that it is easier to photograph a model with clear skin, because they can spend their time highlighting her beauty instead of figuring out how to light her to hide her flaws.

In a perfect world, everyone's looks would be judged beautiful. In our somewhat flawed world, the fashion industry has designated certain characteristics that are appropriate for models. Almost all models are tall—5'9" or more—and, as you see in magazines, almost all are very slender.

As we have noted, there are exceptions to the height rule, but they are few and far between. Most models have a minimum of body fat. If you aren't very tall and aren't particularly slender, your opportunities in the business are highly curtailed. Although work for plus sizes is definitely on the rise.

There are no specific weight guidelines, but it is important to have a lean and well-proportioned body. Most models have measurements close to 34-24-34. These are considered the ideal measurements for models.

Some scouts and agents will actually measure a model on a weekly or monthly basis to keep track of her size and watch for any severe fluctuations. For editorial or advertising work, there is some leeway with models' measurements, but with very precise work—like fit modeling and runway—maintaining the right measurements becomes more significant.

In general, features that work best include wide-set eyes, a long neck, and high cheekbones. Eyes can be any color or shape.

Hair can be any color or any length, though sometimes I (and others in the business) suggest a cut or some other change. The important thing about hair is that it be healthy, in good condition, without a lot of split ends or breakage. Not only does healthy hair photograph better, but it is better able to withstand hours of brushing and curling and the styling products that are used day in and day out.

I do not want to dwell too much on the physical requirements, because industry standards change all the time and there always seem to be exceptions to every rule. Many models become successful even though they don't conform to accepted rules. Each model is a different, individual person with her own specific features and attributes, and what "works" is a model who looks like herself, with all her unique beauty—and her flaws.

3. SELF-CONFIDENCE

Self-confidence is a prerequisite for stepping in front of the camera. Without it, there is no way that someone can set a mood or project her beauty that is going to create the perfect image. Would you buy a dress if you saw someone in it who looked embarrassed and sheepish?

So self-confidence is important on the job, to be sure, but it is equally important off the job. I look for models who are self-possessed not just because

they are more likely to look great on film but also because they are the ones who are going to be able to handle working in this fickle, rough-and-tumble business.

When a young girl starts modeling, it's hard for her not to take everything people say about her personally. Someone may tell her that she is too short or fat or thin for a particular job, or that she has the wrong hair or wrong body or wrong "look." That doesn't mean that she isn't a terrific, vital person—it just means she may not be right for what the client or agent is looking for at that moment. If she isn't secure about herself as a person, she's not going to be able to take that news in the right light.

Without self-confidence, it's impossible to persevere in a business that is a roller coaster of successes and failures. Models must keep in mind that being rejected by an agency, being passed over for a choice assignment, or even being photographed for a spread and then have your pictures not be used, is not a statement about the model as a person. She must have the inner strength to realize that outside forces beyond her control are at work: the agency may already have four other girls who look just like her, the client may need a model with a different hair color, or the magazine may not have liked the lighting or how the clothes look. If she has confidence in her beauty and talent, she can handle whatever comes her way.

Think of Tyra Banks. When Tyra walks down runways for the top designers in the world, she exudes confidence. Her walk, the way she carries herself and shows off all the clothes, all say, "Look at me—I feel great about myself!" Designers have come to know that having Tyra walk down the runway for them will definitely bring their creations to life.

4. A GREAT PERSONALITY

Everyone who is qualified to become a model is beautiful, so it is your personality that will make people—clients in particular—remember you and want to work with you.

Clients are looking for models who are happy, enthusiastic, and energetic. The model must add some uniqueness to the shoot. Well-rounded girls with many personal interests make the best models, because they are able to draw on their life experiences when asked to convey emotions or react in

specific situations. This is where there is a fine line between acting and modeling: actors draw on their own feelings and memories to depict characters, and models must do the same when they are trying to evoke a desired mood or scene.

Since there is only one *you*, it is your job to show a client, agent, or photographer what it is that makes you special. By that I mean that you need to be yourself and to understand, appreciate, and believe in yourself. Everyone in the modeling industry appreciates the opportunity to work with girls who are upbeat, friendly, and self-aware.

I have seen models get jobs almost solely on their personality. (This may account for the times you look through a magazine, or see an ad, and think, "She's not that pretty—how could she have gotten the job?") Personality, energy, and enthusiasm play huge roles in the selection process. Clients want to work with models who are easy and fun to be around, especially during long days of shooting.

It is your personality that is going to separate you from all the other beautiful models out there. Also know that your personality is seen in every photo of you. The combination of your look and your personality is what makes you unique.

5. VERSATILITY

Versatility is the ability to look different in different photos, to portray a variety of looks. Versatility is partly a function of external changes—different hairstyles, makeup applications, clothing, lighting—but it also comes from the range of emotions and moods a model is able to project.

A versatile model can work on a beach wearing shorts or a summer dress, looking very natural in minimal makeup and windblown hair, and can then turn around and model in dramatic makeup with a complicated hairdo, an evening gown, and studio lighting. The model who can successfully portray these extremes—and all the degrees between them—stands a better chance of getting quality work than one who only looks good in one or two specific scenarios.

If you want to know why more and more print models are finding themselves doing runway work—which didn't used to be the case—it is because

they are versatile. For some editorial models, it took a little bit of learning to become as graceful on the runway as they appear in magazines (Claudia Schiffer had a difficult time learning to "walk"), but their versatility was the quality that enabled them to succeed in the new milieu.

Versatility is partly a mental state of being ready to tackle any situation or job presented to you. It's also about being adaptable. Think of Kate Moss or Linda Evangelista—sometimes you can barely recognize them from one picture to another. Kate has played the youthful waif in some photos and the mature woman in others (think of her ad campaign for Calvin Klein). On the runway and in print, Linda has shown her chameleon-like qualities: think of the hair color advertisement she did for Clairol, which shows her looking beautiful and spunky as a blonde, a redhead, and a brunette.

6. INTELLIGENCE AND EDUCATION

I cannot stress enough the importance of intelligence and education to anyone who wants to pursue a career in modeling.

As with any career, to truly succeed, you need the strong base that an education provides. The unfortunate conflict for many girls who choose to pursue modeling is that the most advantageous time to start coincides with their prime school years. While some girls opt for home schooling or part-time programs, I believe it is imperative for a girl to complete her education and that the choice need not be black and white, between modeling or school. Especially at the beginning, when a girl is starting out, she should model part-time while she is going to school.

Keep in mind that the best models—the most successful ones—are those who are intelligent as well as beautiful and outgoing and charming. Remember that the intelligence of a model is picked up by the camera, which records not only her outward physical beauty but also her inner beauty, of which intelligence is a key part. When a model is photographed, you can definitely tell if she's intelligent or not—you can see in her eyes if there's anybody at home, or if the house is vacant.

Being intelligent and able to think on your feet will help a model in whatever professional situation she encounters. That includes dealing with agents and others in the business. Always remember that this is a very grown-up

business, and you must know how to look out for yourself and make decisions regarding your career, your life, and your future. If you are wise and well educated, you are less likely to be taken advantage of.

More and more models are recognizing the value of an education. Many of them have turned down jobs because they conflicted with school. Others have dropped out of modeling completely to pursue their education, and some have returned afterward, older and wiser. Many, many have stayed in school, modeled part-time, then pursued modeling full-time after graduating. Some wait until after high school, and some until after college.

As I've said, being a model is more than being beautiful. As a model, you will face very demanding situations and sometimes uncomfortable pressures that might test your intelligence and common sense. You will confront difficult life and career decisions which will overwhelm you if you are mentally unequipped. Dropping out of school to become a model is not the answer.

The best teenage models start out slowly, work mostly during school breaks, and recognize that nothing replaces the value of an education. What if your shiny new modeling career goes bust for one reason or another? You will have nothing to fall back on if you don't have your diploma.

7. RESPONSIBILITY AND PROFESSIONALISM

Being a responsible model means fully understanding that this is a job, that you must answer to people, and that people are depending on you to fulfill your commitments. If you pursue modeling, you cannot treat it like an optional school activity, a soccer practice or an art class that you might blow off if you're not in the mood.

As a model, you have responsibilities to your agent, who will work extremely hard to advance your career. You also have responsibilities to the people you work with on each job—the photographer, makeup artist, hairstylist, art director, and others—who cannot get their own jobs done without you, the model. On each shoot, everyone works together as a team, and the client is spending a lot of money for them to do so. Everyone is there for the same purpose, to create the image the client is seeking, but everyone has a specific job to do. There is no room for a model who behaves unprofessionally, arrives late, or forgets to bring something critical to the job.

A model must arrive on time for all appointments, be ready to work when she shows up, and maintain a good attitude at all times while she is on the job. She can't bring personal dramas to the set, act whiny, or complain. Models who do this find their work flow dries up quickly.

Off the job, a model has other mature responsibilities. She must take care of herself and her body, keep track of numerous appointments, pay bills, hand in vouchers to her agent, make sure her taxes are paid, and so forth.

Being professional means understanding completely that this is a grown-up business. It is important to treat everyone with respect, the way you would expect and deserve to be treated. This means not gossiping, not abusing the wonderful opportunities modeling may offer. At times, working may seem more like fun—with all the exotic locations, great clothes, and interesting people—but it is still a job and must be treated as such.

No matter what business you choose to work in or what type of job you take on, you must be professional. If you work in a bookstore, for instance, even part-time, your employers are depending on you to show up on time and ready to work, with a positive attitude. In this respect, modeling is just like any other business. The difference lies in what job you are performing.

These qualities that make you successful as a model—like self-confidence, intelligence, poise, and professionalism—are important ones to carry with you whatever you do in life. But if the camera does not pick up on these qualities, you will not be photogenic and therefore not cut out to be a model. Again, it has nothing to do with who you are as a person. There's nothing you can do about it but accept it, go on with your life, and make fresh plans for your fabulous future.

QUIZ: ARE YOU CUT OUT TO BE A MODEL?

Part 1. Choose the most appropriate response.

1. When someone wants to take a picture of you, you feel:
 a. Nonchalant. You just act natural—it's no big deal.
 b. Nervous. You don't think you look that great in pictures, even though people always tell you that you do.
 c. Happy. You enjoy posing and like to ham it up.

2. The night before a big test in school, you:
 a. Make sure you've studied properly, eat a good dinner, and go to bed early.
 b. Pull an all-nighter to cram in all the studying you can.
 c. Talk on the phone to your friends about the test, and have a study date.

3. If someone told you that you needed to lose ten pounds, you would:
 a. Laugh it off. You look and feel fine!
 b. Be really hurt and upset—maybe you do look fat.
 c. Start dieting right away.

4. If you were given plane tickets for a month away from home in Europe, you would feel:
 a. Jittery but excited—you would want to go, but would want to make sure you could stay in touch with your parents and friends.

 b. Quite nervous. The thought of being away from home for that long is
 a little scary.

 c. Thrilled! You can't wait to get away and enjoy a taste of freedom.

5. You've been practicing hard to make the soccer team, but in the final
 cut, your best friend makes it and you don't. You feel:

 a. Disappointed, but still okay. Maybe you'll make the team next year.

 b. Pretty crushed. The decision was totally unfair.

 c. Not too bad. You weren't really trying that hard, after all.

6. The girls in your class are starting to get a little catty—you think
 they're talking about you behind your back, and you don't like what
 you're hearing back. You:

 a. Confront them—you want to know what their problem is!

 b. Ignore it. You don't need "friends" like that.

 c. Feel kind of depressed. You want people to like you—doesn't
 everyone?

7. You've been looking forward to the school prom for a year now, and
 you've got a dream date. But now you're working as a model, and your
 agent has just called you with an amazing assignment—a possible
 magazine cover—that would take you out of town on prom night. You:

 a. Go on the assignment, of course!

 b. Ask if the assignment can be rescheduled.

 c. Go to the prom. It's a once-in-a-lifetime event, and other modeling
 assignments will come along.

8. A man approaches you in a shopping mall, introduces himself as a
 fashion photographer, and asks if you're interested in becoming a
 model. He says he can help you and offers you his business card. You
 would:

 a. Take his card, give him your phone number, and call him the next
 day.

 b. Take his card, check out that he's legitimate, and call him only if his
 credentials are good.

 c. Refuse his card—who is this guy?—but think about approaching
 agencies on your own.

9. You've been doing all sorts of odd jobs—baby-sitting, dog-walking, a little part-time waitressing—and are making a small stream of money. Do you:

 a. Spend it as you go, for daily expenses like food, movies, and clothes.

 b. Save it up for a big-ticket item you've been longing for—a new coat or maybe a trip.

 c. Save and invest it for college.

10. Your best friend invites you to go with her—just the two of you—on a weekend trip to the city. She's got concert tickets, and her aunt and uncle are letting her stay in their apartment while they're away. You're dying to go, but your parents say "No way." You would:

 a. Go anyway. Her parents are okay with it, what's wrong with yours? They'll get over it.

 b. Stay home and fume at your parents, just to spite them. They are so unreasonable.

 c. Try to negotiate with them. Maybe the plans could be modified in a way that would make them comfortable with the situation.

Part 2. Answer, as best you can, whether these statements are true or false for you.

1. I am 5'9" or over, and my body looks healthy.

2. There aren't a lot of things I'd really like to change about myself. I think I'm pretty good the way I am.

3. When someone keeps me waiting for a long time, it really drives me nuts.

4. I'm always dieting. Sometimes I eat a lot and then not much for a long time, and sometimes I try new diets. It's very important to me to be as thin as I can.

5. I have my own style of dressing that is unique to me. I know what looks good on me and what I like to wear.

6. I have a really great relationship with my parents. Even when they don't understand me perfectly, I still consider them two of my best friends.

7. When other people do better than I do—at tests, sports, or whatever—I pretend to be happy for them, but secretly I am really jealous.

8. If something doesn't come easily for me, I usually give up pretty quickly. It's not that I'm a quitter, I just hate the feeling of failure.

9. I love to dance and move my body. A great tune can always get me going.

10. People like to joke about the fact that I'm always five or ten minutes late for class or to meet my friends—it's just one of those things about me!

Part 3. Choose as many of the responses that apply to you.

1. I like it when people describe me as:
 a. Beautiful
 b. Funny
 c. Shy
 d. Serious
 e. Outgoing
 f. Cool

2. Among the things that make me happiest are:
 a. Hanging out with friends.
 b. Looking great and knowing it.
 c. Doing well in school.
 d. Having a boyfriend.
 e. Going shopping.
 f. Being at home with my family.

3. I would like to try modeling because:
 a. I want to travel and see new places.
 b. It would be so thrilling to see my picture in print.
 c. Everyone tells me I should model, and I think they're right.
 d. School can be a drag—I'd rather get a taste of the working world.
 e. My family and I could use the money.
 f. Being a model looks so exciting and glamorous—it's all I've ever wanted to do.

172 ▲ CAN YOU BE A MODEL?

4. If I were a model, I think my life would be:
 a. Much happier. I would feel like I was a success.
 b. Not too different—just a little busier.
 c. More rewarding and fulfilling. I would be broadening my horizons.
 d. Really crazy, schedulewise. I'm already doing so much!
 e. A lot better than my friends' lives.
 f. Finally worth living.

5. If I ever do become a model, among the things I would really want to do would be (be honest!):
 a. To get back at all those girls at school who were mean to me.
 b. To use some of the money I make to buy great stuff.
 c. To figure out if the career suits me, or if I might prefer acting or something else.
 d. To use my status to help out charities and causes I believe in.
 e. To hang out with famous designers and other celebrities.
 f. To enjoy myself, work hard, and cross my fingers that everything works out.

SCORING

Part 1. Score yourself accordingly:

1.	a) 2	b) 1	c) 3
2.	a) 3	b) 1	c) 2
3.	a) 3	b) 2	c) 1
4.	a) 3	b) 1	c) 2
5.	a) 3	b) 1	c) 2
6.	a) 2	b) 3	c) 1
7.	a) 2	b) 1	c) 3
8.	a) 1	b) 3	c) 2
9.	a) 1	b) 2	c) 3
10.	a) 1	b) 2	c) 3

Part 2. Give yourself points as follows:

1. True: 2 False: 0
2. True: 2 False: 0
3. True: 0 False: 2
4. True: 0 False: 2
5. True: 2 False: 0
6. True: 2 False: 0
7. True: 0 False: 2
8. True: 0 False: 2
9. True: 2 False: 0
10. True: 0 False: 2

Part 3. For each answer you marked, score yourself accordingly:

1.	2.	3.	4.	5.
a) 1	a) 1	a) 2	a) 1	a) 0
b) 2	b) 2	b) 1	b) 2	b) 1
c) 0	c) 2	c) 0	c) 2	c) 2
d) 1	d) 0	d) 0	d) 1	d) 2
e) 2	e) 0	e) 0	e) 0	e) 1
f) 0	f) 1	f) 1	f) 0	f) 2

Total your scores from all three sections.

If your score falls between 50 and 80: It's likely you have many of the qualities needed to become a successful model. You're self-confident, and you make your own decisions rather than letting people make up your mind for you. You take a great interest in life and in trying new experiences, and you aren't afraid to confront situations that might not be familiar to you. Most likely you're the type of person who knows that achieving your goals is a long-term process, not something that can be done overnight, and you're not afraid to work hard to pursue what you want. Your upbeat, patient, and flexible personality would surely be an asset to your modeling career.

If your score falls between 20 and 50: You definitely have some of the qualities you'll need if you're going to make it in modeling, but you may need to

work on some of the others. You might well be cut out for modeling, but you might also need to identify certain traits that could hold you back—maybe a small shortage of self-esteem, or some uncertainty over whether you're equipped to make the best decisions for yourself. Perhaps you're doing great in some areas—you've got a great personality, a great group of friends, and a terrific sense of yourself and how you look your best—but other areas of your personality are still developing. The best thing might be to take an honest assessment of your strengths and weaknesses, to see how they might mesh with the demanding world of modeling.

If your score falls between 1 and 20: You may not be ready for modeling quite yet. It may be a simple matter of maturity, of waiting until you're older and more ready to confront the adult world and take on grown-up responsibilities. Then again, you may be one of those people—a large majority of the population!—who aren't cut out to model. That's okay, and it's better to know it sooner rather than later. You may want to reevaluate your reasons for wanting to model. The best models pursue their work because of the inner satisfaction it brings them and because of the specific life goals they want to achieve, not to puff up their egos or show the world how gorgeous they are.

Study your answers to these questions. If you think you've got the right attributes, you're ready to move on to Part III, "Step by Step," which will explain how to optimize your chances of breaking into modeling.

Talking to . . . Niki Taylor and Her Mother, Barbara

From the moment I first saw pictures of Nicole Taylor, I knew she was something special.

Each day I make my way through a thick pile of mail from girls who want to be models and from their agents. A lot of the agencies send pictures of their new model prospects along with letters that say things like, "She's going to be a star!" In one of these envelopes was a Kodachrome slide of a stunningly beautiful fourteen-year-old girl. She had crisp features and clear skin, and she seemed to me to radiate wholesomeness.

The slide was of a "new face" from the Irene Marie agency in Miami. I asked them for more photos. All I got were three photocopies of pictures from a test shoot. What struck me besides her radiant beauty was her ease and grace in each photo. She also looked slightly different in each photo—an example of versatility—and, to me, she looked "genuine." That is, she seemed to photograph just like who she was—a beautiful teenager with a great spirit.

I called her agency and booked (hired) her. We were shooting our August 1989 cover the next week.

Nicole flew up to New York with her father. When I met her for the first time, she seemed just as sweet as she had looked in her pictures—but I do remember she was a little shy. She came off as an unpretentious ninth grader, with schoolbooks in tow.

The crew took Nicole and two other models to a location on Long Island, about two hours outside New York City.

Nicole was chosen for the cover (at my suggestion, she later changed her name to Niki), and the rest is history. Today, at age twenty-two, she is one of the most coveted models in the world, and her name is a household word.

Niki, who is 5'11", worked exclusively with *Seventeen* for about a year before she was scooped up by the adult women's magazines. At age fifteen she signed her first contract, which was with L'Oréal. In 1992, at age seventeen, she was signed exclusively with Cover Girl cosmetics. She was also the youngest model to grace the cover of *Vogue*.

Niki has appeared on more than two hundred and fifty magazine covers—you name it, she's been on it. In May 1996, she appeared on six magazine

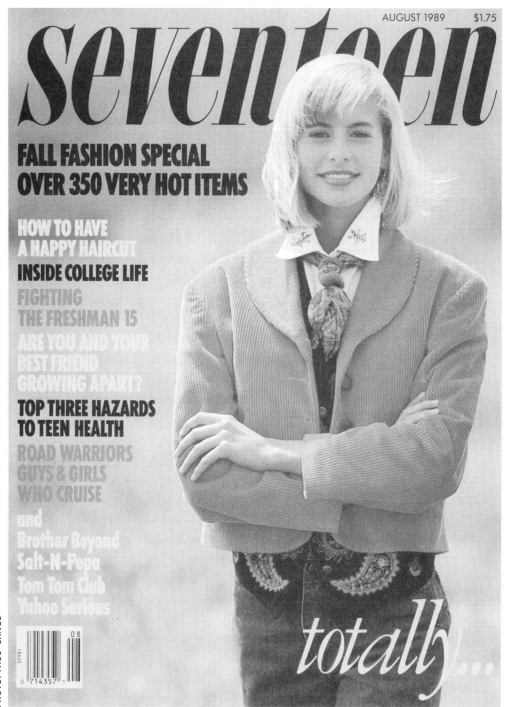

NIKI TAYLOR

covers at the same time. They were later referred to as the "Niki six": *Allure, Vogue, Elle, Self, Shape,* and *Marie Claire.*

She has worked with famous photographers like Patrick Demarchelier, Marco Glaviano, Francesco Scavullo, Albert Watson, Gilles Bensimon, and Pamela Hanson. On top of her ongoing exclusive contract with Cover Girl, she recently signed an exclusive contract with Liz Claiborne; her other advertising contracts have included Ellen Tracy, Lee jeans, and L'Oréal. She is now represented by IMG Models and managed by Jean Renard.

I remember talking to her during that first shoot. She was quiet and kept mostly to herself, but she did talk a little about her family and school, her friends back home. She said she wasn't viewed with awe by her classmates, despite her great looks and what was happening to her now. Even as her modeling career was starting to take off, exams and papers, homework, and regular teen stuff were still the center of Niki's world.

When Niki stood out in the field along with the other two young models we were photographing, she came alive. She was able to express emotion for the camera, and showed an innate sense of how to move and compose herself to produce the best possible image. In each shot she came across in a totally different way, but in all of them she just seemed like a warm, beautiful girl.

Not only did Niki appear on the cover of the August 1989 issue, but she also had her own four-page spread on the inside—a dizzying accomplishment for a fourteen-year-old!

I had found a model perfect for the magazine. Niki appeared regularly in *Seventeen*'s editorials and did four covers right away: August, October, and November of 1989 and March of 1990. Because of her family's insistence that she complete her education, we sometimes had to work with Niki after school, sometimes two consecutive afternoons, to get the number of shots that would normally take one full day of work.

Unlike what most people might imagine about a girl who very suddenly breaks out as a top model, Niki's life did not change significantly. Though the word about her was out and everyone wanted to know who this amazing fourteen-year-old from Miami was, she continued to attend public school and live at home with her parents and two sisters. Niki took everything at her own pace. She turned down jobs for her own reasons, like attending the high school prom. Her parents made sure that modeling did not overtake her life.

Niki was always very professional. She faithfully arrived on time and

ready to work. She maintained a positive attitude and was always a pleasure to be around. When she walked in front of the camera, she brought that same enthusiasm and beauty with her. Even off the set, she behaved like a true pro: Niki would send notes of appreciation for the jobs she had done, and always autographed her magazine covers and sent them to me. It was extremely thoughtful.

Niki Taylor is a good example of someone who had the right qualities to become a model and who followed an ideal career path. Though she had tried to break into modeling earlier, she had been told by a few agencies that she was too young, so she waited until she was ready. Like most models, she was in the right place at the right time: her picture crossed my desk the week before an important cover shoot.

What Niki's story also illustrates is that there are certain personality traits and physical attributes that contribute to a successful career. There are also numerous supports—a caring family, a secure school situation and good business advice—that a young model must have in order to pursue a career in a sane and healthy way.

Another thing that is important to note about how Niki got started is what the climate of the industry was like at the time. The modeling landscape in Miami was quite bare. There were only three agencies there then (there are nearly twenty now). While *Seventeen* has always been in the business of trying to find and launch new faces, other clients were more reluctant to use brand-new teenage models. In a sense, the calmer environment helped Niki grow, develop, and learn until she was able to handle what was in store for her.

When I see photos of Niki today, she still has that sparkle and radiance I first saw when she was a young teenager. And when I see her in person and talk to her on the phone, it's heartening to find that she has remained the same sweet person I met eight years ago. Even though she's a supermodel, Niki still lives only thirty minutes away from where she grew up in Florida.

Though Niki's life might seem like a dream to young girls who aspire to be models, she has certainly experienced her share of hard times. Perhaps the hardest was the sudden death of her younger sister, Krissy, from a rare heart defect (RVD) in 1995. Niki and Krissy were extremely close, and Krissy had just begun to follow in her sister's modeling footsteps.

I talked to Niki for this book about her career, and the interview follows. I also talked to her mother, Barbara Taylor, about how parents can handle the pressures of their children's modeling careers.

Niki Taylor

What were some of your favorite modeling experiences?

Where do I begin? There were so many . . .

My first big break was with *Seventeen* magazine. I was fourteen years old, still in middle school. The shoot was in New York and my dad went with me—I think we set a precedent here, as they weren't used to having parents come along.

My first trip to New York City. Wow! Our first night in town, we parked our rental car and had dinner with my agent. Within only minutes, the car was broken into, and all my luggage and clothes were stolen. I'll never forget that warm welcome. At least I was in the right line of work—you didn't need any special clothes. A few weeks after I got home, I found out I had the cover for the August back-to-school issue. It was my first shoot with *Seventeen*.

I will never forget the shots I did with Krissy, my sister. We had so much fun. We worked together for *Seventeen, YM, Vogue, Mademoiselle, Elle, Marie Claire,* Italian *Glamour,* ET, MTV, Cover Girl, the runway shows in Milan and New York, and our last shoot—*Ocean Drive.* We were never jealous of each other, just enjoyed working together and being together. She was my best friend, not just my sister.

Another fond memory is a shoot I did with Paul Lange for *Mademoiselle.* He knew how much I loved dolphins, so he arranged to do a swimsuit shoot in the Florida Keys and the Dolphin Research Center. I got to swim and dive with dolphins all day. A longtime dream of mine come true.

Then there was the shoot I did in New York for *Vogue* in 1993 with the "Welcome Home Desert Storm Troops" ticker tape parade as the backdrop. Wow, there were over 25,000 uniformed troops in New York that day and I was in the middle of them shooting a Ralph Lauren military story. Can you see me with the U.S. Army Special Forces? It was really funny.

NIKI AND KRISSY TAYLOR

My mom pulled me out of school, in the middle of finals, to do this shoot. She said that no book could teach me what this day would show me. And she was right—it was awesome. There were helicopters flying above, soldiers of green and tan, and a sea of white uniforms everywhere you looked. Then the sky filled with colorful confetti and people lined the streets and leaned out their office windows, and the world came to a stop to welcome home our troops from the war zone.

I made up my tests that following day and shared with my class the history I felt I was a part of.

Then I fought the sandstorms in the "white sands" of New Mexico, shooting with a famous Paris designer, Thierry Mugler, for his new collection. The desert was "cool" looking, blanketed by white sand, swept in layers whichever way the wind wanted it. We were out in the middle for a "vast" effect when the wind changed and all of a sudden we were in the middle of a storm. We closed our eyes and made our way back to the van somehow. We sat out the storm for a couple of hours and then finished the shoot. Thierry used it as his ad campaign that year. I'll always remember standing on a ladder in heels when the storm hit.

I went from sandstorms to glaciers and icebergs in Iceland for a shoot for *Elle*. Iceland is beautiful, deserted, cold, and had a look all its own. You constantly hear cracking sounds, and as you look toward the sound, an iceberg will capsize.

So they put me on an iceberg in an evening gown and heels. While the photographer and crew were bundled warmly in the boat, I was left alone on this iceberg while the boat circled and took the shots.

Next we snowmobiled to the top of a glacier. It was amazing! I remember reading about icebergs and glaciers in school, but I can appreciate them more having seen them up close and personal.

On another shoot, we traveled to the rain forest of Mexico, where the movie *Predator* was filmed. Picture a beautiful, green, wet forest, full of waterfalls, vines, flowers, and birds. It was a Cover Girl shoot, a mascara commercial (waterproof). I had to float down the river and under waterfalls on this trip.

I may have missed a few assignments in school, but what I gained firsthand in these locations was more than I could have gotten from any

PHOTO: PAUL LANGE

NIKI TAYLOR

history or geography book ever printed. I got to experience up close different cultures and peoples. Those shoots come to mind first.

How did you juggle school, jobs, friends?

My mom and I found that the secret of working with your teachers and school was to make them feel a part of what you were doing. They were truly excited for me to have these opportunities, and they worked with me so that I could do them. We kept them informed and aware of my progress as my career developed. They were happy to be a part of my success. Modeling kept me very busy. My friends had been around for a while and knew what I was doing, so they were accustomed to my comings and goings.

How did you feel when you saw your pictures from your first shoot?

I remember my first test shots. They were my first modeling steps. I got to play different "me's." They sort of put me in different characters—different clothes, makeup, hairstyles. I tried to feel each idea out and get into that character. It was from these shots that they could tell my potential.

I can remember my first cover—*Seventeen*'s August 1989 back-to-school issue. My mom didn't tell me—she wanted the agency to break the news to me. She's a firm believer in giving credit where credit is due. My agent was just as excited to deliver the news as I was to receive it—I screamed!

How do you think the reality of modeling and models' lives differs from the public's perception?

I can honestly say—it's hard. The public only sees the final result. They have no idea of what it takes to get that one shot or that one thirty-second commercial. There is a crew working with you, and then there are many, many more in the background doing the behind-the-scenes work to put the shoot together and organize it. The model is the "talent" they rely on to bring life to the story or project. You are the key person who is going to make the magic happen. You usually have to be on the set early—sometimes at the crack of dawn, 5:30 or 6:00 A.M.—travel to the location, go through two hours of prepping (hair and makeup), people pulling and

touching you all the time. It's not as glamorous as you may think. But the experiences, the places, and the people you meet along the way are definite perks.

What is your advice for girls who are starting out?

Make sure you're ready for a commitment. Don't forget your family or friends—they are your base. When this part of your life is over, they will still be there. They will keep you anchored. Stay in school—at least finish high school. College can come at a later time, but finish high school with your peers. They, too, will be going off to other places, either college or jobs. If you're under eighteen, let your parents guide you through the beginning years. No one out there cares more about you than they do. You will find a lot of hands reaching out for you, but remember they are strangers.

What role did your parents play in the beginning of your career?

My parents were the framework of my career. They not only got me started but guided me and protected me and set things in place for the future for me to build the career that I have today. They—or a family friend—traveled with me until I was eighteen. It was comforting to have someone there. It can get very lonely away from home.

A trust was set up for me, to protect and secure my earnings for the future. Niki Inc. was created for tax benefits and became my business structure. I'm president! A network, which included an accountant, an attorney, a publicist (George and Isabel Dassinger), and my business manager (Jean Renard), was set in place to handle everything smoothly for my career. I'm represented by agencies all over the world through IMG. But most of all, my family is my family. They are home base, and today I try to keep my professional life separate from my personal life as much as possible.

What is the hardest thing about modeling?

The traveling. I'm a homebody, and it's hard being away for any length of time, especially now with my sons. Home is where I want to be, with them. But I understand my work requires travel, so I grin and bear it.

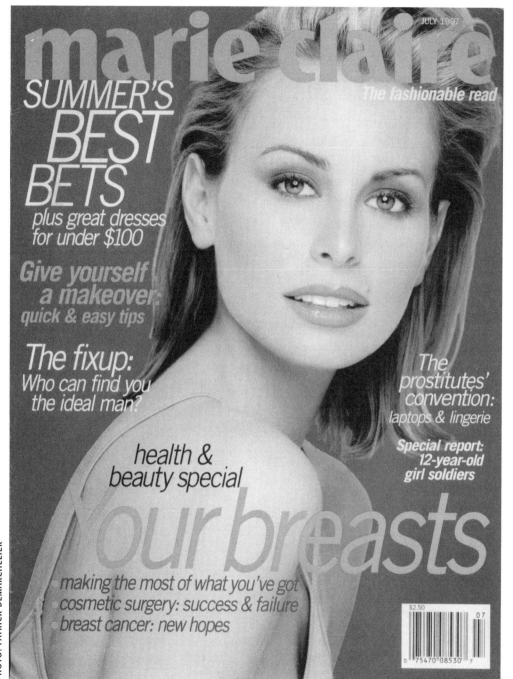

NIKI TAYLOR

What's your favorite thing about modeling?

I feel very fortunate to have this as a career. It has been very good to me. My favorite part of modeling is the runway shows—and commercials. You get to see all your industry friends and catch up on everyone. The clothes are always a surprise—you never know what the designers are coming up with from year to year, or what exotic location you're heading to.

The shows I will always remember and treasure were in Milan in 1991. My whole family went with me—Krissy, too. She was only thirteen then, tall and shy. The designers took one look and grabbed her and fitted her and put her in the shows with me! One show we ended up on the runway together, but we didn't know it was planned. She came from the left side and I came from the right and when we saw each other, we started to giggle. Slowly we grabbed each other's hand and by the end of our walk we had our arms around each other. The shot made all the Milan papers the next day: "Big sis, little sis." I miss her every day.

Do you ever feel insecure?

Sure, at times. And there are days when you have your doubts about things. But usually they work themselves out. My professionalism usually counters my shyness.

When you see photographs of yourself, is it the same person you see in the mirror?

I like to think it's me, only with a different outfit each time. I try to be me, only I feel the mood that is at hand—sort of like an actress would read a script. I read and feel the clothes or the setting of the commercial.

What do you think about when you are on the runway?

I hope I don't fall or trip! And I think about showing the outfit I'm wearing and feeling beautiful wearing it. Each outfit requires character, and I try to portray it.

What do you think about when you are being photographed?

Secret thoughts! And, getting the right shot that makes the day all worthwhile.

If modeling hadn't worked out for you, what might you have pursued?

I'd probably be in the ocean doing some sort of oceanography, working with sea life. I'm a Pisces—and it's a natural lure for me. Or I might have worked in film, behind the scenes.

What would you like people to know about you?

I have twins, Jake and Hunter, and a dog and a cat. I also have two sisters, Krissy (my guardian angel) and Joelle, my older sister, who a lot of people don't know about. Joie is my personal assistant—I don't know what I'd do without her. She's indispensable, but sometimes I give her too much to do. Also, I'm usually quiet and shy.

Barbara Taylor

Few people know better than Barbara Taylor what it's like to be the mother of a model. Throughout Niki's tremendous career, Barbara has been there for her, helping her make professional decisions and offering constant comfort. She worked equally hard for Niki's younger sister, Krissy, whose modeling career was starting to soar before her tragic and premature death. A heart defect, called RVD (right ventricular dysplasia), was the cause of her death.

I have deep respect for Barbara and for what she has done to nurture, love, and support her daughters throughout all the good times and bad.

What do you think the mothers of young models should know?

A lot of mothers ask me for advice. One thing I tell them is that it's okay to say no.

A mother called me once, upset, asking me if I thought she should let her daughter, a model, do a job for a foreign magazine in a Third World country. I said, "Be a mom." You know your daughter is tired—she's been working a lot—and she needs to be home to recoup. It just wasn't worth it, the long travel and the inoculations that she needed to have to go there for a few photos that no one here would see anyway. They turned it down, and she's still modeling today. It's okay to turn a job down, on occasion, for good reason.

What role do you think a model's family should play in her career?

Support, protect, encourage, and love. I believe that girls will have more longevity if they stay close to their families and work together. No one else cares as much about them as their families . . . no one.

If your daughter wants you to handle her career, you must act as the liaison between her and her agent. If you don't, you will surely lose her early on. Trust me on this. They are young, they want to please, they will do anything they are told to make everyone like them.

It is a tough age for these young girls. They are on the verge of adulthood, only a few more years to go. While they're being told they're magnificent "on set," we the parents are telling them to do their homework and clean up their rooms!

If they had a choice, where do you think they'd go? And this happens more often than not. Hold on to your daughters, Mom and Dad. Make an arrangement with them. If they want to do this before they're eighteen, then it's under your rules and you are involved. After they turn eighteen, it's their choice, but I think they will be thankful for you being there and putting things in place for them. It's a good start.

How do you and your husband view modeling as a learning experience for Niki?

Every shoot was a learning experience. The travel took her all over the world. Just going through international airports was a learning experience. All the trams, schedules, baggage claims, gate changes, security checks, transfers, and customs are an education in themselves. Niki is such a pro, she pretty much knows all the airports and terminals now!

For us, decision-making consisted of "How important is the job to her career?" "What experience will she gain?" It's like learning from a book versus being there, touching, hearing, seeing, and experiencing.

There are times you just gotta take them out of school, the once-in-a-lifetime opportunities that come along. . . .

Several shoots come to mind.

Niki did a trip to Iceland—who in school would get to ride up a glacier on a snowmobile? Not many.

One day the agency called up and asked if Niki could do a shoot for *Vogue* on a Wednesday. Niki was in the middle of midterm exams that week, and would have to miss a couple of them. I turned it down for that

reason. About a half hour later, the phone rang and it was the story editor from *Vogue* calling directly. "We have to have Niki for this shoot," she said. "She's the all-American girl, it's a Ralph Lauren military story with the backdrop of the New York City ticker tape parade to welcome home the Desert Storm troops from the war zone." I called Niki's counselor (Mrs. Brown) at her high school and told her about the opportunity that was being offered to Niki, and you know what—she said, "Can I go with her?" It was so nice to work with people who were so enthusiastic and supportive of her career. We left the next day, and it truly turned out to be one of the most moving experiences I will never forget.

Then on a job for Cover Girl, Niki went into the endangered rain forests of Mexico. She has also seen Third World countries, swum with dolphins, and walked through a sandstorm in the white sands of New Mexico. This is hard to do in a book! She—and we—have been so thankful for these experiences.

What lessons do you think Niki has taken away from these experiences?
Tolerance, respect, and appreciation are a few. There is not a prejudiced bone in her body. In this industry, you work with many gifted individuals from every background you could imagine. She has learned they are all talented individuals, and everyone works together to make the shoot a success. This is something you cannot learn in a book or private school. Sometimes children are so sheltered, and then go out into the real world and don't know how to deal and communicate with all these different people. The thing is—they aren't different—this is the real world.

Are there any rules of thumb you have used to help Niki make career decisions?
Every case and situation is different. You have to trust and work with your agency. Be a team—you both have the same goal, of wanting your daughter to succeed. Sometimes you have to go with your gut feeling, though.

Timing, sometimes, is everything. Take advantage of the fill-in jobs that come your way. You will be the hero of the shoot when "Celeste" cancels or doesn't show. If you do well, I can guarantee the client will request you the next time instead of "Celeste." Don't ever look at it as being a second choice—instead, think positively. It's an opportunity that you didn't have before—grab it! This is a terrific way to get your foot in the door. My

girls saved the day for many shoots, their agency was appreciative, and the clients discovered how terrific they were! Be available and ready to go. (Beepers are wonderful for immediate contact.)

In this business, word of mouth is the best publicity you can get. If you do good, everyone will hear, but if you do badly, the word will also get out. Don't forget, the makeup artist, stylist, and hair designer you worked with today will be working with different photographers and magazines tomorrow . . . and if they have something good to say about you, the word gets out. Remember the "little" people—they make you look good!

Be careful of signing releases. You will be asked to sign them. If you are underage, take it back to your agent—let them be responsible. Never sign a personal release for a photographer. Take it back to your agent and have them look at it first. Let them handle it. You do the shoot for one client, and the photos should not be used for any other usage without your and your agency's permission.

Misusage (usage of an image without arranged compensation and consent) happens frequently. When it does, let your agency deal with the client—they will know what to do. It's happened a few times with Niki, but the agency will intercede and handle it professionally; you should not have to get involved.

Do you have any financial advice for parents of models?

If you see that your daughter's career is going well, set up a trust for her. This is a legal document which structures a plan to safely hold and manage their earnings until a future date. It sort of protects them from themselves.

Have an accountant do their books and help you with incorporating them as a business. There are many tax advantages to having a business structure incorporating an individual. Niki Inc. and Krissy Inc. were both formed for the girls—they were presidents of their corporations, and we were vice president and secretary/treasurer.

How visible a role should parents play in their daughters' modeling careers?

As parents, you should be there for them in the background. It's important for them to know that they're not alone—we may not always be visible, but we're there.

Don't get in the way! Make your presence known, say "hello," meet the group they'll be working with, ask about the story, look at the beautiful clothes they'll be wearing. Make sure it's nothing that would put them in a compromising situation, then, on their cue, if they feel comfortable . . . leave! Come back for lunch or at the end of the shoot. Carry a national beeper, so you can be reached at any time. It's a worthwhile investment.

Once you've established you're there for your daughter's well-being, not to interfere, they will respect you and your efforts. And your daughter's confidence will show through, as she has nothing to worry about except doing her best on the set.

As parents, we are responsible for our children until they are eighteen years old. It's the law. You have the right to—and honestly, you should—travel with them until this time. It's like an insurance policy for the client. They don't have the responsibility of looking after a minor (your daughter). If they want young talent, they have to accept the parents' involvement. The security for them is also the security of the family. If you are unable to travel with them because of your employment obligations, try to find a relative or friend.

What was it like at the beginning of Niki's career?

Before Niki started, this was all a dream. Then when we saw the first test shots and the reaction from the photographers, we felt that Niki had genuine talent. With every shoot, it grew like a seed. This business is a small world and people talk, so everybody knew in one month that there was "a new face on the scene." It has been nice to see that seed grow into a beautiful tree that blossomed . . . and became a supermodel.

What are your thoughts on models leaving school?

Stay in school! It's hard, but it's the best way all around, emotionally. You need to keep grounded, and school keeps you there. You need to be with your peers during these growing years. You may not think so, but later you will look back at this time and be so thankful that you finished high school with all your friends, got to go to your homecoming and prom, and graduated with your class. It's called tradition, and that's hard to beat.

But sometimes it's hard to do both. Some teachers will work with you—like Niki's did—and others have rules that they simply won't bend. In that case, you will have to make a decision. Just remember, you will only get more mature, more sophisticated, and more beautiful as you develop. Growing in mind and body are equally important, and in the end, I think the client will appreciate and respect your commitment. It will show.

In our case, we did both. Niki stayed in school. It was extremely hard, with the immediate appeal that she had and her career taking a giant leap, instead of going slowly, as we had originally thought it would. We took it one day at a time. We had a school and staff that worked along with us, to allow her to take advantage of the opportunities presented to her, and she was able to stay in school and graduate with her class.

With Krissy, we took her out in her junior year and enrolled her in a home school program offered to professional young people in the industry of entertainment. She did quite well, and would have earned her diploma before her graduating class. She got to do a lot with her peers, and attended the school's sports events, homecoming, and prom (as she didn't like to travel, it left her a lot of time at home). I have to admit, I had second thoughts about taking her out of school, but it was so hard with Niki, and I didn't think we could put those teachers through it again with Krissy. Looking back now, with Krissy passing away, I'm sure glad we did it—it gave her more time to enjoy the short time she was with us. Sure do miss her.

If you look at modeling as an after-school activity, like you would a hobby or sport, it will give you a good attitude. Otherwise, you will probably burn out.

Modeling can be a quick thing, but if you really want it to last, you have to develop it properly. You've got to go slow at it and stay fresh. If, for example, you move to New York, quit school, then you simply become "common." To stay special, with a smile on your face, it's hard. You've got to jump, sparkle, enjoy life. So keep school, your friends, and other things that you have.

Did other people share your attitude as Niki went through her early career?
No. What was odd was how much the industry was fighting me. I had to deprogram Niki several times after she came home from shoots. Some

agents and photographers would say to her, "Why don't you quit school, you could be doing so much more. Tomorrow we're going to the islands for a shoot, sure would like you to come. . . ." Now picture your daughter trying to reason this one out with you. "I don't think so," would be my reply. What attracted them to Niki in the first place is what they were fighting me against: if Niki did that (quit school to work full-time), she would have lost what they liked most about her, her naivete.

Then again, there were times that photographers heard that we'd turned down jobs and afterward would say, "Good for you, you are so right." She is who she is because she's different from the rest. It's not an easy thing to do, to pass up jobs most girls would drop anything to do.

Modeling is one of the most exciting and lucrative professions a young woman or man could ever dream of doing well at. It has its ups and downs, like everything else in the entertainment world. The trick is to be mature enough to handle it. It targets youth, and most just aren't able to deal with everything that comes with it. They need you and their family and friends to keep them grounded.

How do you feel about Niki and her career today?

We're so happy and proud of both Niki and Krissy and their accomplishments. They are an inspiration to many young women.

Niki's had a lot of heartache in her life of late, but she's come back strong. Just remember, everyone is human—they have feelings. People say some weird things, so don't believe everything you hear. Believe in yourself and be proud of who you are.

You will succeed if you believe in yourself and stay close to your family.

THE WEIGHT ISSUE

WHAT BODY TYPE is right for modeling?

Every person's body has a natural size, shape, and weight, and what is healthy and right for one person is not right for another. Some people are naturally thin and delicate; some have an athletic build or large bones. No matter who you are or what kind of work you pursue, you should seek to maintain a healthy body at a size that is right for you, that feels good, and that is easy to maintain.

Some girls are naturally thin, of course, and if they have the inclination to become models as well as the other necessary qualities, they may do quite well. These girls often say that people make hurtful remarks to them out of jealousy. They also say they are tired of explaining that they are *naturally* thin, and yes, that they *do* eat. I understand why this happens, given the climate we live in.

Models themselves are emphatic on this point—that they eat normally and don't understand why people can't accept that. While it may be a nuisance for naturally thin girls to have to explain themselves over and over, the real problem arises when girls who are built more fully try to fight their body's natural state in order to be as thin as the models they see in magazines or television.

The fashion industry, particularly the modeling industry, is criticized

all the time for promoting girls who seem to the public to be unnaturally thin.

As I've said, there are girls who were born with a wiry physique and who have no trouble maintaining a small size. Their body type is in demand now by clients and photographers, and agencies are supplying them. After all, this industry, like any other, is based on the laws of supply and demand.

Right now, there are real and specific body measurements that models must meet. The industry requires models to have specific measurements of their hips, waist, and bust or a proportionate shape and size. This is so they can fit into the current standards in fashion: to fit into sample-size clothes, to fit the image the photographers and stylists like to create, and so forth. If models don't have these specific measurements, they don't get work.

The people in the fashion industry are in the business of creating fantasy and beautiful images—that's what it is all about. Every generation and every culture has its standard for beauty. The women depicted by the painter Rubens were considered sexy and voluptuous ideals in his day, but plump by our standards. In the 1950s, Marilyn Monroe was considered a gorgeous pinup—complete with her full hips and bosom. What is sad to see is that the fantasy ideal of today is a woman with a low body weight, whether it is natural or not.

People in the industry, however, are not thinking about that by photographing thin models, they might be encouraging eating disorders. They expect that women should be able to look at a photograph of a model and understand that it is a well-scripted fantasy, an illusion, designed to influence the buying patterns of the public, or simply to be aesthetically beautiful. The images are created either as pleasing and inspiring works of art or as incentives for people to buy clothes or products.

Unfortunately, however, many young women are influenced by the industry's physical standards, and it does concern me. Because the general public—and impressionable teenagers in particular—are not able to look at a photograph and understand that it represents a fantasy image that each woman must translate into her own life in a way that works for her and reject ideals that are far-fetched.

PHOTO: ALESSANDRO DOTTI

KRISTIN KLOSTERMAN

The problem comes when young women try to change their natural body state in order to look exactly like the models they see in magazines, advertisements, and on television. That can be very damaging to them, and it's not a desirable or realistic goal. Deserving or not, the fashion industry has been blamed for some young women's body obsessions and eating disorders.

There's a lot going on here. Young women's eating disorders cannot be blamed wholly on the modeling and fashion industries. We know that problems like bulimia and anorexia stem from deep-seated emotional disturbances and other personal circumstances. Yes, models are thin and fashion does cater to smaller-size people, but no, eating disorders and low self-esteem cannot be attributed to these factors alone. After all, every person's beauty and complexity come not from what is on the outside, but from what is on the inside.

There also must be an across-the-board attitudinal change in the industry, adopted by television, movies, designers, magazines, advertisers, and everyone else. By creating a demand for models of all sizes, the agencies will be forced to supply them or go out of business.

Sometimes I'm surprised by the standards the industry sets. I have seen girls whom I'm interested in booking for a job and then been told by her agent, "Oh, she's going to lose ten pounds." It doesn't seem to me that the girl needs to lose any weight at all, but then again, the standards being what they are, she may need to lose weight to model. Models are thin now, and not everyone can look that way or fit that industry standard. Remember, if you try to change who you are to fit into the standards that exist today, you may turn around and find that the standards have changed.

I have two responses to this. The first is "Don't model." If a girl is at her healthy, normal weight but is still being told by her agent or by other people in the industry that she must lose weight to get work, the best answer is for her to reject the idea of going against her normal body shape. But it takes a girl with a strong self-image to accept that she does not have the right body type for modeling.

My second answer is "Do model"—as long as you do it at your healthy body weight. If you're not naturally slender, it may be much more difficult for you, and you must know this up front. But models who pursue modeling at the size that is right for them—and that is larger than the standard—can help set in motion changes in the industry, as many plus-size models are doing. For an example of this, read Kate Dillon's story later in this chapter.

I have been working hard to set a change in motion. I talk to models, agents, and parents to emphasize the importance of maintaining a healthy body, not striving to be too thin.

Life as a Plus-Size Model—
One Model's Story

▼

Liris Crosse, eighteen, tried to break into modeling through all the normal channels—and kept being told that she needed to lose weight. Every time a mainstream agent would see her, she heard the same thing. Modeling had been her dream since childhood, and she spent years trying to gain agency representation. So Liris got depressed—and gained more weight.

Liris said: "A friend gave me a pep talk—'You need to get out there and lose weight.' I went to the gym five to six days a week for two to three hours a day. My diet got messed up, but I lost some weight. I had some test shots taken, but I was told I needed to lose more weight. I went back to a second convention sponsored by Model Search America, and only got one callback, from a local Baltimore agency. I thought, 'Man, I lost weight and went back to the convention and I'm still too big.'

"First I thought I would try to get into a different type of modeling, but then I thought I'd wait to get the weight off. But then my father showed my pictures to a friend who was a model and who said I could work, and not to worry about my size. I decided to move to New York to look for work. I'm staying with family here in New York.

I find that the industry is a mirror of the times. The good news is that we are moving away from the mantra of "You can never be too thin" and more toward a healthy, holistic way of living. I hope that shift will be increasingly embraced by the fashion industry and reflected by its use of models who are physically, emotionally, and spiritually healthy.

As I've said, I've seen healthy, great-looking models who were told by their agencies to lose weight. One model who was only too happy to talk about it was Kristin Klosterman. There were times when I would want to hire her for a job, only to have her agent say that she needed to lose weight. To me, her healthy, athletic body is one of the attributes that make her stand out as a model.

Kristin, who is now nineteen, said her agency has been on her case about her weight since she was fourteen. "When I was younger, it used to bother me," she said. "I didn't understand why that was so important. For a teenager, I was not overweight, but to be a model I was told I was. I've thought about this a lot. The whole industry contributes to this—not one person can change it. It confuses people to see a beautiful girl on the cover of a magazine and go home and see regular bodies."

Kristin is able to tolerate the nagging about her weight because she has decided that modeling is what she wants to do. "As a model you must keep your weight down because of the job. It's easy to place blame on modeling but I realize I can quit if I want. If I didn't want to deal with exercise and staying fit, I would quit. It is a choice."

As in any business, there are certain professional responsibilities. If you're an athlete, you have to train your body. If you're a singer, you have to train your voice. If you're a model, you have to stay in shape and keep your body and mind healthy.

"Once I got here, I contacted the convention and called all the agencies to find work. They sent me to Wilhelmina's 10/20 division. It was weird—I had entered Wilhelmina's model search in eleventh grade and didn't get a callback. I even dropped off a photo at the agency last summer, with no answer.

"When I met the agent this time, we spoke about plus-size modeling, she showed me portfolios—it looked legit. Then she said, 'I'd like to offer you a contract.' I said, 'Okay.' That is all I have waited for all my life! I followed my dream, and there she was offering me a contract. My first go-see was for a fashion video—they said I was too small! I have some more appointments and will be testing. I'm happy with my size 9 self."

▲

Kate Dillon's Story

Kate Dillon's rise to success in modeling could come from a storybook: at sixteen, she was spotted by a photographer in a San Diego café and signed by agents from Elite, who then had her modeling for catalogs and magazines. Kate had never had any intention of modeling, and suddenly she found her career taking off.

But the dizzying ascent from normal high school girl to fabulously popular model took its toll, and Kate began to lose her grip. She developed an eating disorder and felt her life spinning out of control. One day, the storybook snapped shut: she quit.

Kate's story does have a happy ending—or perhaps the ending is still being written. She has returned to modeling as a plus-size model and has found that the demand for her size 14 body is almost as great as it was when she wore sizes 6 and 8.

Kate's first break into modeling came in 1991, when she was seventeen.

"I entered my agency—Elite's—Look of the Year contest, and I made it to the finals in New York," she recalled in an interview. "I won third place and a money modeling contract. I had been living in San Diego at home, going to school, and working part-time for about a year and a half, then after the contest I moved to New York and everything went nuts.

"I felt more excited about living in New York than I did about modeling. Then I moved to Paris for six months, and I felt life was pretty cool. I was by myself and lonely at times, but I knew I was having an incredible, unique experience. I was working editorial, ad campaigns, runway. I do remember I broke my arm and had to take two days off—that was the exception!"

Kate's credits from the high point of her career would make any model proud. As a teenager, she did print campaigns for L'Oréal hair-care products and Christian Dior clothing, as well as a television commercial for Diesel jeans. She modeled for all the top designers on Paris runways. She appeared in *Vogue, Harper's Bazaar, Allure, Mademoiselle, Seventeen* and French and Italian *Glamour.*

At nineteen, she moved back to New York City. "At this time, I was realizing that I did not want to do this for much longer," Kate said. "I knew I had a problem with eating, and I did not want to have this problem anymore. I did

not like myself. I felt I was getting too involved in the whole world of model-ing, and I didn't know myself anymore.

"About a year after that, it happened. I had been working again for about eight months, then one day, after taking four months off, I walked into my agency, Elite, and said, 'I'm done—goodbye.' "

Kate moved back home to San Diego for two years.

"Initially, I felt total ecstasy at my decision," she said. "The reality hadn't hit me yet. It was tough to go back into myself and figure out who I was again. I had to deal with the problems I had with my body, and the weight problems I had been having since I was twelve years old. So for those two years in San Diego, I did normal stuff. I worked in cafés, bookstores. I wrote for magazines. At times I did freak out—I cried, I laughed. Back at home, I began to feel comfortable with myself."

But eventually Kate started to feel like she was just drifting through life in San Diego. Ultimately she decided to move back to New York. When she returned, a model friend told her about the plus-size division of her agency and recommended she try it.

"My friend said, 'It's not what you'd think,' " Kate said. " 'There are girls who are voluptuous and beautiful, sizes 12 and 14.'

"I had always thought plus size was like size 18. I decided to give it a try. So I called one agency and got a brush-off, but I called Wilhelmina, and for me, they were great! As a plus-size model, the process is still the same—go-sees, testing, jobs—but the clients are different."

Kate's return to modeling placed her in a new magazine called *Mode* in April 1997 (*Mode* is a high-fashion magazine for plus sizes). She has done catalog work for Bloomingdale's, Macy's, and Rich's department stores and ad campaigns for Playtex, Liz Claiborne, and Lane Bryant. She also shot a na-tional television commercial for Playtex. At twenty-three, she works two or three times a week and is planning to go to college.

Kate's goal for her new career, she said, is "not to be bitter." "I needed to be able to move on and feel good about my past and my future," she said. "I know I had to go through what I did to be where I am now. I do still freak out and look at myself and say that two years ago, I would not have been able to do what I'm doing now, could not handle this. But now it seems easy, effort-less. It feels good to be making a difference. It's okay not to have to be

What Sets You Apart Is Who You Are

▼

Kate observes: "There are so many beautiful models, it's crazy. The one who gets the job on a go-see of one hundred girls is the one who sticks out, tells the funniest joke, had a great handshake, a great smile. On a trip job, it's the model who you'd want to hang out with who gets the job, not always the one who is more beautiful, in my experience. It's someone who had a spark—something in her soul.

"I know models who are tempted to want to play a role—act like a model, an actor, an artist. But the more you are just you, and understand who you are, the more you are able to project that. Modeling is about projection. If I didn't get a job, it's not because I wasn't pretty, it's just that I wasn't able to project.

"I've seen girls pick up the idea of what models are like from television and magazines and to try to emulate that. But fashion modeling is all about fantasy, not reality, so the biggest problem for some models—and for me at the time—was to believe that who they are in front of the camera is who they really are. I'm glad I recognized that and stopped to learn who I was. I've seen girls I have worked with on their first day of work who have become supermodels. I look and hear stories that are so unbelievable, how they've changed.

▲

skinny—you are still a beautiful person. It feels good not to have to worry about it.

"Thinking about my early career, I wasn't proud of it until about a year ago. When I put it in its place, I thought, 'Wow, what I've done is pretty neat and unique!' Then I think it's funny, at least. My take on it is that modeling—and everything else that went along with it—is what I did when I was eighteen. It clicked for me at that time. But at that time, I also felt like I was failing, because I couldn't keep my weight down.

"My advice is that if a girl has a problem with food, she shouldn't do modeling. It's too much work. It felt like I was fighting an uphill battle with one arm tied behind my back, it's snowing, and the wind is blowing."

To me, the importance of Kate's story is the incredible degree of strength it took for her to recognize her problem, place herself first, and walk away from her great career. She reassessed herself, took responsibility, took charge of her life, and did something about it. She was then able to come back to the business that had played such a large part in her alienation from herself. Not only did she return, but she is doing extremely well. More important, she is happy. She says it loud and clear: I'm proud of who I am.

Kate's liberation came not from leaving a lucrative modeling career, but from freeing herself of people's unrealistic expectations of what size she should be and what her body should look like. She had struggled long and hard to meet those expectations, pushing herself to the brink. Then the small voice inside her that she

had been muffling started speaking up, and she found the courage to say, "No more."

When Kate was a teenage model, I remember meeting her on a go-see at her agency, Elite in Los Angeles. I booked her on the spot for a job. She was so fresh and beautiful and had such a great spirit. After that I was so happy to see her career take off—I'd get European magazines and see her in them, looking beautiful. I always like to keep track of the careers of models I've worked with, and so I was pleased to see Kate was doing so well.

When I suddenly stopped seeing Kate in magazines, I didn't really think twice about it. I just chalked it up to the nature of the business. Some models quit to go to school, some get tired of modeling, some change careers or decide to pursue other interests. But then a stylist I used to work with told me she had worked with Kate—as a plus-size model. I was intrigued and called around and found her agent and confirmed that, yes, Kate is modeling again.

After I called her up and heard her story, I was touched. I began to realize that you may be working with models and think that they're happy and that everything is fine, but find that beneath their beautiful exterior there is a very troubled girl struggling with tremendously difficult problems.

Kate had the strength to value herself the size she is today and has been fortunate to have a successful career in the modeling industry at that size. I am very proud of Kate, not just that she has found a career that is prosperous and comfortable but also that she is happy with herself as a person. Kate is truly an inspiration.

STEP BY STEP

PREPARATIONS

"The journey of a thousand miles begins with one step."
—Lao-Tzu

T'S THE BIG QUESTION, the one I get asked most often: "Donna, I think I have what it takes. How do I break into the industry?"

The answer is that there is no one way, no set answer, but there are a number of sensible ways to go about it.

The first and most important point to know is that anyone who wants to have a career in modeling must be represented by a reputable modeling agent in a major market. These agents have access to the most lucrative, prestigious, and high-visibility modeling jobs.

The most effective way to start a modeling career is to send snapshots of yourself to reputable modeling agencies. This is the most straightforward and direct approach. Though a lot of models have quirky stories to tell about how they were spotted, the meat-and-potatoes way to break in is to go to an agency near where you live. A list of some of the major agencies appears in the appendix of this book, though the list is highly selective.

Of course, not everyone lives near a major market city. Some models start at local agencies in their hometowns and work their way up.

Another good way to begin—especially if you don't live near a major market city—is to check out conventions that bring the major market agents to your area. You could also enter contests sponsored by agencies and magazines, which usually only require a photo and an entry form.

Dos and Don'ts—a Checklist

▼

Do have a family member or friend take pictures of you. One good head shot and one full body shot that shows you wearing flattering clothes are enough, provided the pictures show how photogenic you are.

Do send the photos to every agency that you can realistically travel to, along with a brief biography (I'll explain what to include later in this chapter).

Do look into agency open calls, modeling conventions, and contests sponsored by major magazines and companies. Try every avenue that is reasonable for you.

Do your homework. Before you sign with an agency, meet with someone who claims to be an agent, or before you agree to work with a photographer, investigate credentials. You have to make sure that the person is reputable and can actually help you obtain modeling work.

Don't give any money up front to someone wanting to represent you.

Don't spend a lot of money to have professional pictures taken before you are signed by an agency. Even if you can afford the pictures, there's no reason to make the investment.

Don't attempt too fancy a "look" when presenting yourself to an agency—either in person or

If a model is accepted by a major agency right away, that's great, and she may well be on her way. If, however, she needs to start at the local level, that, too, is fine, as long as she can see a path in front of her that will lead to the bigger markets. The model must always keep in mind that her goal is representation by a reputable agency in a major market city, preferably New York.

How do you find out which agencies do business in your area and the kinds of models they are interested in? The easiest way, perhaps, is to check your local Yellow Pages—they're usually listed under "Model Agencies" or "Talent Agencies"—and call them to see when their open calls are held, if they have any age requirements, and what kinds of models they look for. Some agencies are only looking for a particular type, like male models, plus-size models, or models in a certain height range.

You can also go to your local library to do research on the modeling market. There are directories of modeling agencies and the types of models they work with, and you can use those to find agencies that seem like the right ones for you. If you haven't heard of an agency you find in the phone book, call the Better Business Bureau to make sure it isn't the subject of complaints.

Finding an agent to represent you may seem like an insurmountable task. But remember that agents are always on the lookout for new models—that potential star. They even have staff members called scouts whose sole job it is to find new models. Nobody can tell you that getting noticed by an agent is easy, but there are certainly ways you can improve your chances.

FINDING AN AGENCY

An agent with a trained eye can tell if a girl is cut out for the camera. The agent doesn't always have to see you in person but can usually judge from photographs that you send. The rule of thumb is to send at least one close-up shot of your face and one full-length shot of your entire body and face. You don't need to send more than two or three, and certainly shouldn't swamp an agency with a huge batch of pictures.

These initial pictures don't need to be taken by a professional. A family member can take pictures of you in your home or outside. The best photos I've seen are the ones that show a girl in her most familiar environment—and with her most "natural" look. That means no makeup and clean, neatly styled hair.

When choosing which photos to submit, remember that agents are looking for your *potential*—they want to look at your face as if it were a blank canvas. That way, they can envision how professionals could make you even more beautiful using makeup, lights, styling, and other tools. All too often I (and agents) get pictures of girls wearing tons of makeup and teased, overstyled hair. Wrong, wrong, wrong. Your idea of beauty and your best "look" may not mesh with professional standards or with current trends, so keep it simple.

The same rule goes for the clothes you wear in the photos. Nothing too elaborate, preferably something that shows your body. A leotard is perfect. Try to have the body shot be as much of a silhouette as possible: ideally, the photograph in pictures. Keep your clothing simple and relatively casual, makeup and hair natural.

Don't expect that it's going to be easy. Brace yourself for rejection and disappointment.

Don't give up too easily. Try to take as objective a view as possible. If your first efforts to attract an agency don't work, try again a few months later. After that, you may want to reassess your chances.

▲

will feature you standing in front of a white or light-colored wall, with no major distractions in view.

WRITE YOUR RÉSUMÉ

In addition to the pictures, you must send the agencies information about your physical characteristics. Make sure the information is legible!

The information you must supply includes the following:
- Your height
- Your weight
- Your measurements: chest, waist, and hips
- Your hair color
- Your eye color
- Your name, address, and telephone number, plus the best times to reach you
- Any modeling or acting experience you might have

Make sure the information is accurate to the best of your knowledge. If you lie about these things, you are sure to be found out.

To take your measurements, hold a cloth tape measure around the fullest part of your bust. You might ask your mother or a friend to help you take the reading. Write down the number: this is your chest measurement. Next measure the middle of your waist and then the fullest part of your hips. Again, tell the truth.

A sample submission might look like this:

<div align="center">

Jane Smith
100 Maple Street
Anytown, NY 10110
Telephone: (555) 555-1212

</div>

Height: 5'10" Weight: 130 lbs.

Measurements: Chest: 35"
Waist: 25"
Hips: 36"

Hair color: brown Eye color: blue

The best times to reach me are weekday afternoons between 3 and 5.

You don't really need to write a more formal letter to the agency. If you send your pictures and the above information, they'll know why you are contacting them.

Another caveat: since you are sending your home address and most likely your home telephone number to these agencies, it is *critical* that you check out the agencies in advance to make sure that they are legitimate outfits. For further advice on this front, see chapter 15, "Scams and Cautionary Tales."

You should send your photos to as many reputable agencies as you can, all over the country, or attend their open calls with your photos if you live close enough. The point is to have as many people in the business see your photos as you can. Start with the biggest and work your way down. First, concentrate on major markets like New York, Miami, Los Angeles, Chicago, Atlanta, San Francisco, Seattle, and Phoenix.

Know that each agency looks for the same basic characteristics and standards for its models. There are some differences in what each agency is looking for and the type of models it represents. That's why it's important to send your photos to as many reputable agencies as you can. While one agency may not see model potential in you, another agency may view you as a future star.

GO FOR NEW YORK

The most direct way to start your career is to send photos to reputable agencies in New York City, the modeling and fashion capital of the United States.

Of course, if that's not a plausible option for you, or if you are not accepted right away, you should go ahead and try the other routes I will outline

below. If you strike out with the New York agencies, you can try other major markets, and maybe try the New York ones again in six months, when you may be more mature or fashion trends may have shifted.

You don't need to be in New York to be a successful working model, but it is certainly the city where most models aspire to work, where careers are made and stars are launched. Few superstar models have ever made it big without spending ample time in New York.

For girls who have their eye on rising through the ranks of modeling, New York is the place to be, the place to come and to get connected to an agent. For further proof, refer back to the stories in chapter 3, "Business Life," particularly the sections about models who live in New York, move here, or work here on school breaks.

OTHER MAJOR MARKETS

After trying New York—or instead of it, when you are starting out—you may also want to try agencies in Miami, Los Angeles, Chicago, Atlanta, Seattle, San Francisco, and Phoenix. Check the appendix for some places to try.

It's a good idea to keep in mind that you want to be with an agency that is no more than a three-hour drive. Remember, you will be driving back and forth a lot in the beginning for testing and appointments.

Most agencies in these markets maintain ties to the big agencies in New York City and to markets abroad. These agencies with connections to other markets are very good launching pads for models who want to climb the modeling ladder. It is usually in the agency's best interest to promote its models to a New York agent to get her more prestigious work, even though the original agent may maintain "mother agency" rights (I'll talk more about the system in the next chapter).

These agencies are also very good at fostering a new model's career and grooming her until she is ready to try the big leagues. They will have test shots taken of her and compile a starting portfolio that will equip her for early jobs. After she has a small portfolio, the new model will then try a few jobs, working after school or during breaks, to see if she likes it and if she has the aptitude for it. If things work out and the model is a hot prospect, the agency will then contact other markets.

Even if a girl is referred to another agency, she must keep in mind that each market is different. A model who is in demand in Miami might not be in demand in New York. While the model and her agent may strive to place her in New York, she may be better suited for a different market, either because of her particular "look" or because of the type of models who happen to be in fashion at the time.

If a model is striking out in one location, the agent can opt for another U.S. market or Europe. Refer back to stories in chapter 3 about models who moved to different markets to advance their careers.

LOCAL AGENCIES

For some girls, it doesn't make sense to start off with the big agencies in large cities. Some girls want to start off slowly, or would prefer to begin modeling close to home, where they feel most comfortable. For them, applying to local agencies makes the most sense.

That said, there are some drawbacks to local agencies. While they are certainly one route to the larger agencies, they aren't the most direct route.

Depending on how small your town is, it may or may not have any modeling agencies. If you're from a really small town or rural area, it's better to approach agencies in a nearby city, although you don't want to go *too* far away.

The larger the city, the better. One thing to look out for is the fact that the farther you live from a major market city, the greater the possibility of getting ripped off, in both time and money. In a market with little demand for models, there is not enough work for an agency to stay in business from commissions alone, so the agency must affiliate itself with some kind of modeling school, which charges money to girls with the understanding that they will be represented by the agency when classes end. This representation may or may not happen.

Make sure you ask lots of questions and be sure you have the agent make a clear distinction between the modeling school and the agency.

Don't worry if you have to start out locally, though—you can still get "discovered." Agents from the major markets send scouts to local agencies across the country all the time.

From South Dakota to the Big Apple: One Model's Story

▼

Living in a small town does pose logistical problems, but they can be overcome if a model has talent and perseverance. January Jones, who has appeared in magazines like *YM, Mademoiselle,* and *Cosmopolitan* and on television in MTV's *House of Style,* is an example of a model who worked her way up from the local level to major agency representation.

January, who is nineteen, grew up in Sioux Falls, South Dakota, and began working four years ago through a local agency in her hometown. At first she nabbed a little catalog work here and there, then her mother took her to a larger agency, three hours away in Omaha, Nebraska, that was connected to a modeling school. She signed up for a course in runway training and drove there twice a week.

"My mom paid for the classes—I figured that what we paid for the classes was like what we would pay for my sister's basketball camp," January said. "For me the classes were a hobby, it was fun. At the end of the session, we had a graduation, a runway show where we were able to put the outfits together. The agency had scouts from agencies all over the country attend. A scout from Metropolitan Models in New York was

Rules of thumb:

- If you live in a large city or up to three hours' drive away, go directly to agencies in that city. Send photos or attend an open call.
- If you live in a small town, go to local agencies, and check out modeling conventions or national contests.

The bottom line is that you want representation from a reputable agent in a large city.

OPEN CALL

Most reputable agencies set aside a specific day and time, maybe once a week or twice a month, to meet with girls who come in without appointments to be reviewed for modeling. Each agency has its own policy—just call in advance to find out what it is.

Think of an open call as your first go-see. Be sure to show up only on the right day at the right time. Be neatly dressed, look clean, style your hair simply, and wear minimal makeup. Bring at least two snapshots of yourself. You do not need professional photos.

This is a job interview. You are presenting yourself to see if the agency is interested in representing you, so you must put your best self forward.

Usually, there is a waiting room full of girls who—like you—dream of becoming a model. Don't get spooked by the competition.

At an open call, you will have two or three

minutes in front of an agent to convince her that you have modeling potential. The agent knows exactly what she is looking for in a potential model and whether or not you have what she is seeking. Since agents are all looking for different things, it pays to go see as many of them as you can.

Also know that each girl has her own needs and personal style, so some agencies may be better suited to represent her than others. If you are not accepted at open call at one agency, try another. But know your limits, and try to be sensible about how many agencies you approach. After a certain number of agents don't accept you, it may be time to say, "Enough."

Agents say that open calls can be tedious. It's hard for them to have to tell so many girls that they have no chance of becoming a model. The person you're seeing may be overwhelmed and having a bad day, so try to be gracious about her hectic schedule.

Plenty of girls have started their modeling careers by boldly walking into a major agency, and this is why agencies continue to set aside times to meet with hopefuls. Think of Allison Ford, who lives in Los Angeles and went to open calls at age fifteen with her mother. "I chose a smaller agency called It," Allison said. "I got my first job after I was with them for a week. I stayed with that agency for two years, then switched to Elite."

Meilan Mizell was referred to an agency by a scout. "When I was fifteen, I just walked into an agency, Irene Marie, in Tampa, Florida," said Meilan, who is eighteen now. "I was at Dillard's with my friends and the agency was having

interested in me, and I ended up going with them after my mom did some research and felt good about them."

That happened during January's senior year of high school. After she graduated, she moved to New York and lived in the agency's model apartment.

▲

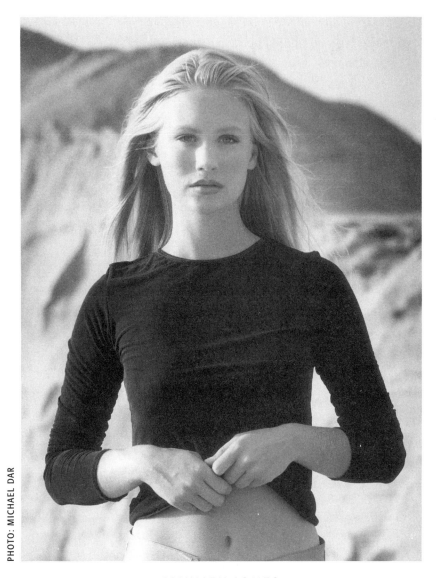

PHOTO: MICHAEL DAR

JANUARY JONES

a model search there and told me to come in. I had never thought about being a model. Even there, I was like 'Well, whatever.' But people used to tell me, 'Hey, you should be a model.' " Meilan was signed right away.

But for every success story, there are countless other stories of models who were rejected time after time at open calls—even some who are now

working models. Your chances of snagging an agent's eye through open call are best if you have a realistic assessment of your viability as a model—and if the agency is looking for someone like you.

CONVENTIONS

Modeling conventions are held all over the country and attended by reputable agents from major cities. These conventions are wonderful opportunities for any aspiring model, since she can be seen by up to twenty or more agents in a single day, but they can be especially valuable for girls from small towns who don't have easy access to major market cities.

In the appendix, I have listed the conventions that accept participants who have no experience and who lack an agent. Some conventions, however, will only admit models who are attending, or have attended, a modeling school, or who are already represented by a local agency.

The sponsor companies screen girls for the conventions in advance through an open call (there can be five to ten separate review sessions for each convention) and charge a fee to the potential models. The companies advertise in magazines and newspapers and on the radio. If you can't find an ad, you can also send your photos directly to the convention companies, which will direct you to opportunities in your area.

The alternative to attending a model convention is to travel to each major market city to try to meet agents in person. But this exercise is costly, time-consuming, and may be disappointing. It's also overwhelming—you have to figure out where to go, how to get there, whom to see, and what to bring. The conventions solve all those problems. They also give girls who never thought about modeling an easy chance to give it a try.

Even if you are not accepted by an agency, the conventions can still offer value. Each weekend includes a variety of seminars, workshops, and panel discussions with industry professionals, who help participants gain the information they need as they try to enter the business. Conventions can help girls boost their self-esteem: some girls say that even though they didn't get picked by an agency, it was thrilling to be able to walk on a runway for such a distinguished audience. And some girls say that undergoing the rigorous expe-

rience of being reviewed by dozens of agents was good training for the demands and realities of the modeling world.

Even if an agent is interested in representing the girl, she may still suggest that the girl wait a few months, then submit more pictures. In that time, she may get her braces off, grow a few inches, gain or lose some weight, or mature in some other way. Sometimes it is a long process.

I always think of it this way: if a girl has potential and attends a convention, she will be spotted. Conversely, if she has no potential, she will not be accepted by an agency, and she has learned the answer to her burning question—whether she has what it takes to be a model at that particular time. Maybe the agencies all have girls that look like her—she can always try again later. Or maybe she just does not have the potential to be a model.

Before you enter any modeling convention, you should get the facts. Some things to ask the sponsors or try to figure out are:

- How much does it cost?
- What agencies will send representatives to the convention? From what cities?
- How will I be learning about the industry?
- In the last few years, what models have you placed with what agencies, and how are their careers going?

GOING THE CONVENTION ROUTE: MODELS TALK

Shaundra Hyre, eighteen, got her start through a convention sponsored by the Palm Group. "I live in Indiana, about forty-five minutes outside Chicago, and when I was seventeen, I heard an ad on the radio for a modeling convention. I went with a friend of mine to a mall for their screening process and I was selected to attend."

Shaundra was astounded when she got callbacks from fourteen agencies, including one, which only one year earlier told her she needed to lose weight. "Before I went to the convention, I had no training," Shaundra said. "I hadn't had my picture taken. But my mom told me I was photogenic."

After the convention, she entered the Elite Model Look contest, and she was chosen as one of forty national finalists. She went to New York for some

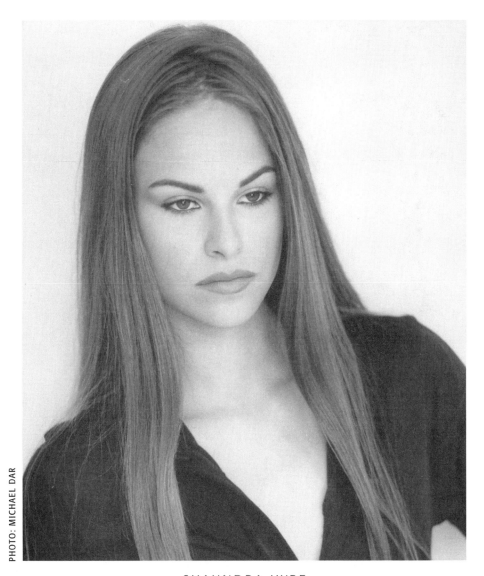

PHOTO: MICHAEL DAR

SHAUNDRA HYRE

testing, a job for *Seventeen,* and went home to model part-time and finish school. Now that she has graduated, she is working in Chicago, mostly for catalogs, and trying to save money to go back to New York.

As Shaundra looks back, she is glad she took the approach she did: "I learned a lot about the business at the convention."

PHOTO: MICHAEL DAR

MELISSA WHITE

Melissa White, of Omaha, Nebraska, had always wanted to model, but opportunities in her area were limited. Her first step was to attend an open call at an agency in Omaha, where she was thrilled to find that the director picked her—with one hitch. "They told me it was my lucky weekend and all this stuff, and then it turned out they wanted me to go to their school," Melissa recalled.

At first, Melissa was so eager to try it that she considered taking on a job after school to pay for the modeling lessons. Then she decided to take a less expensive route instead.

Melissa attended two conventions sponsored by major modeling companies—ProScout and Model Search America—and said that after the second one, she got fifteen callbacks.

After the conventions, Melissa, who is fourteen, traveled to New York with her mother to meet with top agencies.

Melissa signed up with Elite in the summer of 1996, right before she started ninth grade. She was planning to return to New York to begin the testing process in January 1997.

Melissa understood what so many modeling school students do not: that you are not a model until someone pays you to model. Paying to attend classes on modeling, or paying to have someone represent you, does not make you a model.

Lindsay Frimodt, fifteen, also dreamed of modeling but was having difficulty distinguishing between legitimate modeling programs and ones that offered no access to major agencies. One day she heard a radio ad for a convention run by ProScout, and she and her mother went to a screening event.

Lindsay was selected for a convention in Sacramento, where—this time—her dreams came true. "There *were* agents from major agencies there to meet us. We did pay a small fee, but we did get to be seen by the agents," she said.

Lindsay got seven callbacks. But she was still thirteen and only 5'6", so a few agents told her to keep sending pictures, because she was too young and too short. One, Mitchell Agency in San Francisco, asked her to come in and have test pictures taken.

CONTESTS

Yet another way to get started is to enter a reputable modeling contest. Contests run by major agencies, magazines, or apparel or cosmetics manufacturers usually cost little or no money and are easy to enter. The simple requirements are a straightforward application and some photos. A list of

Winning the Prize: A Contestant's Story

▼

Heather Lett was spotted in a mall by a photographer, who persuaded her to enter a model contest that Next, the agency, was sponsoring. Surprise—she won.

"It was a four-year money contract," she said. "I was guaranteed that by working I would make the money.

"When I won, I felt numb," Heather said. "It was a total surprise. Then I started to work. I was glad to make my break. My first job was for *Seventeen*—I couldn't sleep, I was so excited. When I got that job, I thought, 'Even if I quit today, I have had the biggest success of my life.'"

Heather has done runway jobs in Paris; she has appeared on the cover of *Self* and in editorial spreads in *Elle* and *Mademoiselle.* "I never thought it would be me—but here I am doing this," she said.

▲

some prominent annual contests appears in the appendix.

The prizes for winning an agency contest are contracts with major agencies. This is not necessarily the same thing as a guarantee of modeling work, but is usually pretty close. The prize money is not just handed out to the winner; she must work for it through the modeling jobs an agency will get for her.

Magazines offer a chance to get on their cover or in their editorial pages. For example, *Seventeen* has an annual contest. All you need to do is fill out an application, send it in with a few pictures, and you can have your shot at landing on the cover of the magazine. *Teen* and *YM* have similar contests.

Manufacturing companies offer contest winners the chance to appear in an advertisement and represent their product. Contest winners are noticed by everyone in the business, and the attention generally leads to more jobs.

MODELING SCHOOLS

It should be obvious from the stories the models have told that attending modeling school is not a prerequisite to becoming a model.

Even if you graduate from modeling school, getting "awards" and a certificate or diploma, there is no assurance that you will become a model or even get a single job. If you understand what the schools offer—a glimpse into the modeling world, plus some beauty tips and fashion advice—you can gain some important information from them. But modeling schools

HEATHER LETT

Exceptions to the Rule

▼

Keep in mind that it's only the exceptions–the girls who have achieved success in modeling–who appear in this book. For every story you read here about a girl who went to modeling school and became a model, there are far more stories of people who didn't.

But, Barbara Stoyanoff, a twenty-one-year-old from Houston, got into modeling through a modeling school affiliated with Page Parkes. At modeling school, "I did see lots and lots of girls who were not chosen to be represented," she said. "I was astonished I was chosen."

Barbara got her start as a preteen in beauty pageants. Her mother entered her to showcase her skill as a saxophone player and because she thought Barbara was cute. A judge at one pageant told Barbara to try modeling, in part because she was tall. At twelve, she enrolled in a modeling school.

"I didn't know anything about how to start, so I thought this was appropriate," said Barbara, who has appeared in tons of fashion magazines and in a Maybelline commercial. "The classes were helpful–we learned how to dress, and makeup tips. It was for four months. Then the agency affiliated with the school represented me."

are costly—fees vary depending on the length of instruction and where the school is located.

Actually, there are two kinds of modeling schools, and one kind is a better launching pad than the other. Some schools are affiliated with agencies and/or modeling conventions. These connections mean that their students have a good shot at meeting an agent from a major market who can launch her career. Schools that boast these ties are not a bad option for some girls.

On the other hand, some schools have no connection to agencies and offer nothing more than finishing school courses. I'll discuss this type more in chapter 15, "Scams and Cautionary Tales."

Included in this book are a few stories of girls who have gone to modeling school and then broken into modeling, and, of course, that does happen. But they are the huge exceptions. For every girl who goes to modeling school and becomes a model, there are hundreds, if not thousands, who pay money to the school and go through the same courses but never get a single modeling job or any interest from an agent.

For certain girls, attending a modeling school may be the only way to tap into a network that can give her access to the larger agencies. Some schools have access to conventions that are not open to the public. The IMTA (International Modeling and Talent Association), MAAI (Modeling Association of America International), and IMSI (International Modeling Search Invitational) are conventions attended by girls who are in modeling school, have graduated from one, or who already have an agent.

Modeling schools that feed talent to these

conventions also have a responsibility. They must make sure that the potential models are well prepared to meet with the agents. Thus, these specialized conventions serve as private seminars, learning experiences for girls who are fascinated by the world of modeling. Some girls who don't get discovered may fulfill a dream just by meeting, say, a top agent.

But the opportunity to meet good agents this way usually comes with a large price tag. You must pay the tuition of the modeling school as well as any convention fee. Girls who consider going this route must factor in the time and cost involved and determine if it works for them.

In addition to supplying girls for modeling conventions, these schools may also hold their own "agent reviews," in which they invite reputable major market agents directly to the school to see students.

Modeling schools are a close call. On one hand, they can foster a model's career by helping her develop grace, style, and self-confidence and by giving her experience and ease in front of the camera. They can instill healthful diet and exercise habits and proper beauty regimens. They can even introduce girls to agents from major markets.

On the other hand, these schools may set up girls who have no chance at modeling for a lot of disappointment. If you don't have the right size or look for the industry, no school and no amount of money will make you a model.

There are some girls who need the early grooming that modeling school provides, but certainly not all. I tend to believe that a model is born, not made, and that anybody who really

Later, at age fifteen, Barbara broke into the national modeling scene by being selected as one of eight national finalists in *Seventeen*'s Cover Model contest and appearing in the magazine in 1990. She recalled being flown to New York and being shown off at a press breakfast. "That was the best," she said. "We were introduced, there was a bio on each girl, her personal intentions, her school. It was great. We were more than just contestants.

"If I had to do it again, I'd do it the same way—model school and starting slow," she reflected. "At that age, you are not developed physically or mentally."

▲

has what it takes to become a model and has access to a reputable agency does not need to go to modeling school.

MODELS ON MODELING SCHOOL

"I was in a modeling school for a little bit, but it wasn't really good," said Janelle Fishman, sixteen, who has appeared in *Self, Jeune & Jolie, Amica, Seventeen,* and *YM,* in runway shows for Giorgio Armani and other top designers, and in ad campaigns for Kookai, Vivienne Westwood, and Delia's catalog. "It's more for someone who wants to learn poise or how to walk on the runway." Janelle attended for two weeks before she entered—and won—a Miss New Jersey competition.

When Kristin Klosterman came home from her first agency visit and announced that the agents were interested, her mom was skeptical. Her sister had tried to break into modeling, but she had gone through what Kristin described as "one of those rip-off schools."

Kristin said: "My mom was asking, 'How much money do they want?' So I took her to the agency, she met the people, and we paid no money."

Kristin's point is one that many models have made—that anyone who is truly cut out for modeling will find she can enter the field with minimal costs.

Megan Hoover, who is sixteen, was twelve when someone at a shopping mall approached her about attending a modeling school. "I was 5'5" and a tomboy, and I was like, 'No!' " Megan recalled.

Her mother and father were proud that someone had asked her to try modeling, so she went to the school's contest. "The other kids wore dresses, had on makeup and fancy hats—but I won!" Megan took classes for about six weeks, on Saturdays. She wasn't too enthusiastic about them. "It was about makeup, but not really about modeling." Megan said she viewed it as an after-school activity, something that was fun and interesting, but "I didn't see it as a way to become a model."

Nevertheless, she was identified by the director of the school as one of the students with potential. "When I was thirteen, the director took me and some other girls to the MAAI (Modeling Association of America International) convention in New York," Megan said. "This first time, I got fifteen callbacks— fifteen agencies were interested in me. I thought it was crazy. I didn't really

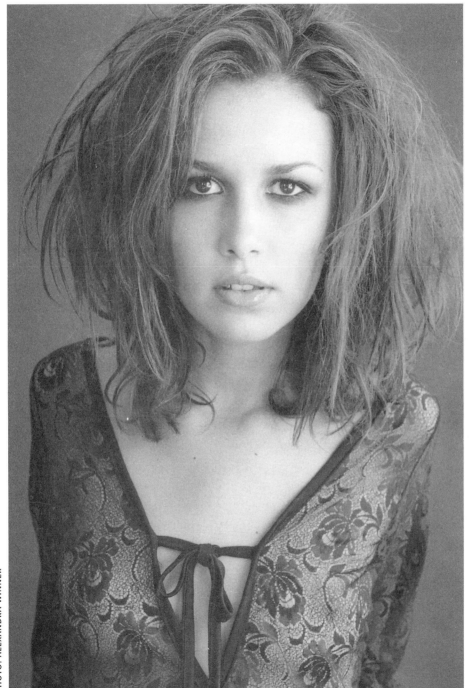

BIANCA ENGLEHART

care. I wanted to see New York, but modeling was not my main concern." She was 5'6", and the agencies told her to come back when she was taller.

A year later, at 5'10½", Megan returned to New York for spring break and went to the same convention. "Now I was interested and thought I could do it," she said. "This time I narrowed my choices to three agencies, then went with Next." When summer came and school was out, she went back to New York, did test shots to start her book, and went on go-sees. Her first job was for *YM* magazine. Since then, she has appeared in Spanish *Vogue, Vogue Sposa,* and *Harper's Bazaar.* She has done catalog work for Macy's and runway shows for Romeo Gigli and Lolita Lempika, and is now represented by Elite.

MODEL CAMP

One agency runs what it calls a camp program to plunge aspiring models into the business and teach them what they should know to start out.

Bianca Englehart, seventeen, got her start through Page Parkes in Houston. She saw an ad for the camp in the back pages of a fashion magazine, submitted a school photograph as an application, paid a fee, and gained admittance.

Camp lasted four days, and Bianca said she learned a lot. "I decided to do it because I wanted to be a model, but I wanted to feel comfortable in front of the camera, so if I did get to be a model, I wouldn't feel like a fool."

All campers got makeovers and new hairstyles. They were shown how to move for the camera. They were also told something that a lot of the models in this book have emphasized—that it takes patience to get into modeling.

"It was funny," Bianca said of camp. "We took Polaroids of us moving. We danced, jumped to get loose. Then we learned the technical stuff, about vouchers, castings. I thought it was all crazy at first. I learned it takes a lot to get something done. It's not just about taking pictures."

Bianca began getting jobs soon after camp ended, but not all the campers decided to pursue modeling. "I did see girls at the camp who didn't come back to get portfolios, but one other girl did well," she said. "I went home and one week later, I got a job. It felt great."

When it came time for real modeling work, Bianca's experience at model camp paid off. The client praised her for moving so well in front of the camera.

MODELING SCHOOL CHECKLIST

Some important questions to ask before enrolling in modeling school are:

- How much will it cost?
- What courses will be taught and by whom? What are the instructors' credentials?
- What local agencies does the school work with, and what major market agencies?
- How often does a representative from an agency visit the school?
- What percentage of graduates have gone on to work as models? What percentage have made it a career? Who are they, and how successful are they?
- May I talk to current students and recent graduates about their experiences?

HOW MUCH TO SPEND?

One thing I can't emphasize enough is that you don't need to spend a lot of money to get started, to get that agency to notice you. As you try to break into the business, you must constantly ask yourself whether the time and money and effort you are spending are worth the goal, and whether the goal seems realistic in light of those expenditures.

There *can* be some costs associated with pursuing a modeling career—after all, you are basically going into business for yourself, and, as such, there will be "start-up" costs. These can include getting a good haircut, having a few

A Model Does Her Research

▼

After years of fantasizing about what it would be like to be a model, Liris Crosse, eighteen, was signed by Wilhelmina.

"When I was young, about six years old, I would take pictures of me posing—I still have them," she said. "It has always been a dream of mine to be a model."

In high school, people even suggested the career to Liris: "Everyone would say, 'You're pretty, you're tall, you should model.'"

"I looked in the Yellow Pages in Baltimore, where I live, for modeling agencies," she said. "I called a friend of the family who was a model and makeup artist, and her friend, a photographer, took pictures of me. When I saw them, I was happy. I said, 'That's me.'"

Then Liris looked for advertisements for modeling conventions. "I read the newspaper and magazines, anything about modeling, to learn," she said. "In eleventh grade, I went to a convention, Model Search America. My mom checked it out, found out it was legit, so I wanted to take a chance." Read Liris's story in chapter 9.

▲

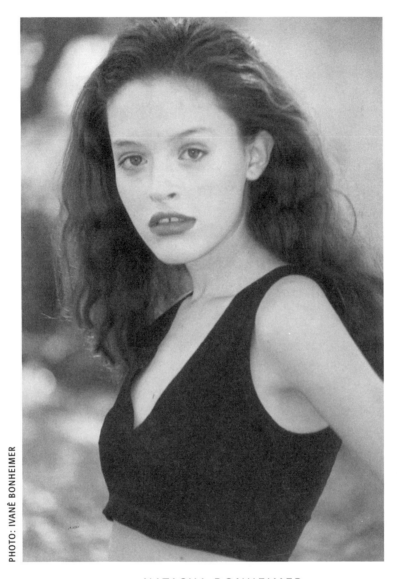

PHOTO: IVANÉ BONHEIMER

NATASHA BONHEIMER

initial photos taken, some new clothes, or transportation to agencies. For instance, Jessica Blier, who is only twelve, says she owes her parents money for the facials, test shots, and travel costs associated with launching her modeling career.

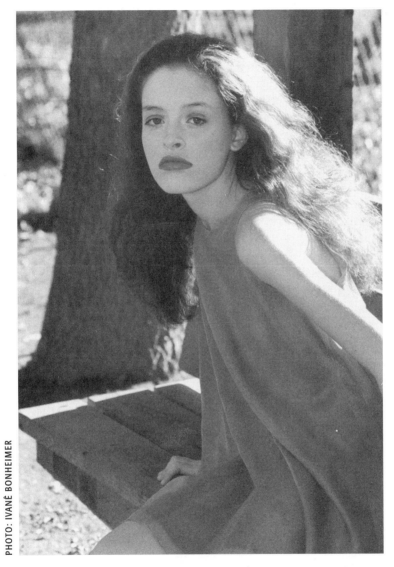

NATASHA BONHEIMER

At the opposite extreme is Charlene Fournier, who laughs when she boasts, "I didn't spend a red cent to start modeling." She did, however, borrow some money from her agent, which she had to repay once she started working.

The System *Does* Work: One Model's Story

▼

Natasha Bonheimer, fourteen, had grown up watching fashion shows on television and thinking that modeling was the greatest. At 5'8", the Sacramento, California, teenager wanted to give it a try.

"I had my mom take photos of me in a park," Natasha said. "I used my own clothes and we shot about seven rolls of film. I sent a few photos to seven major agencies in New York, along with some statistics like my height, weight, age, and phone number. I sent it to their New Faces divisions."

"I remember sending the photos on a Friday, then by Monday or Tuesday, I got calls from all seven agencies! It was overwhelming. They all wanted me to come to New York to meet them.

Natasha had never been to New York before and was reluctant to make the trip, so each agency sent a scout to Sacramento to meet her and her family. "This really helped us decide," she said. "We asked so many questions."

Among the questions Natasha and her parents asked were: How many girls at the agency are Natasha's age? Where are they now—are they working? What does the agency have in mind for Natasha? What kind of work do they think she could do? How much time would it take up? How

BE PATIENT!

Breaking into the modeling industry can be a long process. There are some girls whose careers start almost instantly when someone spots them and hires them with maybe one Polaroid (photograph). But for most girls, it's a process that takes time, attention, hard work, and sacrifice. At the end of all that, there may be disappointment as well.

I remember a girl who came up to me once and said she'd done all the right things—sent her pictures out to agencies, called to follow up, and attended open calls. When the first round of inquiries didn't bear fruit, she tried again in six months, to see if perhaps the climate had changed and there was more of a market for her "look." Again, she was disappointed. She asked me if I thought she should try again, or should try a different approach. My opinion was that if she had given it her best shot with no results, that she wasn't cut out to be a model. I hate to discourage people from pursuing their dreams, but everyone must be realistic. If you're not getting any positive feedback after numerous attempts, turn your attention to something else and feel good that you tried your hardest.

It's a good idea to check out all the possible ways of getting started (without spending tons of money), but it's also sensible to cut your losses after a certain point, before the rejection becomes overwhelming.

All this may sound discouraging, and the reality is that many girls get frustrated by the huge barriers in front of them and the enormous rejection. It's extremely unlikely that an agent

is going to get your pictures and call you to say, "You will be a star tomorrow."

After you've sent your photos to an agency, don't expect an answer right away—or even at all. Some agencies do not take the time to respond, though a few do have form rejection letters. The New York agencies receive an average of thirty letters a day from girls who want to model. If they're interested in you, you will hear from them.

If an agent does see any potential in your photos, she may contact you and ask for more photos. Better yet, she may ask that you come see her the next time you are in New York (or wherever she is). Even better, she may ask you to come to New York to see her *now*.

Should you jump on a plane and go? Not necessarily. If an agent is interested in you now, she will still be interested in you during a school break or summer vacation. If more than one agent asks you to come in, it is probably wise to do so, but again, you should make sure to arrange your trip at a time when it won't disrupt school. You should always come with a parent or family member.

When you do come, try to make the most of your trip. Ahead of time, you should call the agencies you haven't heard from and tell them you're going to be in town and find out when they hold open call.

Even when a model does find an agent to represent her, getting a career started can still be a lengthy process. Some models say it took up to a year before that first job came in and that they had to take things day by day.

Those who do succeed are the ones who stay focused. They are persistent but maintain a healthy attitude and believe in themselves.

would it mesh with her school schedule?

"We basically knew nothing about the industry," Natasha said. "After we met with them all, we decided to go with the one who gave us the warmest feeling—a family feeling. But they were all so nice. Everybody was great. It was a hard decision, and I could have worked with any of the agencies. I had to dig deeper, to decide which could help my career the most and go the extra mile for me." The Bonheimers ended up choosing Elite in New York, which then sent Natasha to New York for a week of testing and go-sees.

▲

234 ▲ STEP BY STEP

SUMMARY

Here's a chart showing the different paths girls can take toward major agency representation. As you can see, some paths are more direct than others:

Girl ——> Major Agency

Girl ——> Local Agency ——> Major Agency

Girl ——> Local Agency ——> Convention ——> Major Agency

Girl ——> Model School ——> Convention ——> Major Agency

Girl ——> Contest ——> Major Agency

Girl ——> Convention ——> Major Agency

There are many different combinations, and you have to take into account your circumstances to decide what makes the most sense for you.

There are also less direct routes—or slower paths—to take:

Girl ——> Local Agency ——> Convention ——> Local Agency ——> Major Agency

Girl ——> Model School ——> Local Agency ——> Convention ——> Major Agency

Girl ——> Contest ——> Local Agency ——> Major Agency

Girl ——> Local Agency ——> Major Agency (tells her to wait a year) ——> Local Agency ——> Major Agency

In this book are examples of girls who have successfully taken each of these paths and have become working models. Some girls decide to stop right in the middle of a path, and some girls we didn't talk to stop even sooner, finding that it's enough for them just to enter a contest or attend modeling school.

What you want to avoid is:

Girl ——> Model School ——> Nowhere

(Unless, of course, your goal was just to go to a modeling school and get a diploma. But if that's all you're looking for, you're probably not reading this book!)

Whatever route you choose, keep in mind that the ultimate goal is to find a reputable, respectable, knowledgeable agency to represent you. If a good

agent sees a girl who she believes is truly ripe for modeling, she will do everything in her power to advance the girl's career and help make her a star.

The agent is not concerned with how she found her new model—whether it's a convention, contest, modeling school, or a city bus—just with the girl's potential, whether or not she can become a rising star. That may mean delaying a meeting or photo shoot until she has a break from school. It may mean waiting until her braces come off or until she grows a few inches. It may mean the agent must advance money for her expenses (which the model must pay back) if her family cannot or will not support her budding career. I have found that when an agent really believes in a girl, she will go to extraordinary lengths to see that the girl is successful—after all, the model's success enriches the agency.

Roundup: What's your advice to girls who want to become models?

▲ Danielle Bassett, sixteen

If you want to start out, go for it. You basically have to go in saying, "I'm me, and this is what I look like, and this is how I am, and if they don't like me, it's not something personal about me." Don't go in saying, "I'm going to get hired right away."

▲ Jessica Biel, fourteen

If you really want to do it, go for it, but remember about the rejection. You get rejected every day, but you can't take it personally. You can't beat yourself up about it and keep asking, "Why?" I say, "Okay, they missed out." You've got to do that to be successful.

▲ Jennifer Davis, nineteen

Stay close to your family. Be in tune with reality constantly, because the truth is that it's a very short-lived career. While you may be "in" today, you might be "out" tomorrow. Always think of tomorrow. Don't just quit school. Don't just give up your old friends, because friends that you might make in modeling you aren't going to stay friends with—you may only see them once or twice a year.

▲ **Charlotte Dodds, nineteen**

Keep an open mind, and don't jump in too soon. Know it's a business, and don't go thinking you will become a supermodel.

▲ **Charlene Fournier, twenty-one**

Friendliness, open-mindedness are the most important qualities to have. Be willing to learn, don't feel judged. People say the wrong things—some people might say, "Oh, you have terrible skin, what are you eating?" If you take things to heart, you're just going to hurt yourself, and the other person isn't even going to care. Personal confidence—that comes with time.

▲ **Tomiko Fraser, twenty-two**

Make sure it's something that you really want to do, because it's fun but it's definitely a job. There are some models who are not 5'9", but they are definitely a small percentage, so before you invest all this money in pictures or clothing or makeup, if you're 5'5", you might want to think twice. Don't spend a lot of money.

▲ **Megan Hoover, sixteen**

Don't get discouraged. Don't say, "No one likes me." Don't compare yourself to others. Be an individual.

▲ **Shaundra Hyre, eighteen**

Wait until you are out of school. It's so hard—you're not mentally ready before then.

▲ **January Jones, nineteen**

My advice to girls starting out is to finish school, so you can handle this. And if modeling doesn't work out, you have something to fall back on. Also—just relax.

▲ **Nina Kaseburg, sixteen**

You better have wonderful confidence and an incredible intelligence. People aren't going to hire stupid people, because people don't want to be around stupid people.

▲ **Jenny Knight, fifteen**

Be yourself, have a good attitude, and don't get jealous of the other models!

▲ **Andrea Pate, fourteen**

Make sure you stay on top of things and make sure you have a really good agent. Aside from looks, you need a great personality, because when you go on castings and go-sees, they're going to remember you. They don't remember the people who just sit there and don't say anything.

▲ **Melissa Tominac, sixteen**

Don't compromise yourself or your values or your goals. Be sure to keep a really broad perspective on everything. It can be easy to get caught up in the "Oh, I'm going to be a superstar" type of mind-set.

▲ **Nikki Vilella, twenty**

You have to have the personality to succeed in this business. Not everybody has the opportunity to try to be a model, since it's mostly based on what you look like, so if you do have the opportunity, make the most of it.

THE AGENCY

HE AGENCY IS the single most important ingredient in a successful model's career. Her relationship with her agent is critical, and can spell the difference between a career that soars and one that never gets off the ground. Though a model may work with dozens of photographers and stylists, her relationship with her agent is the primary one.

The model's own talent can take her far—but only so far. Beyond that, it is the hard work and skill of the agency that can elevate her from ordinary model to superstar. Naturally, the agency cannot do this on its own—the girl must have tremendous abilities to begin with—but it can use its marketing savvy to add luster to a girl's career.

It is extremely important for the model to be comfortable with her agent, to trust her, and to believe that the agent is doing all she can to give the right advice and promote her career. The dynamic between a model and her agency is complex and ever-changing. I liken it to a well-choreographed dance in which each dancer plays her part to make the performance perfect.

THE STRUCTURE OF AN AGENCY

The New Faces division is often not labeled as such, but it is the part of the agency responsible for developing a new model, one with little experience.

This division guides the model through the testing process: getting photographs taken, maybe getting her hair cut, and preparing her to meet clients and photographers. It is the agency's job to get a model ready for these career-sensitive meetings, and even though a girl may be a new face, she may be landing modeling jobs already.

The New Faces division is also in charge of sending out scouts. They are the ones who approach potential models at airports, modeling conventions, shopping malls, and the like.

The Working Board division may also go by a different formal name, but it uniformly consists of the agents who represent actively working models. By this point, the clients—meaning the companies who hire models—are likely to be familiar with the model and her work. When that happens, the agent is ready to direct a model's career and negotiate for higher fees.

WHAT AGENCIES WILL DO

The agency is a model's link to jobs. The way the industry is set up, agents are in charge of finding out about all job possibilities and sending their models to clients to try to get those jobs. As any working model knows, there are numerous misconceptions about models, how they get jobs, how they get paid, and other aspects of how the industry works. For any question a model might have, her agent will know the answer.

AN AGENCY WILL GET MODELS SETTLED

When a model is in a new city, the agent will help find a place for her to live. But even if she is staying in a model apartment, she must still pay rent and utilities and buy her own food. She must pay her own cab or subway fares and keep her wardrobe up-to-date so she can present herself properly in any situation.

Sometimes, if she needs financial help at the beginning, her agent may offer to pay these expenses as an advance, to be deducted from her future earnings. An agent who does that must be extremely confident that the model will get work, and that it is in the agency's best interest to do anything it can

to promote her. While the model is obligated to repay the agency after she starts earning money, some agents will work out an installment plan, so the model can repay her debt over time.

If the model never gets any work, she is still obliged to repay the agency. Always remember that nothing is free and that this is a business. An agent who makes an investment in a new model wants to make sure the investment is worthwhile.

AN AGENCY WILL SET UP TESTS, GO-SEES, AND JOBS

In general, when a new model is in the testing process, the agency will find reputable photographers to take pictures of her for a minimal fee—usually just enough to cover the costs of film and processing, hair and makeup. The photographers themselves are testing, so it works like a barter system.

An agent is also responsible for making all of a model's appointments—with clients, photographers, and everyone else—and with relaying information about the appointments to the model. An agent keeps a chart for each model, with all her personal statistics and daily records of her appointments and jobs.

It is not a model's responsibility to call a magazine and ask for work. Nor does a magazine, or any other client, hire a model directly by calling her at home. A model does not call the company that sponsors a television commercial and say she wants to be in the next commercial, nor does she call a designer and ask when he or she is hiring models for the next collection. A model does not work for a photographer or a magazine or an advertising agency. A model basically works for herself, and it is through her agent that she has access to jobs. Her agent makes the contacts, calls the clients, and tells them why the model would be perfect for the job.

After a while, the model establishes a rapport with the clients she works with regularly. Sometimes she finds that it is her working relationship with the client as well as the agent's relationship with the client that lands a job.

Any reputable agent can set up go-sees and tests and can confirm modeling jobs. But it is an aggressive, knowledgeable agent—someone with vision—who can direct a model's career and steer her toward supermodel status. The agent does this by monitoring the model, the market, trends, and

photographers. The agent must have his or her finger on the pulse of the industry. He or she must know which jobs a model should accept and which she should turn down. The agent must also be willing to take risks and to sense which jobs will lead to even more lucrative and prestigious ones.

AN AGENCY WILL PAY MODELS AND MAKE MONEY

Along the same lines, the model is not paid directly by the photographer, magazine, advertising agency, designer, or other client. All payments go through the agency. The agency takes a commission and then pays the model the rest, sometimes taking out money for expenses or other costs.

The standard arrangement is that the agency receives a percentage cut of the total payment for a modeling job—a percentage from the model herself and the same from the publication or company that has hired her. The publication or company pays the agency, then the agency pays the model.

The way this is done is called the voucher system. After a model completes an assignment, she and the company that has hired her both sign a voucher stating what the job was, how many hours she worked, and her fee. She then gives the voucher to the agency.

The bottom line is that agencies must make money to stay in business. They may have all of the most sought-after models, but if they cannot keep their models working, visible, and happy, the models will leave, taking with them the agencies' profits and their big-name moneymakers. An agency only makes money when its models do.

Remember, this is a business, a highly competitive business in which a young girl can make an awful lot of money. Agencies are extremely competitive with one another, and they are all vying to discover and sign up the next "star" who can make their agency the hot one. Knowing this enables a model to chart her career accordingly.

On the subject of money, anyone interested in a modeling career must understand that you do not make money right away. The minute you are accepted by an agency, you don't make a cent—nor do you necessarily get work right away. The process is long, and it takes hard work, dedication, and perseverance.

Another money tip: when you do start making money as a model, make

sure to get solid financial advice, preferably from a professional. Most models report that they never expected to make so much so soon. Learn how to handle your hard-earned money, and save, save, save. Refer back to the interviews with Beverly Peele and Niki Taylor on the importance of watching your money.

WHAT AGENCIES WILL *NOT* DO

Any reputable model agency will *not* charge a model to represent her. Beware of any agency that tries to charge an up-front fee to get you jobs.

An agency will not continue to represent a model who it feels is not working out. If the agency is dissatisfied with a model—if she continuously shows up late for bookings, say, or behaves in an unprofessional way—the agency will drop the model and end the contract.

MODELS' RIGHTS

The agent takes care of all the business aspects of a model's career so that she is free to take care of herself. The model's job is to be on time for jobs and appointments, do her best for each client, develop her "look," build her confidence, and stay focused and happy.

If the model is dissatisfied with the representation she is receiving, she may want to end the contract and sign up elsewhere.

It is up to the model to decide. But she must be professional and talk to her agent about any differences. Given the nature of the business that is based on relationships, a model doesn't want to burn any of her bridges or leave her agent with hard feelings.

A model must understand that her role within the agency is an active one. She should feel free to exercise her will and listen to her best instincts. She must take the time to understand her place in the agency and the industry and to gauge the personality of her agent. She must participate in selecting jobs and must be a partner to her agent in making decisions about her career. This is important. Anyone who lets an agent dominate her choices and decisions is likely to get swallowed up by that person's own mind-set.

At the same time, a model who refuses to listen to her agent's advice may get left out in the cold.

A model is not an employee of any agency, or any magazine or advertiser she may work for. As an independent contractor, she must sign contracts with her agencies and must prepare quarterly income tax returns with the help of an accountant.

Being one's own boss and keeping track of financial matters are very grown-up responsibilities for a young girl who is starting out. It's hard for her to make decisions that are going to be in her best interest, and there's a lot of pressure from agents and other people to do things their way. That's why it is extremely important for all young models to have help from their families—and even financial advisers—throughout the decision-making process. A new model must always ask questions and know that she has the power to voice opinions and objections to whatever is being presented. A reputable agency will work with a model and her family and answer any questions, but ultimately the decisions belong to the model herself.

It's a good idea for models to try to learn as much as they can about the business side of their work. They should understand how the voucher system works, what they are being paid and why, and so forth. The more a model understands what is going on with her career, the less beholden she is to anyone else, the less dependent she is on her agent. No one, not even her agent, has her best interest at heart as much as the model herself.

FIND THE BEST AGENCY FOR YOU

Choosing an agency can be a dizzying task for a girl who is starting out, especially when she is being pursued by multiple agents who make grand promises. Ultimately the decision must come down to whom she feels most comfortable with.

Models report that if more than one agency is interested in representing her, each agency will try to outdo the other to capture the contract. Agencies often take prospective models out for fancy dinners and invite famous models or celebrities along.

When Heather Dunn was getting started in modeling, she, like many hot newcomers, was being wooed by several agencies. One agency, which is now

defunct, invited Heather and her mother to a trendy restaurant in New York City.

"At dinner, they told me you can make a lot of money and that they were really interested in me," Heather said. "When they found out that another agency was interested in me, too, they started saying all this bad stuff about the other agency. I wasn't too excited that this agency would cut down another one, so I didn't choose them, even though they took me out to dinner with famous people. In the end, I chose Elite as my New York agent."

HOW MANY AGENTS DO YOU NEED?

When you sign with an agency, they will require that you work exclusively with them in that particular city. They may have you sign a contract for a specified amount of time, or, better yet, for a specified amount of money. If you are fortunate enough to be offered a contract that names a dollar amount, keep in mind that you are not given the money up front—you must earn that money through the jobs your agent will be working hard to get you. But know that not all contracts are for a dollar amount.

At the same time that an agent may sign an exclusive contract with you, they will also submit you to other agents in cities around the country—perhaps around the world—to get you as much exposure and work as they can. The contract gives the agency the right to use the model's name and photograph and the power to sign contracts and releases on her behalf.

Your "look" may be perfect for other markets, not just the market where you got started. And that's why some models have as many as ten agencies working for them, but only one in each individual city.

When models sign with multiple agencies, one agency, usually the one that discovers or signs the model first, is designated as the "mother agency." It is then that agency's responsibility to keep track of the model's schedule and bookings no matter what city she is working in. The mother agency must have a close working relationship with the other agencies the model may be with. To avoid scheduling conflicts, all agencies that represent the model must report to, or get clearance from, the mother agency before booking jobs.

For example, although Delana Motter is based in Phoenix, she has agencies working for her in New York, Los Angeles, Dallas, Seattle, Chicago, Miami, and

even Brazil. All those connections—all those agencies trying to find jobs for her—were generated originally by her mother agency back home.

Nikki Vilella has agencies at home and in New York, Miami, and Los Angeles. Though Nikki attends college in Chicago, all her agents are at work trying to get her modeling jobs through direct bookings. "I'd say I do 50 percent of my jobs in Chicago and 50 percent in either Los Angeles, New York, or Miami," Nikki said. This system is working fine for her.

Another example is Lindsay Frimodt, who is based in San Francisco and has been modeling for two years. She has agents in Korea, London, and Australia and has spent about two months in each market and has worked for clients, including magazines *Dolly, Girlfriend, Brigitta,* catalogs for Macy's, Nordstrom's, and Japanese catalogs.

Melanie Hansen, whose first agency was a local one in Spokane, Washington, has been traveling around the world for jobs found by her agents in New York, Chicago, Milan, Athens, Paris, Germany, and Australia. Her agency at home tracks all these jobs and monitors her progress in each market.

Although Charlotte Dodds now calls New York her home, her mother agency is in her hometown in Tennessee. That agency is in constant contact with the other ones that represent Charlotte—including London, Paris, Milan, Spain, and Australia—and all of them work together to coordinate her modeling schedule.

Some major agencies, like Ford and Elite, have branches worldwide and may encourage their girls to stay within their network, but those that don't must rely on their global network of connections.

IN AGENT WE TRUST

Because of the trust factor—and the fact that the agent is handling all the most important aspects of a model's career, the money and the jobs—it is critical to sign with an agent who knows what she's doing, works hard, and seems honorable. A model must feel confident that her agent is doing all he or she can for her career and has the resources to do so.

Some girls are so close to their agents that they describe them as surrogate mothers.

"They're great—they're like my home away from home," said Brittny

Starford, eighteen, who lives in Dallas and works with Page Parkes. "My booker, we're like mom and daughter. They're so nice. When you go on a trip or something, they call you to make sure everything's okay. When I went to Europe over the summer, they called and faxed all the time and made sure I had everything I needed."

Janelle Fishman also describes a close relationship with her agents at Ford in New York. "I'm really close with them. I love my booker. She's the best. She tries to help me not just as a booker but as a friend. She knows my family, and if I'm having a problem at my job or at home, she tries to help me."

Danielle Lester also describes her agency as "like family to me." Danielle says her priority is finishing high school—she views modeling as a part-time job and secondary commitment—and she said her agency is highly respectful of that. "They're very understanding, encouraging," she said. "They're concerned about my education, and they know how important it is to me. I appreciate that."

Nicola Vassell also compared her agents to family members—but said they put her through the paces. When she first signed with an agency, she recalled, "It was like training. I was little by little learning about the industry and clients."

Other girls take a more detached view of the agency relationship. "I was on a good, working, professional basis with my agent," said Jennifer Davis.

A lot of the agency relationship depends on a girl's personality, how close she wants to get, and what her needs are. For Meilan Mizell, a "strictly business" attitude doesn't work. She has spent most of her three years as a model with Irene Marie, first in Miami and now in New York.

"I'm a very loyal person, that's who I am, and I can't get into the business thing," Meilan said. "I'm not a good businessperson. All the people in my agency are there for me. They say, 'Let's talk,' if they see I need to, and we'll talk for half an hour or an hour—whatever. I hang out with them. It has made it a lot easier."

One frequent topic of discussion between Meilan and her agent is the way she dresses. Meilan prefers the "grunge" style and said her agents had to work to persuade her to put aside her baggy clothing during job interviews. "I was like, 'No way. I want to go to castings with my pants five sizes too big,'" she said. "But I noticed I didn't get too many jobs."

How to adjust your "look" is one of the first things a new model will discuss with her agent. The agent might suggest changes—like a wardrobe update, a haircut, or perhaps getting in shape.

"They cut my hair—they just layered it and colored it so it wouldn't be so straight and conservative," said Marysia Mann, who recently started a modeling career with Ford in Miami. "It's always been blond, but they highlighted it and tried to cut it so it's not the plain high school girl look, straight across." Marysia has worked for *Seventeen, Fashion Spectrum,* and German catalogs.

SWITCHING AGENCIES

Models switch agencies at times, and there is fierce interagency competition for the top girls, the names who attract the other models to the agency, and make the agency money.

When a model does switch agencies, sometimes it is because her agent, or booker, has switched agencies and the model feels comfortable and confident with this agent. A model usually holds strong loyalties to her agent, since her agent is her friendly liaison to the rough, hypercompetitive fashion industry. Models lean on their agents for all kinds of help, and agents tell stories about how they get calls at all hours from models with questions and problems of all stripes, from personal catastrophes to missed connections at an airport.

A model may also switch agencies to give her career a boost. Maybe she feels her current agent has done all she can and another agency could do more. If this is her reasoning, however, she should keep in mind that she might not be right—it's possible that no other agents would have more success than her present one. Switching agencies may be more about a personal choice than the efforts of the current agency.

And also know it's not a good idea to keep switching agencies. Yes, girls do jump around, but sometimes all that's needed is to talk it out with your current agent.

Then again, sometimes a particular agency isn't the right fit for a particular model, and it may take switching agencies to get her career back on track.

It is extremely important for a model to be comfortable with her various agents and to believe that the agents are doing all they can to find great jobs,

MARYSIA MANN

give advice, and map career strategies. A good agent will also be tuned in to a model's personal and emotional needs.

Roundup: Do you want to be a supermodel?

▲ **Jillian Baker, fifteen**

I want to keep this all in perspective. I'd love a career in modeling, to be the next Cindy Crawford. But I also want to go to college. I can't think about long-term goals with modeling now.

▲ **Jessica Blier, twelve**

Yes. When I get older, I want to move to New York. I'm probably going to buy apartments in New York and other places where there's fashion like Milan, Paris, and South Beach. Because right now, I live in a small town in Florida.

▲ **Cassie Fitzgerald, seventeen**

I just want to pursue all my goals, which means hopefully being one of the top models and not letting everything go to my head, having fun traveling and meeting different designers. After I graduate from school next year, I'm moving to Los Angeles with one of my best friends. I'm going to start taking acting lessons next year and hopefully get into movies.

▲ **Charlene Fournier, twenty-one**

Yes, I would like to be a supermodel, but at the same time I would be happy being a schoolteacher—that's another goal that I have. I admire supermodels because I don't see it as easy—they

If the Agency Is Interested, It Will Pursue You

▼

Jillian Baker, fifteen, had entered two Elite Model Look contests and was selected as a regional winner both times. The agency kept urging her to send in photos and called once a month, but no jobs came through for a while, and Jillian was happy to take it slow and pursue schoolwork, ballet, and track.

"Elite kept calling me—I didn't have to go after them," she said. "At the time, I had braces, but Elite kept calling me. They started to set up some test shots to make my portfolio. I was worried I wouldn't get jobs because of the braces, so I would always keep my mouth shut!"

▲

are working every day. At my level, you have the time to make a decision: Do I want to go to a casting? Do I want to work? I realize that the models who are top models have paid their dues, they've been around for years. Just because we have started seeing them in magazines doesn't mean that they're new.

▲ Melanie Hansen, nineteen

Of course I would like to be a supermodel, but that isn't very realistic. I would like very much to get magazine covers and do shows and editorial. I want to try it all. It's all part of the business. I would like to make great money, and I enjoy traveling.

▲ Danielle Lester, seventeen

I love modeling and being in front of the camera, and I'd like to continue to see where it takes me. If I do well, great. If not, I will have saved enough money to pay for college.

▲ Kim Matulova, sixteen

I guess all models would like to continue, to become something, become known. I'd like to keep doing it—it's fun. It's an opportunity that a lot of people would like.

▲ Delana Motter, sixteen

I have no ambition to be a supermodel. I like the money. Money does buy a lot of freedom. My parents are not too wealthy, and I'd like to send myself to film school.

▲ Krystina Riley, fifteen

I have always wanted to be an actress. Acting has been my greatest goal of my whole entire life. So when I got a modeling agent, I thought, "Well, they're related—it's an entree into the entertainment world." Hopefully, I can make the crossover to acting.

▲ Brittny Starford, eighteen

No. What I'm modeling for is to earn money for college. If I didn't have this, I wouldn't be able to pay for it. I'll model during college if it's convenient. Ultimately I think I'd like to go into either marketing or broadcast journalism.

Talking to . . . Navia Nguyen

Navia Nguyen has become the first Asian supermodel. She has been model-
ing for several years, but her career has only recently begun to take off: in
February 1997, she was the first Asian to be featured in *Sports Illustrated*'s
prestigious annual swimsuit issue. Shortly before that, she was selected by
People magazine as one of its "50 Most Beautiful People."

Navia, who is twenty-three years old, was born in Vietnam but grew up in
New York City, where her family owns a chain of small electronics stores.
After a few modeling experiences in her early teens, Navia went to London to
study at St. Maarten's School of Art & Design. She went back to modeling in
earnest after a prominent photographer saw her on the street in London and
launched her back into the fashion world in a big way.

Navia, who is 5'8½", has been featured in major spreads in American,
French, German, and Italian *Vogue, Harper's Bazaar, Allure*, and *Mademoi-
selle*. She has done runway shows for Chanel, Karl Lagerfeld, Chloé, Vivienne
Westwood, Donna Karan, Anna Sui, and Fendi. In 1996, Navia was selected
as the first Asian model ever represented in the Pirelli limited-edition calen-
dar, shot by Peter Lindbergh. She is represented by I'M NY.

How did your career develop?

When I was younger, I was living in New York, and at the time I was thir-
teen or so, I'd model on and off, nothing serious.

Then when I was nineteen, a photographer saw me at a flea market in
London. I was going to school there at the time. He took pictures of me
and showed them to French *Vogue*. I was then hired to work with him—
Juergen Teller—for eight pages for French *Vogue*. That's when my career
took off.

I now live in New York and Paris and Los Angeles. Paris is the place
of my heart and New York is the place of my mind.

Did you ever dream you would have this degree of success as a model?

Little Asian girls do not dream of growing up to be a model!

NAVIA NGUYEN

How does it feel to be the first Asian supermodel?

It's nice to see the industry change so much and see Asians represented in the media. When I was growing up, I had no one to look up to. It's great for me to be that role model for young girls, Asians in particular. It's great when young girls come up to me and ask for my autograph.

I'm proud to be the first Asian supermodel, as everyone keeps saying. For me, other than the money and the traveling, it's great to be breaking the barriers.

What's your advice for girls who want to be models?

For modeling, there are those that are inclined to be models naturally. If it's meant to be, it will happen. You need to be secure in yourself and confident. Presence works better than beauty—being confident and fluid.

For young girls, how they feel about themselves is so connected to how they look. So with them putting on makeup and stuff, it's not about them being vain, it's about understanding who they are. How you look is how you feel about yourself—it's not wrong. They are trying to find their self-image. It's a survival tactic for young girls. I say, "Go for it!"

For me, I know that beauty comes from within. That lasts longer.

What does your family think about your career?

My family? My dad is so happy—he tapes everything!

What have some of your favorite jobs been?

When I did a job for the Pirelli calendar. Also when Arthur Elgort photographed me for an upcoming Tommy Hilfiger campaign.

What has modeling done for you?

When I was younger, I always wanted to be a performer, an actress. So modeling has helped me. I go to Los Angeles to study acting.

What are you working on these days?

For the past two or three months, I was back in Vietnam working on a children's fund. I work with the Shree House Fund—it's based in New York, and we set up new programs for kids. So I was in Vietnam working on it. I still have family there.

I don't model full-time now—I'll take time off to backpack and work on the Shree House Fund.

THE TESTING PROCESS

AS I'VE STATED BEFORE, you cannot really "learn" to become a model if you do not already possess certain personal characteristics and if you don't have certain physical traits to begin with. There is no handbook, no twelve-step course, and no gifted instructor who can teach you to be a model if you don't have the right qualities within you.

That said, there are some things that can be taught to people who have modeling potential. You can learn to walk on the runway (if you already have some innate talent for it), learn which angles flatter you, learn to work with lighting and makeup and hairstyles. These things can be brought out, so long as there is enough that lives inside of you that is suited to the job. That's why I always say that a model must have a strong base to work with.

The testing process is an acknowledgment that not every beautiful girl who has the internal resources needed for modeling can instantly know what to do. During the testing process, a budding model works with her agent and with photographers to build her portfolio of pictures—the pictures that will be shown to clients who decide whether or not to hire the model. Testing is also a time for the model to learn about the industry and about how to make the most of her particular "look."

Many agents lend formal and informal advice to their young charges. The Irene Marie agency in Miami gives a weekend course in walking on the runway. Jessica Blier, a new model with no runway experience, was looking for-

ward to it: "They cover everything from how to hold your hands, how to place your feet, what to do with your face, and how to wear your clothes," she said.

One brand-new model, Krystina Riley of Sacramento, California, said her agent from Look "gave me the rundown of what was expected of me" when he agreed to represent her. "He told me to be on time. He told me to be bubbly and energetic and have fun with it, but told me that it's a job at the same time."

Andrea Pate, who is represented by the Arlene Wilson agency in Atlanta, said both her agency and the photographers she's worked with have helped her learn the moves. "When I go to castings for the runway, I just watch the other models. On MTV, I watch the fashion shows, and I learn from that. My mom goes with me and she gives me little pep talks before I go."

BEING IN FRONT OF THE CAMERA

The testing process for many models is the very first time they have had a professional photographer take their picture. Sure, they've had their friends and family take snapshots, but it's much different when it's done professionally.

What are the differences? You have your hair and makeup done professionally. You are usually in a studio or outside in a staged location. There are often people watching. The process is meant to help show models what working will be like and what is expected of them.

A professional photographer—or two—will be called in to take some preliminary pictures. A reputable agency has a stock of photographers on call to take pictures of new models at minimal cost (the photographers themselves are often testing for their own portfolios). Sometimes even the bigger-name photographers like to work with the brand-new girls to help develop them as models.

You and your agent will put together a composite card—known as a comp card in the business—with one, two, or three photos of you in different settings, projecting different attitudes. One may be a casual shot of you, and another may be a more styled shot of you. The point is to show off your versatility as well as your beauty and personality.

If the testing process proves successful, then the model is considered ready to visit clients with her composite card and her initial test pictures in

ANDREA PATE

her portfolio. An agent will help her judge when she has enough photographs and experience, then will call clients and make appointments for them to see her new model. After the model begins working, she will have tearsheets—pictures of herself that have appeared in print—that will replace some of the test pictures.

Even after she becomes a working model, the test shots will remain a critical part of her portfolio. Established models sometimes show their test shots to clients, since testing allows them to show their creative range. On a test shoot, you are not hired by a client to project a specific look or create a prescribed mood, so you and the stylist and photographer have more leeway in creating the images you want. The agent may have input, too, suggesting the type of look that might work best.

The length of the testing process will vary from model to model and from agency to agency. Sometimes the first tests don't work out, and the next set does. Charlotte Dodds, nineteen, didn't get much work after her first test shots were taken, but after a second set was shot by a local photographer in Nashville, near her home, her career took off. The new pictures "really brought out my personality," she explained.

EVEN WORKING MODELS MUST TEST!

Testing is an ongoing process—it doesn't stop when you land your first job.

If a working model decides to change her look—by getting a new hairstyle or hair color, for instance—she always gets a fresh set of test shots taken to highlight her new persona. Likewise, if a model is trying to work in a new market, she's likely to get new test shots done there.

"Each time I go to New York, I test just to build my book up," said Heather Dunn, whose work has included catalogs for department stores Rich's, Nordstrom's, and catalogs in Japan. "I really like the testing. Sometimes they have photographers who are just starting out and they give you free tests, and there are some you just have to pay for." As noted before, a reputable agency will set up test shoots at a minimal cost to the model—basically to cover costs of film, hair, and makeup.

Some models may only do one or two tests before they begin working. Others may test and test and test, and have a whole portfolio filled with test shots before they meet their first client. Either way, I always feel that all models should continue to test throughout their careers. Working with a variety of photographers and stylists is refreshing and helpful.

When new models go abroad and try to work in a new market, they some-

times end up doing nothing but tests. As always, it helps to take opportunities in stride.

"One summer I went to Milan for a month, and I did a lot of testing," said Bianca Englehart, seventeen. "I liked it because I got to be in front of the camera—I get adrenaline from it. I wasn't bummed out because I didn't work—it was a great experience. I was on my own and learned how to deal with things."

IT'S A LEARNING PROCESS

The whole testing period functions as a learning process. The model is working with professionals in the field, usually for her first time. Test shoots are set up so that they resemble real shoots—or jobs—as closely as possible.

The photographer, a hairstylist, and a makeup artist are present. The professionals place the model in a variety of settings to test her versatility: there may be studio shots (indoors with natural or artificial light) and outdoor shots; glamorous getups and casual ones.

Most important, the testing process is a time for *you*, the model, to decide if you want to get involved further. Maybe it's not what you expected or what you want to do. While the agency is testing the model out by monitoring her maturity and professionalism during sample shoots, the model herself is also testing how she reacts in this new situation.

No matter how beautiful a girl may be, she can't be a model if she can't project her special qualities to the camera. "Projection" means having the ability to work with both the photographer and the camera, to be able to portray different moods and emotions. The testing process is a good time to find out if you can project your beauty and succeed as a model.

Often, an agent tests a promising new girl and it doesn't work out. Maybe she didn't photograph the way the agent had expected, or maybe the photos were great but there wasn't enough positive feedback from the clients. Or maybe the girl tried it out and was flabbergasted by the amount of time and energy it took, or felt that being away from home for two weeks was too long. There are many reasons why it might not work out, and it's better to find out during the testing process before any more time, energy, and money are spent.

But if it doesn't work out, you can still take something away from the experience. Appreciate that you tried, met great people, and hopefully had fun.

TIME TO TEST

Many models report that testing is fun—in general, the pressure is off. "I did lots of tests," said Danielle Lester, seventeen. "I felt it was important to do, not only to be able to show the clients what you can do and how you photograph but also so you can get used to being in front of the camera."

Models appreciate the time it takes to go through the testing process. It's one thing to get all giddy and excited at the prospect of working as a model— you've signed a contract and you're thrilled at your future prospects—and it's another thing when the reality sinks in that you're going to have to figure out what to do. Testing can reduce the anxiety.

"After signing with my agency, I had to make an appointment with a photographer, and he suggested that I make an appointment with a woman photographer because it would be easier for my first time," said Krystina Riley. "She did my first shot—it was an all-day process. She was telling my mom how I was going to be pretty tired. But I found it to be a lot of fun. I was just sitting there having people do my hair and makeup—it didn't feel like a lot of work. My agent and I made the decisions as to what pictures to put on the card."

Nina Zuckerman, who signed with Elite in New York, said the flurry of test shoots her agency arranged helped her learn what to expect from a job. She even got a bit fed up with how much testing there was to be done. "They started sending me on test shoots—so many!" Nina said. "With half of them, you don't ever use the pictures, so it seemed like a waste, timewise. I knew I had to be patient."

Nina continued to go to test shoots and go-sees after school, and her perseverance has led to a flourishing career, with appearances in magazines like *Seventeen* and *YM,* catalog shots for Dillard's and Dayton Hudson, and appearances on the Style channel on the Internet.

The pace of each career is different. Some models work with only one meager test shot in their book, while for others the process is long and slow.

PHOTO: RODNEY RAY

DANIELLE LESTER

Danielle Bassett, who signed with Look in San Francisco, worked with three or four test photographers and amassed a portfolio of eight or nine shots. At the same time she was having test photos taken, she was also attending castings. "It was real slow at first," she said. "I got my first job after about two and a half months, and I must have gone on about twenty go-sees."

While some models think testing is a drag and just want to get it over with, other models really like the process and value the photos that come from the tests.

"Actually, my favorite picture of myself is a test shot," said Katie Hromada. "It's in my book. It's black and white, and it's by a waterfall, and I'm wearing a white swimsuit. I like the really natural look, and that's what it is."

And Nina Kaseburg said that one of her best experiences in the modeling field was the fun she had during a test shoot. "The photographer gave me a character to play," she said. "He told me the scene was *Taxi Driver* and I was supposed to be Jodie Foster. He gave me a role and I really felt I could play it. For me, if you just tell me to stand there and smile or act natural, it just doesn't work. You have to give me a character to play. I was really there, and I was working with some of the top people, and it was fun."

When Holly Barrett first signed with the Ford agency in Miami, they brought her to New York City to begin the testing process. "I went to see a couple of different photographers," she said. "They would supply the clothes and the makeup and basically shoot four or five rolls of film to build up the book, try to get all the types of looks in there."

But the testing process didn't end when Holly, who is eighteen, began working. Most of the work she was getting was for catalogs, and she wanted to expand her repertoire. "Now I'm trying to go for a more mature look. The last time I tested was two years ago, so I'm going back to New York to build up my book."

There is also a different dynamic going on while a model is testing. Holly says: "The testing photographers know that you're beginning—they give you more directions. With the jobs, it's pretty much more like you're having fun."

Roundup: How do you keep yourself looking in top condition?

▲ Jillian Baker, fifteen

I'm a ballet dancer, and ballet helps me with posture and grace. I'm comfortable with my body, which is good for photographers and people dressing me.

▲ Danielle Bassett, sixteen

I go to a dermatologist. I belong to a health club, I work out. I make appointments with trainers sometimes and they tell me what machines to work on. I try to eat well. I used to eat a lot of greaseball hamburgers and I would feel lousy. If you go to a job and you're feeling like that, it's not easy.

▲ Jessica Biel, fourteen

I work out every day. My hobbies are sports, and I love to play soccer, basketball, football, and hockey. I'm a health freak, very strict. I'm a vegetarian and eat rice, beans, and vegetables, and I make sure to get my protein. I keep in shape through sports and running around with my friends.

▲ Jessica Blier, twelve

I get facials—anybody who thinks that models don't get zits is crazy. Also, I have this habit of eating a lot of chocolate. My agent keeps telling me I have to start exercising—I have no definition, I'm skinny, nothing is firm. I just started working out to the Cindy Crawford tape once a week. Also, I have to drink lots of water. I hate water so much.

▲ Heather Dunn, eighteen

I don't eat as much as I'd like to. I eat healthy, but I'm a chocolate freak and I don't eat chocolate or candy. Occasionally I do—on my birthday.

▲ Janelle Fishman, sixteen

I have a very fast metabolism, so I really don't have to do that much. I just eat very small portions. When I started, I wasn't really doing a lot of exercises, but I'm just starting to get to the point where I have to, because my metabolism seems to be slowing down.

▲ Tomiko Fraser, twenty-two

I have my parents to thank for my looks. I have nothing to do with it. I am not strict with it, but I do try to eat properly. I should exercise more, but I'm lazy. It's not that I don't have to exercise. I wash my face, cleanse, use moisturizer and astringent.

▲ **Melanie Hansen, nineteen**

I learned I have to stay in shape constantly to look good and also to have the energy for castings every day. I play basketball and volleyball, though I had to cut back on basketball because of my modeling schedule.

▲ **Kim Matulova, sixteen**

I eat a lot of organic food, I take my vitamins. I do stuff to take care of my skin. I do skateboarding for exercise.

▲ **Jessica Osekowsky, fourteen**

My agents told me not to eat a lot of sweets and stuff, and to do sit-ups at night. For my skin, I just wash it every day and don't wear too much makeup.

▲ **Brittny Starford, eighteen**

Dove soap and Colgate.

THE GO-SEE

A GO-SEE IS literally that—you go see someone. Usually it's the client, but it may be a photographer, agent, or someone else in the business. It is often called a casting (more commonly in acting circles) or an appointment.

Whatever it's called, it's a chance for a model to meet someone in the business who is in a position to hire her for a job.

For a young girl who wants to break into modeling, the idea of actually going to see someone who could help launch her career is highly stressful. The inclination might be to act like a sheepish schoolgirl explaining to the principal why she cut study hall. But, of course, the opposite demeanor is what's necessary. It's important to be composed and to project your personality at its best—it's just as important as looking good.

That's not to say you want to act in a particular way. You don't want to call *too* much attention to yourself by putting on a show or behaving the way that you think the client wants you to be. You can't "act" like a model. All you can do is convey who you are by being natural. Modeling is about projecting— projecting what's inside you—so the more you show a client your fabulous, confident self, the more you will stand out.

A go-see is a time for the model to convince the client to hire her. You'd be surprised how far a little self-confidence can take you.

WHY GO-SEES?

The go-see is a major way that clients see and ultimately hire models. A client can look at portfolios of photos, tearsheets, and even recent Polaroids, but it is a go-see that lets us know a model and what she's like. You see her quirks, how she moves her body, and get a sense of her personality. If I'm trying to decide which of two or three models to use for a shoot, the personal interview almost always helps me. It lets me find out if a certain girl's personality matches the desired image.

The go-see is the perfect time for a model to show her unique qualities and let a client know who she is on the inside, not just the outside. A client may be meeting with ten, twenty, or even thirty or more models for a particular job, so it's important for you, the model, to make a positive and lasting impression.

Mastering the art of the go-see is a must, especially for girls who are just starting. Once you're well established, you probably won't have to go to a lot of go-sees anymore, or at least you will be used to them.

THE ROUTINE

In essence, a go-see is a mini job interview that typically lasts less than five minutes. It can be with a magazine editor, or with an agent who is thinking of representing you, or with a photographer for a testing or a job. It could be with an advertising executive who wants to find out if you're right for a new campaign, or with a company representative who's deciding whether or not to use you for an upcoming catalog. The person you'll be meeting is most likely a decision-maker, and that's why having butterflies in the stomach is a natural reaction.

Here's the drill: You show up for your appointment (optimally, a few minutes early so you have time to regroup) and tell the receptionist what your name is, what agency you're with, and the name of the person you have an appointment with. Then you wait to be directed to whomever you are meeting.

When you meet the person, you shake hands firmly, tell her (or him) who

you are, and wait for her to take the lead or give you a direction. She will ask to see your portfolio.

The woman or man you're seeing may ask you to stand up, sit down, or walk a slow circle so she or he can see you from all sides. The person may ask you to walk across the office as if you're walking on a runway. Depending on what kind of modeling job you're up for, the person may also ask you to flip your hair or to show off your hands. Usually they'll take a Polaroid of you, and sometimes they'll ask you to try on a sample piece of clothing.

You might also be asked questions about what size dress or shoe you wear, or whether you'd be willing to color your hair or cut it for a particular job. Be honest!

There may also be a little small talk about where you live, where you go to school, your family, or your impressions of the city you are in (if you are new to it). Be prepared to give ready answers. If you're the shy sort, practice ahead of time.

Keep in mind that it's okay not to answer any questions that you feel are too personal or intrusive. But, in this business, asking your sizes, your measurements, and your age are all considered legitimate questions.

On the other hand, it's not at all cool for someone to make inappropriate comments about your body or to ask you dirty-sounding questions. If you are sufficiently discerning, you should be able to tell when someone is behaving in a less-than-professional manner.

Representation by a good agency is insurance that the people you will meet will be professionals who conduct themselves properly. But nothing is ever for certain, and you must know your own limits and determine not to do anything that makes you feel uncomfortable.

It's hard to stay modest in this business, and lots of models say they quickly learn not to be embarrassed about showing off their bodies. Though a client may ask to see your body, there are professional ways to do that, like putting on a swimsuit or leotard.

Because go-sees are so important, they take up a large part of my working day. I usually see between five and twenty models a day. During school breaks and summer vacations, it can be even more than that. The meetings take place in my office, though I sometimes do them on location (at the agencies) when I travel.

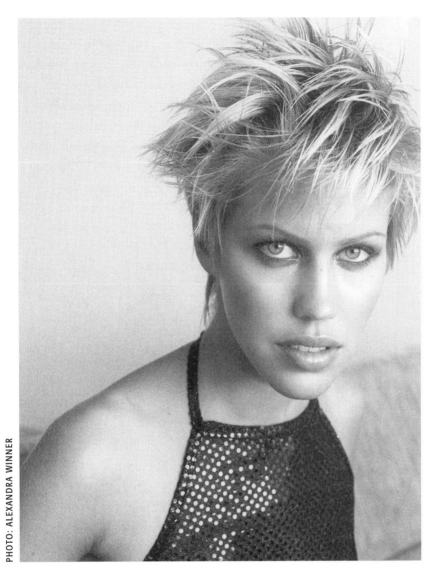

BRITTNY STARFORD

Either I call an agent to set up a go-see or the agent calls me, usually one or two days in advance or even the same day. I try to schedule them so that not too many girls are waiting in the reception area together, though there have certainly been crunch times when up to twenty models are waiting because everyone's in town at the same time.

The Go-See Lands the Job

▼

Once I was working on a story for an upcoming issue that had a rock and roll theme, and I was seeing several models on go-sees.

A model named Pia came into my office. She was not just beautiful but also eager and enthusiastic. Pia was from Canada and was only in town for two weeks. She had never been to New York before, and she told me lively tales of her many adventures in the big city. Her portfolio only had a few pictures in it, but she made a great impression on me.

When I called her agent at Next Management to see if she was available, I was told she was leaving in two days. I made my request to use her in our story the next week. Her agent said we needed to book her right away so she could change her plans, and we did.

Not only was I impressed by Pia on her go-see, but the photographer agreed, too. It's standard procedure to have the model meet the photographer in advance, so they can get to know each other and think about how to make the best pictures possible. You can say that Pia won us over not just with her photos and beauty but also with her personality.

▲

From the model's perspective, the go-see gets to be routine, but the first ones can be rough. "I have been on two interviews so far, and both of them were really nerve-racking because I had no idea what I was doing," said Krystina Riley. "One was for a commercial, and I was one of the first ten people brought in. It was really crowded, and they ask you to hold a sign that says your name. And then they ask, 'What's your name?' They ask you where you're from and what school you go to and what you like to do. It was really quick."

Going on a go-see "can make you a little nervous," said Brittny Starford. "You just try to do your best, and if they want you, they want you. There's nothing you can really do about it. Sometimes they ask you to try on clothes, and if it's for runway, they'll ask you to walk and then you show them your book."

A GO-SEE MAY LEAD TO A JOB

Your agent will arrange as many go-sees as she can. Constantly going on go-sees raises a model's visibility and enhances her chances of being at the right place at the right time. There have been dozens of occasions when I happen to have a job a model on a go-see would be perfect for, and I book (hire) her right away.

Other times I've had models in on go-sees who were so charismatic that they actually made us reshape a job to suit them. There have also been times when a certain model would be great for a particular fashion story, and somebody fabulous comes in for a go-see—someone

so outstanding that my colleagues and I rethink our story so we can work with the newcomer. We usually do this if the model is only in town for a short while, and we need to use her before she returns to school or another client uses her.

HOW MANY GO-SEES?

Don't get discouraged if your first go-see doesn't lead to a job—or even your second or third. Most models go on dozens of go-sees for every one job they get. This is especially true at the beginning of a career, before clients and photographers are familiar with a girl and the way she works.

A model may have an extra-heavy schedule of go-sees after a change or two: if she gets a haircut or new color, her body changes, or has returned from Europe with new tearsheets. A trip abroad almost always matures a model, and when she returns, she wants to show clients her new "self."

Each day you are in the business, you may change through the experiences you have gained. You may have new tests or tearsheets in your book. Clients need to see a model constantly, sometimes two or three times, to see her most current look and evaluate her confidence level. As the model starts to work and develop her personality, she grows in self-confidence and maturity.

Nicole Blackmon has been on so many go-sees that she seldom gets jittery—unless it's for a really big job. "If my agents put the weight on the importance of the go-see, I tend to get more nervous, but I always stay positive," she said. "If you go on more go-sees, you get more work."

CONFIDENCE

Confidence is very important when you are going on rounds of go-sees. It's critical to show the client that you feel good about yourself and what you're doing. The best go-sees are with models who seem to feel at ease, who are enthusiastic about being there, and who are proud of their photographs.

The last point may seem like an obvious one, but it isn't. Many times I have been leafing through a model's pictures when she declares, "Oh, I

don't like my pictures" or "I look horrible in that one." If you don't believe in yourself or your pictures, how are you going to convince me that I should hire you over the scores of other models who are walking in my door that week?

Kim Matulova agreed that confidence is one of the most important ingredients of a good go-see. "You've just got to bring your book and look your best and act yourself," she said. "They don't like any girls to be pretentious—they just like the normal girls."

Certainly, that's always been my impression of Kim when I've met her. In person and in front of the camera, she is comfortable being herself—she's funny and outgoing and very expressive.

Maturity is a tremendous asset on a go-see. The more confidence and professionalism a girl projects, the better impression she makes. One of the models I've worked with who stood out in these respects was Tomiko Fraser, who got started at nineteen and did her first shoot for *Seventeen*. When I met her, she was upbeat, friendly, full of energy, and significantly more mature than the typical girls I see at ages fourteen and fifteen.

"I've always been an outgoing person, and when I go on castings, it's a business meeting for me," Tomiko explained. "I go in and introduce myself. A lot of girls go in, put their book down, don't smile, don't say anything, and then they leave."

COMPETITION

It's unnerving for young models to see their competitors. They're probably sizing themselves up against the other girls in the room, who represent only a fraction of the actual competition. Only a handful of the girls who are out there making the rounds are actually going to get a job.

Standing in a room with other girls who are trying for the same job is the toughest. "Sometimes on go-sees, if there are other girls who are taller than I am, I feel like a young little girl," said Nina Zuckerman.

Many models report a tense atmosphere at go-sees. Everyone has her own coping mechanism. Delana Motter tries to look her best by putting on her "go-see outfit." "It's intimidating, because everyone is so competitive," she said.

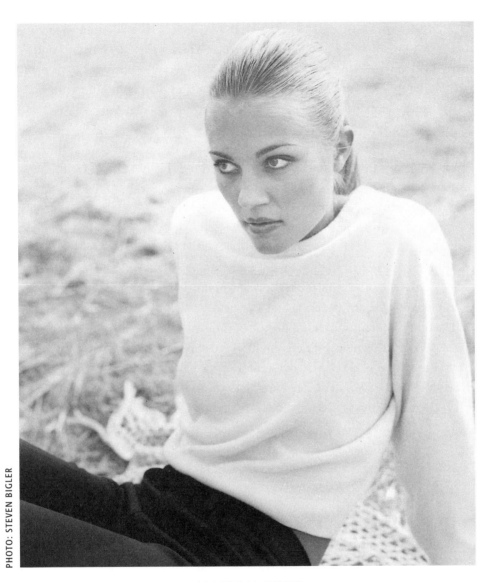

ALLISON FORD

"Some of the girls are snotty and rude. They want to snag someone else's book and see what they have done."

Breann Nelson agreed that the competition can be brutal. "I really don't have a problem with it until somebody is rude to me about it. Some girls let it be known that they're just out for the job."

Many models say they don't feel that competitive with other models. These girls say they are able to value themselves for their own unique qualities, and don't feel the need to compare themselves to others. But it's only natural that in a business where there are dozens of people out there for every job opening, competition does become stiff.

On castings, there can be up to fifty models waiting to meet the client. Models refer to these castings as "cattle calls." It's easy to lose yourself in such a scene, to look around at everyone and feel overwhelmed by the competition. But it is specifically at these times when a model must stay strong and believe in herself and her talent. She must know that all she can do is her best and that it's not the end of the world if she doesn't get the job.

"At castings, it *is* very intimidating," said Allison Ford, seventeen, a model in Los Angeles. "There are so many beautiful girls, and you know that usually only one girl gets picked. You wonder what your chances are. You have to have self-confidence."

Despite the competitive nature of the business, many models report that the dreaded cattle calls can be good places to become friends with other people in the business, since there is often a lot of time spent waiting around. Once you meet someone at a casting and get to be her friend, it's comforting to run into her again and again at other castings.

Having a buddy can make it easier, but probably won't eliminate tensions.

"Some people tend to be really competitive, like their lives depend on it," said Nina Kaseburg. "A lot of the girls I met in Paris—they were really do-or-die. They were so aggressive."

Just about every model can tell a story about girls who got testy during a lengthy wait.

"Once after we had been waiting in line for three hours, this girl insisted she was in front of me and not behind me," Nina recalled. "I was like, 'Okay, go ahead, get a life, get a grip.' "

I find that models who are catty (an extension, for some, of being competitive) are behaving that way because of their own insecurities. Successful models rise above it.

GO-SEE CHECKLIST

Here are some other things to keep in mind when preparing yourself for a go-see:

Dress comfortably and casually. You may be seeing a lot of people, one after another. Your agent may have booked you for up to a dozen appointments in a single day. Since you'll be running around, it's imperative to dress comfortably and sensibly. A model's outfit will not get her the job—it is her beauty, confidence, and personality that will—but a simple and neatly styled ensemble can enhance her natural beauty.

Wear flat shoes, not high heels. Choose casual clothes that are neat and clean and that show off your healthy body—the type of stuff you might consider wearing to a date at the movies or a family brunch. They must be clothes that fit well.

Jeans and T-shirts are fine, as are most kinds of skirts or pants. Muted solid colors like black, gray, navy, and brown work best.

Don't dress up too much or wear tight or revealing clothing—the people you're seeing will think that you're trying too hard and will be frustrated that they can't see the "natural" you. They also understand that you're busy and on the go, and don't expect you to be wearing formal business clothes that would impede your travel. Dress your age. And if it's the dead of winter, don't sacrifice warmth to wear clothes that are revealing.

Don't wear any makeup, and wear your hair naturally. This may sound weird, but it's the best advice I can give you. A clean, cosmetic-free face is the only one clients want to see. The same goes for your hair—it should be natural and styled casually, the way you normally would. Don't try a teased bouffant or elaborate "do." People who choose models want to know what you really look like, not what you can make yourself look like.

We are experts at using our imagination to picture how great you'll look once the makeup artists, hairdressers, and clothing designers have done a number on you. Your job is to present yourself as a blank but attractive canvas for their masterpiece.

Be on time! The client needs to know you're responsible. If you're on time for the go-see, you are professional, and it's more likely that you're going to show up on time for the job, too!

SUPERSTARS ON GO-SEES

The first day Bridget Hall was supposed to come see me, I had great expectations. At fourteen, she had already been signed by Ford Models. She had come to New York from Dallas during a school break—she was only in town for a week—and her schedule was full of appointments with clients and photographers.

Bridget's agent had told me about a great new girl coming in, and I was excited. I was told that she would not be returning to New York soon because she was going to finish the school year and then spend the summer in Paris on her first assignments. The agency obviously had high hopes for her.

The minute I met Bridget, I understood why. On the go-see, I saw she was a classic beauty: blonde, blue-eyed, clear-skinned, elegant. She also had a great smile, a fresh face, and an upbeat personality. She made a great impression on me, and I would have loved to work with her. Unfortunately, we had no jobs open at the time, so she went on to Paris, and the rest, as they say, is history. Currently, she has lucrative contracts with Maybelline and Ralph Lauren, and is represented by IMG Models.

The story of my meeting with Bridget is an important one in two ways. One, it shows that no matter how perfect a girl is for modeling, she may not get an assignment right away if there is no job. Two, Bridget showed how to do everything right on a go-see. She was totally herself—a teenager from Texas.

When I first met Trish Goff, she was still known as Trisha—and she had some changes to make.

On her first appointment with me, she was fifteen years old with long, brown hair and bangs that hung down to her chin. I thought she was pretty, but not a standout. I didn't book (hire) her. Sounds like a mistake, right?

Actually, what I told her agent at Pauline's Model Management was that I thought her face was her best feature and that it was being hidden and overwhelmed by the length of her hair. She cut her hair and came back for a second go-see. The change was startling. Not only had her new hairdo revealed a stunning beauty that the old one had masked, but she also seemed more personable and confident, in part because her new "look" was helping her land modeling jobs. I hired her for a prom story, which came out in March

1993. She began working for other magazines, appearing on a dozen covers and on designer runways in New York and Europe. She has also landed campaigns for Chanel and Versace, and is represented by Elite.

I have met many models who were shy and reserved in the beginning but who nonetheless came across during the go-see. Kate Moss was shy when she first started, but she was extremely likable, giggly, and adorable. Most successful models can point to a time when they, too, were shy and relatively awkward.

Roundup: Describe the best or worst job you ever did.

▲ Danielle Bassett, sixteen

My biggest job—the best one—was an ad for Walt Disney. I wore a black crushed velvet evening dress with rhinestones in the shape of Mickey Mouse's head on the front, and the pictures ended up in *Vogue* and *Harper's Bazaar*!

▲ Jessica Blier, twelve

The best job I had was also the worst job. It was for *Seventeen,* and it was at a private home, and it was for bathing suits. It was best because I liked the people—when I'm working with a good group of people, I have a better time—but the worst part was that I had to jump into a freezing-cold pool!

▲ Allison Ford, seventeen

A great job was one for Pointe Conception swimwear. It was shot in Hawaii, and it was an

You May Surprise Yourself

▼

Carrie Tivador, who is fourteen, thought she blew a big go-see—but she was wrong.

"My agent in Toronto sent me on an audition for Cover Girl," she said. "They asked me my name, my interests, and asked me to dance. They said, 'Go nuts!' It was embarrassing—I felt like an idiot and I thought I did a bad job.

"It only lasted about two minutes. They put me on tape and took a Polaroid. About two weeks later, there was a message on the machine: 'Carrie, you have been confirmed for the Cover Girl job. I think you'll like it, and it's for a lot of money.' When I first heard it, I almost had a heart attack."

How this job for Cover Girl actually turned out is described in "Diary of a Cover Girl Shoot" in chapter 2, "Work Life."

▲

eight-day trip. I live in Los Angeles and like to go to the beach and surf anyway, so this was fun. There were a few other models, and when we'd have a break, we'd go swimming together. But we did work hard.

▲ Lindsay Frimodt, fifteen

My favorite job was for *Girlfriend* magazine. The first day it rained, so we didn't work, and I went to the mall with the guy model. So when we did do the job, we were already friends and had fun being photographed on the beach.

▲ January Jones, nineteen

A hard job for me has been for a catalog company, when I had to be photographed in what seemed to be a hundred dresses in five hours!

▲ Meilan Mizell, eighteen

My favorite job was an editorial job for *Seventeen* magazine. It was in Miami. We drove down to the Keys for a summer issue, and I remember on our day off, I went snorkeling with the crew. We've remained friends. The worst was in Paris. I went for three days, and it was a bad experience. I was young and by myself and very scared. I needed to communicate with people and couldn't.

▲ Breann Nelson, fifteen

My least favorite jobs are when they're foreigners and you can't really talk to them. You can't really understand what they want or how they want you to work. My favorite job was for *YM*. It was a prom story—body glitter, metallic things, on the beach, a lot of running around having fun. It's fun when you can be friends with the people you work with.

▲ Melissa Tominac, sixteen

I did a Geoffrey Beene fashion show. It was out in the Hamptons, a charity fashion show, and I loved the clothes. It was my first runway show and I found out through that that I love runway work. It's just a matter of developing that skill—you have to look kind of fluid and basically just comfortable. If you look like you're nervous, it just doesn't work.

▲ **Filippa Von Stackelberg, fifteen**

One of my favorite jobs was an ad campaign for Abercrombie & Fitch. It was in Miami. It was fun—there were about fifteen models, including guys. It was shot by Bruce Weber. We'd get up at 7 A.M., take a van to the location, and shoot. The people were great.

YOUR FIRST ASSIGNMENT

CONGRATULATIONS—YOU'VE GOT your first modeling job.

The day before your first booking (and all subsequent ones), you will speak to your agent about the job. She'll tell you who the client is, how long the job is expected to take, where to go, whom to see, what the nature of the assignment is, and how much you will be paid. She'll also tell you if you need to bring anything with you (like shoes or panty hose) or if you need to do anything in advance (like get a manicure or shave your legs for a bathing suit shoot).

Make sure you get all the specifics—write them down—and make sure to follow them. Usually the requests are not complicated or unreasonable, but they are oh so important to the client.

If you remember nothing else, remember rule number one: *be on time.* Even if it means leaving extra early so you don't have to worry about the whims of traffic or stalled subways. Why is Cindy Crawford considered one of the most professional in the business, someone everyone looks forward to working with? She's notoriously punctual.

Nobody likes to wait for anyone who is late. But in this business, as in many others, time is money and clients will not tolerate spending money waiting for people to show up—models in particular. Photo shoots are planned very carefully, down to the last minute.

If you suspect you will be late, make sure to call your agent so she can

call the client and give them the option of waiting for you—or of finding another model. (Yes, that does happen!)

PREPARE!

For any modeling job you get, you should do your research. If it's for a magazine, be familiar with it. Buy it or read it in a library. If it is a catalog, you can try to get hold of it. If it's a runway job, make sure you are familiar with the designer and his or her style. Fashion shows are on television daily, and watching them can help you get to know the different designers and their signature styles. Become as familiar as you can with the type of job you are hired for and the company you will be representing. It shows the client she is familiar with the style and what is expected of her.

You can prepare physically. Unless you're told otherwise, you should always arrive at a booking with clean hair and *no* makeup. That will ensure that you are ready to be worked on by stylists and makeup artists.

Most models report that photographers like to work with hair that is clean but hasn't been freshly washed. "When you first wash your hair, it's a little flyaway and fluffy, and so they like it if your hair is a little dirty," explained Kim Matulova, who likes to take a shower in the morning before a job and then munch on a little fruit. Whether or not her hair is perfectly clean, "they put hair gunk and wax stuff in it."

Melissa Tominac doesn't wash her hair the morning of a shoot, and she makes sure to take off any bright nail polish. "Usually on jobs I bring different kinds of hose or some makeup," she said. "I've been at catalog jobs before where I am expected to bring my own makeup. I also bring a sweatshirt in case you end up going someplace chilly, and some money just in case."

Most girls also like to bring a book or homework, or tapes and a Walkman, since there is often a lot of waiting time during jobs.

You can develop your own preparation rituals to get yourself psyched for a job, the same way you might try to get ready for an exam. Each model has her own method or strategy.

"If I'm not feeling in a good mood to go to a shoot, I listen to country music in the car, and I turn it up very loud, and I sing," says Danielle Bassett.

ARE YOU NERVOUS?

It's natural to be jittery when you're going on your first job. If it's any comfort, keep in mind that every supermodel has felt exactly the same way.

Sometimes a model's first job happens right away, and sometimes it doesn't happen until she has tested for months. Either way, the same preparations—logistical and emotional—are needed.

"I usually wake up about two hours before my call time, so I'm not feeling rushed and I can get myself together," said Nicola Vassell.

Many models describe their first jobs as learning experiences that, in retrospect, went a lot better than they had thought at the time

Kristin Klosterman recalls her first job, working for a French catalog: "At the time, it seemed like a disaster, but now that I think back, it wasn't so bad," she said. "I was very nervous. I had no clue how to move. My sister went with me. I couldn't believe how much money they paid me. Not coming from a wealthy background, when I got home, I was crying, I was so happy."

And Amy Smart, whose first job was for *Moda* magazine, said she was nervous and excited—but calmed by the fact that she got to work with her best friend, who was also a model.

Believe it or not, you can actually use your nerves to your advantage. Just learn to work with the emotion and turn it around into pure excitement. It can help give you the adrenaline to get you going and do the best job you can.

HOW LONG WILL IT TAKE TO GET YOUR FIRST JOB?

How long a model takes to get her first job varies from girl to girl and from city to city. Some girls report they got their first job right away on signing with an agency—or even before—while some had to do a few tests, or even test in a few markets.

▲ Right away

"My first job was for *Sassy*, and it was before I even had any tests," said Janelle Fishman. "I was in a studio. I was in overalls and this little shirt, holding a mug. It was an article about how caffeine was so bad for you. I was so happy. I was like, 'Oh my God, it's really coming true.' It was just sort of like a dream."

▲ Three days

"I got my first job in New York three days after I arrived," said January Jones. "Being from a small town in South Dakota, New York was scary! The job was for *YM* magazine. I had worked at home before, but it was *great* here. I remember thinking, 'Wow, they provide lunch for us!' "

▲ A week

"I got my first job a week after I signed with an agency through an open call. It was for B.U.M. Equipment," said Allison Ford. "I was so excited—I got the job after only one test shoot!"

WHERE WILL YOUR FIRST JOB BE?

If you're lucky, your first job will be on location, so you'll get to take a great trip. The downside of that is you may be in for long days of shooting and perhaps a week spent with people you don't know.

"My first job was a pretty big job, and it was my favorite," said Andrea Pate, fourteen. "I did a fall campaign for Abercrombie & Fitch, and Bruce Weber was the photographer. The campaign was for posters in the store and ads in magazines, and it was pretty glamorous. We stayed in the Hamptons in this huge house. It was the best experience for a first job I could have had."

Bianca Englehart, a seventeen-year-old from Miami, said her first assignment was a four-day trip to the Florida Keys. "It felt great to get the job," she said. "It was for a young brides' magazine. I didn't tell them it was my first job. When I did tell the crew at the end of the day, they said, 'Oh you move so well.' So I decided to stick with it."

And Barbara Stoyanoff, twenty-one, got to go abroad for her first job—to Japan. "It was a swimsuit job," she said. "I was standing on a surfboard in a studio, acting like I was surfing, in front of thirty Japanese men and women! I was so embarrassed. Then it was fun. The crew was serious, but they laughed when I told jokes."

OBSCURE FIRST JOBS

Not all first assignments are high-exposure cover shoots or ad campaigns. Many models cringe when asked what their first job was, citing a local newspaper or a cheesy, low-budget ad. And a lot of first jobs are at the local level, like a department store catalog or newspaper advertisement.

Then again, the first jobs may be even lower-profile than this—perhaps in-store modeling for a boutique or local fashion show.

These smaller opportunities, however, can be welcome ones. By starting slowly, a new model gets exposed to the process and routine of fashion modeling. She develops her own signature style and learns the ropes. When more important jobs come her way, she will be comfortable on the set and ready for the big leagues.

Katie Hromada started out doing newspaper ads and other "little jobs, which led to bigger jobs—*Teen* magazine and department store catalogs." For Amy Owen, starting out meant working as a hand model (hands only!) for a friend who was a local photographer.

"My first job wasn't very much fun," said Nina Kaseburg, sixteen. "The good part was that the client chose me even before I had my composite card done, which my agent said doesn't happen often. I had to do my own makeup and model in front of a fake Christmas tree. It wasn't that much fun, and I still don't even know exactly what it was for."

Many models have a hard time remembering their first assignment. But whatever it was, models universally say that it was a thrill and a surprise to be chosen.

JENNY FILLER

ONE JOB LEADS TO ANOTHER

When a model does get that first job, it often leads to more work. Clients like to use models who have already proved successful for other clients.

"My first job was for *Seventeen*," said Jenny Filler, fourteen. "It was a skin story, and the pictures were small. I've done a few more jobs for them, including a prom story in 1997 that was fun—there were about six models on the shoot—and I got the cover of that issue. I was happy—everybody at school was talking about it." Jenny has also worked for *YM, Dolly, Gracia,* and *Top Model,* where she was named one of the top upcoming girls.

Breann Nelson's first assignment, for an Italian magazine, was a great first job, very high profile, and it paved the way to further work. But she still had to do smaller jobs afterward with magazines, catalogs, and department stores, to get exposure and meet people in the industry. These smaller jobs were in her home market, Los Angeles, and set the stage for her arrival in New York, where she worked for *Harper's Bazaar, Mademoiselle,* and Spanish *Vogue*— not bad for a newcomer!

OTHER TIPS

The duration of the workday varies as much as the type of work there is. A fit job, in which you try on the clothes for size, may be only an hour or two, while a catalog or editorial job may last all day.

There are times when the workday may be especially long. Although your agent will tell you the anticipated duration of the assignment, it's helpful for both you and the client to be flexible, giving leeway if the shoot takes an hour or two longer than expected.

No matter how carefully orchestrated a shoot may be, there are always things that can (and do) go wrong and cause delays. Hair and makeup may take longer than usual, or a key piece of photo equipment may malfunction, or the sample clothes may need to be pressed.

After the job is finished, a model must make sure to get a payment voucher to pass along to her agency. She is also required to sign a release that allows the client to use her photographs. For all your assignments, it's prob-

ably a good idea to have your agent look over the release before you sign it, to make sure everything is in order.

SNAPSHOT OF A ONE-MONTH-OLD MODELING CAREER

I interviewed Beau Garrett, a fourteen-year-old in Los Angeles, a month after she was spotted in a Santa Monica shopping mall by an agent from Elite. Beau's story gives a pretty good indication of what a girl who has the right stuff for modeling can expect after one month.

According to Beau, people had approached her in public places and asked her about modeling from time to time, but she had never before thought seriously about it. When the woman from Elite introduced herself as the former director of the New Faces division and took down their name and phone number, Beau began to get a more comfortable feeling.

"I knew of Elite—my cousin had been with them," she said.

Once she got home from shopping, she told her parents about the encounter, and they were surprised and excited. Her father called the agency right away, and she and her mother went in soon after for an appointment.

"I had no photos," Beau said. "I wore a fancy outfit—a nice sweater and skirt—and I was a little nervous. They took a Polaroid of me and we talked, and I went home and went about my day—rode my horse, did my homework."

Her First Television Commercial

▼

Jessica Biel was twelve when she landed her first television commercial: an ad for Pringles potato chips. "When I walked into the audition, I was nervous but really excited," she said. "I wore a new shirt, a hat. I also wore my hair in braids, with overalls, a turtleneck, and black boots. The agent said, 'You're perfect—I love your hat.'"

After that encouraging start, the audition continued to go well. "I just talked, ate Pringles," Jessica said. "Then I got a callback. There were ten of us, three at a time. They turned on music and said, 'Just dance and eat Pringles.' Then they asked me to roll a chip from my ear to my mouth, down the side of my face, and I did it. They got it on tape. It was a fun audition, and maybe that's why I got the job."

The next thrill was seeing the commercial appear on television. "I thought it was the greatest thing ever," Jessica said. "It was really cool. I was like, 'Wow, that's me!' My friends were really excited and happy. For me sometimes, it's overwhelming what I'm doing, and it is for my friends, too. But they're always happy for me."

▲

PHOTO: STEVEN BIGLER

BEAU GARRETT

Things moved at lightning speed. The next day Beau was sent on a go-see for *You* magazine carrying only one Polaroid. She got the job.

Beau was amazed—all of a sudden, she was on her way to her first modeling assignment.

"The job was in a studio," she said. "I kept to myself. The whole crew—

another model, the photographer, makeup artist, and stylist—made me feel comfortable. I had no clue what to expect."

First she had her hair and makeup done, then came the photo session. "I just did what was natural to me, moved around," she said. "The photographer told me a few things, then I did it on my own. I got the feel for it and had fun."

Since then, Beau has had two test shoots and has been busy with jobs—two or three a week—including appearances in *Teen, Great Looks*, and a Japanese catalog.

Beau says she likes the way her pictures have turned out and is still surprised all the time by how well things are going. She is staying in school and continues to ride her horse every day. Beau has been riding for half her life and plans to continue competing in equestrian events as she works as a model.

When I asked Beau how she juggles riding, school, and modeling, she immediately said, "I have great parents. They help me with my schedule."

Roundup: What is your favorite—or least favorite—thing about modeling?

▲ Nicole Blackmon, twenty-five
The best part is when the pictures come out. It's cool to see pictures of myself—I'm happy—but sometimes they pick the cheesy ones to print. That's the worst part!

▲ Jessica Blier, twelve
The two worst things about modeling are having to go to bed late and get up early, and also having to pluck your eyebrows!

▲ Heather Dunn, eighteen
The best part is you get to know yourself as a person, and you travel and you see places that some people will never see. You're in situations that some people will never know, and you live everywhere, from a little tiny one-bedroom apartment to a huge, beautiful hotel room.

▲ Katie Hromada, fourteen
I think you grow up a lot faster when you're in this business, and I think it can be good. Just the way you learn to handle situations. There's also the

sense of accomplishment you feel when your ad finally comes out. I think the least fun is probably sitting around reading before it happens. I take books or a newspaper or homework.

▲ Kristin Klosterman, nineteen

The best part is traveling—I love traveling and experiencing other places. The hardest part is being by myself. Having to be alone, I couldn't appreciate Italy or New York.

▲ Jenny Knight, fifteen

I like seeing the pictures come out—more than doing them!

▲ Marysia Mann, fifteen

The best part is when the film comes in—I'm always so excited to see it!

▲ Helena Stoddard, fourteen

One of the hardest things is when I see my pictures. A lot of times I think the shoot went well, and then I'm disappointed when I see them because I don't feel they are "me." With the makeup, the lights—it feels like it's not me. In the pictures there's an attitude, then my unmade face—it doesn't match.

▲ Nicola Vassell, eighteen

The best part of modeling is coming alive in front of the camera. Also, meeting people and traveling. I want to be a psychologist, so it's great to meet all these different personalities I have to work with.

Talking to . . . Catherine McCord Mogull

You probably don't recognize Catherine McCord Mogull by her name, but you've probably seen her somewhere: a catalog for Victoria's Secret or Saks Fifth Avenue or Bergdorf Goodman; a television commercial for Salon Selectives, L'Oréal, or Clairol; or maybe on NBC's *Extra* or the E! channel, where she has worked as a broadcast journalist. In addition to her full-time work as a model and budding television reporter, Catherine works with convention sponsor Model Search America, lending advice and a helping hand to girls who want to get started in the business.

Catherine, who is twenty-three, got started ten years ago. Even though she was only thirteen, she was already 5'11", and she began entering modeling contests. She made her way through several contests, winning and advancing through various levels, until Elite offered her a contract. Ten years later, she is still with them.

At fifteen, Catherine spent a summer modeling in New York and living in Elite's model apartment—her first job was a small photo in *Mademoiselle*—and at sixteen, she went to Paris for the summer. Her biggest break came at age seventeen, when Calvin Klein saw a picture of her and hired her for a ten-page advertising insert in *Vanity Fair*.

Catherine's tremendous modeling career has included two covers for *Glamour,* a cover for *Elle,* and appearances in other top fashion magazines. She has walked runways for all the big names: Donna Karan, Calvin Klein, Ralph Lauren, Perry Ellis, Chanel, Armani, Dolce & Gabbana. Yet it is Catherine's belief that she spent the early part of her modeling career in the dark about the business and how to succeed in it. Her early memories have fueled her desire to advise young people about the fashion industry.

In an interview, Catherine talked to me about what she has learned.

You were successful as a teenage model. What do you think was missing from your career then?

When I was seventeen and eighteen, I didn't know the importance of certain people and jobs in the business. I didn't understand the model's relationship with photographers or clients. My agent would tell me where

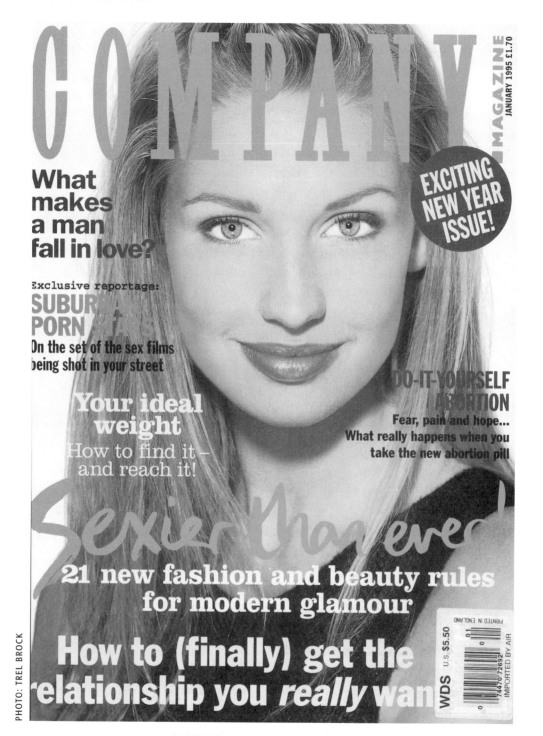

PHOTO: TREL BROCK

CATHERINE McCORD MOGULL

I'd need to be for a job, and I'd get to a job and act like a kid. I didn't realize it was an adult business.

Agents don't have time to explain everything—about who the important people are, how to work with clients, and how you should create lasting relationships with them. I wish I had had someone involved with me at that level for advice. I like to offer advice and guidance to young models, and that's why I give a seminar and work with Model Search America (at their conventions).

What do you tell girls who want to be models?

I tell them it's okay if they don't get an agent and become a model. The experience of trying and learning helps build their confidence and self-esteem. If they do go on to modeling, great. But if they don't, that's okay too.

When I started, my parents and I knew nothing. I like to share what I've learned. I believe that if you keep trying and you have even a small amount of potential and lots of determination, something will come out of it. I also tell girls to listen to their parents. I am fortunate to have always had huge support from my parents. It has helped me stick to my morals, remember my purpose, and forget about all the other things that get in the way. You have to keep your main goal in focus.

Is there anything you would have done differently, given what you know now?

At times I wish I had started later than I did—you're not ready at such a young age. But I stuck it out and it has worked for me.

Have things changed a lot since you started?

Yes. When I started, the industry was different. There were no fashion television shows. There is such huge exposure of models now—everyone knows who the models are.

When I started, it was the time of the supermodel, girls bigger than life, and the "classic" look was in. That was good for me. But a year into when I started working a lot, everything changed. The "waif" look came in and there was less work for me. People said after I went to Paris that Kate Moss was on the plane behind me. There was nothing I could do—it was

timing. You can't make yourself something you're not. I could not make myself into the waif look.

Everyone is destined for one thing or another. I knew for me it was being a catalog model. And that's great. Finding my place has made me really happy. You can get a haircut and change the way you look, but you can't change who you are and your personality. For me now, I feel the most beautiful I ever have, and I know it's because I'm happy.

Did you ever try to adapt to the super-thin look once it became popular?
No. I don't think about food or exercise. I feel happy with myself and the way I look, and that's reflected in my work. My advice to young girls is to throw out the scale. Just make sure you are physically okay. If you feel negative about yourself, it's reflected on the job. If you're miserable, the whole crew is affected.

It's hard, as a model, because your life revolves around your looks and maintaining your weight. Your upkeep includes waxing, manicures, pedicures. You must maintain your physical appearance. Also, for the most part, people don't care about you, what's on the inside—they care about how you look. They don't take the time to talk and ask you about your life's experiences, for example. Maybe that's why some people think models are stupid.

Does that bother you, the impersonal nature of the business?
When I was young, I was so nervous, always wondering, "Do they like me?" I've learned to use my eyes to radiate—to make a connection and look natural. You don't want to look like you are trying.

Models get depressed because they think about everything that's going on and worry about whether they're personally responsible. You just have to distance yourself, relax, and be yourself.

What are you working on these days?
Now my focus is on broadcast journalism. I have been a correspondent for *Extra* and E! for fashion shows. It's great because when I was younger, I was fascinated by Diane Sawyer. I even applied to schools for broadcast journalism.

When I started modeling and then saw, for example, Cindy Crawford

hosting MTV's *House of Style,* I thought that was great. At the same time, my friends from home were pursuing their careers and I was looking at how my career was going to shape up, so I decided on broadcast journalism.

Modeling opened the doors I wouldn't have had. The connections I've made have been invaluable. I did start acting a year and a half ago and didn't really like it. I wanted to use more of my personality, so interviewing people has been a great fit for me. I'm genuinely interested in the people I interview.

Working for *Extra* at the couture shows in Paris, through my connections from modeling, we got access to behind-the-scenes at major designer shows like Chanel and Valentino. I got interviews with the designers and models. I approached them not only as a model but also just as a person, and made them feel comfortable. Models don't understand the importance of public relations and doing interviews. Actors, on the other hand, know this.

Do you have a professional philosophy?

I treat everyone the same—all with respect. As a model you are always working as part of a team. There's the stylist, assistant, hair and makeup people, and so on. You must show equal respect to everyone involved. That respect you show will get you booked again. Just treat everyone you work with or come in contact with in this business as a human being.

How have you changed your image as you have grown up?

One lesson I have learned is the importance of having a "presence." I remember early in my career I did a show for Azzedine Alaïa and was given a great dress. I wanted to wear it for an event, so I put it on with my twenty-dollar shoes. My agent was like, "No, you've got to have the whole outfit work together." I had no clue. You have to be together whenever you are in public.

Also, I remember about three years ago when my agent talked to me about my look. Yes, I was working, but it was time to change and present myself as more sexy. As a young girl you don't know what that means. So I built up my confidence.

It's okay to be shy, but if you work at it and prepare, you can project different emotions. When I'm on the runway, I think about getting the photo at the end of the runway, and I also want to impress the designer. I must think "confidence" as well as walking in those heels!

For me, I take it all day by day. If I have a smile on my face, I can do it tomorrow. I really have no plan—I just have patience.

SCAMS AND CAUTIONARY TALES

YOU ARE NOT A MODEL until someone pays you to model. Keep this one sentence in mind, and remember it every time you size up whether you are reaching your goal of becoming a model—or getting ripped off.

If you want to become a model, one of your goals should be fairly clear: you must be represented by a reputable agent both at the local level and, for career advancement, in a major city. I cannot emphasize enough the importance of this.

But there are many paths toward that goal, and some are less clear-cut than others. You must always pick carefully and ask yourself questions. Among the questions you should ask is whether this is the best, most efficient, and least expensive way of getting represented by a reputable agent in a major city.

Some paths are not as direct as going straight to that big agency, and that's okay, too. Sometimes it's even necessary that a model take those interim steps—maybe she needs to learn and develop through experiences at the local level or by waiting until she's older and more mature. Obviously, it's a good idea not to start off on the wrong foot by trying to do too much prematurely.

A girl who is eager to break into the big leagues is probably the most vulnerable to being preyed on by people with bad motives—and there are plenty of them hovering around the modeling industry. So, as you keep your goals in

Everyone Needs Information

▼

Consider this letter I received from a girl in Norwalk, Connecticut:

Dear Donna,

I wrote to you before Christmas asking you to help me get started in modeling. You sent me back some info about how I could. Well I took your info and put it to use. I wrote to the list of agencies you gave me and I'm waiting for answers. There weren't any agencies here that were reputable and one asked me for all this money, saying I *had* to join their school before I actually got to begin testing or anything like that. Do I have to join a school before signing with an agency? Do I have to be with an agency to put a portfolio together? Can I try to get signed up with a major agency before a local one or do I have to sign with a local agency first? I feel like I'm bothering you with all these questions but your help does mean *a lot* to me. I hope I could meet you someday so you could find out who was the busy little person that wouldn't quit. Sorry but thanks.

I've included the letter exactly as she wrote it, to show not only the types of issues aspiring models are confronting but also the need for information.

I hope readers of this book know by this point that going to a modeling school is *not* a prerequi-

mind, remember to be smart about every move you make. Don't let flattery and your ego make you gullible.

I'll give you an example, a story that could have a happy ending or a sad one. A woman and her teenage daughter are shopping in the grocery store. A man comes up and introduces himself as a fashion photographer and says he would like to take pictures of the daughter because he believes she has potential to become a model. He gives them his business card and asks them to call him. The girl is thrilled beyond belief—what a tremendous compliment, and what a dream it would be to become a model!—but the mother is dubious and skeptical. The daughter pressures her mother to call the man.

How could this story turn out? Several ways, of course. The mother could set up an appointment for a photo shoot, take her daughter there, and find out that the photographer wants thousands of dollars up front to take the pictures. Or, worse, she could send her daughter to see the photographer and find out too late that he is interested in her for unsavory reasons.

I know of a case where this story played out with a happy ending. It happened to Amy Smart, whom you have met in these pages.

When Amy's mother got that business card, she didn't call the photographer right away but did her homework instead. She called around to legitimate modeling agencies and asked if they knew his name and if he was for real. After she was satisfied that the man was indeed who he said he was and that his motives were legitimate, she called him. The

pictures he took helped launch Amy's model- ing career: he took the shots to an agent at Prima in Los Angeles who spotted Amy's tal- ent immediately.

But stories to the contrary are all too com- mon. There was a 1980 movie, *Fame*, about students at a New York high school for per- forming arts who all wanted to become stars. There was a character in that movie whose name was Coco who wanted to become a singer and actress. I remember the scene where a sleazy photographer represented himself as a star-maker and lured her into his studio—only to demand that she pose topless. Foolishly, she complied. The scene in which Coco is sitting shirtless in front of the camera, tears streaming down her face, is a haunting and poignant one. Nobody should have to endure that in order to become a model.

Plenty of models who are in this book tell stories of having narrowly avoided potential traps. Krystina Riley, who recently signed with Look, once did her homework to avoid a scam. After a man who identified himself as an agent approached her at a rock concert and handed her a business card, her mother checked him out. She found that his claim to have an office in San Francisco was false. When the man re- quested that Krystina meet him in a hotel room, she and her mother smelled a rat. Krystina's mother checked with the Better Business Bureau and found that there was a host of complaints against him.

How can young people and their parents determine who is for real and which modeling "opportunities" are actually scams? The in-

site for entering the business, that any agency that asks for money in advance should be avoided, that young people can put together their own first set of pictures with- out professional help, and that local agencies—legitimate ones— can be career-launching pads, with the goal to be represented by a reputable agency in a major market.

▲

Money Down the Drain

▼

When fifteen-year-old Lindsay Frimodt was a little girl, she used to tell people she wanted to be a model when she grew up.

Lindsay did achieve her goal—but not before she fell prey to a scam in the modeling industry.

"When I was eleven, I started answering ads for models in newspapers and on the radio," said the San Francisco teenager. "How wrong. They'd say, 'Pay us this money and you'll get this.' They made me think that I'd be a model, so I paid the money and got nowhere."

She spent years wasting money and being disappointed.

"One place told us to pay a few hundred dollars to get photos," Lindsay recalled. "Then we got these photos—there were about twelve of them and they were the size of a stamp. They said they would appear in a magazine that gets shown to agencies and directors and that I'd get loads of work and be a model. So I went through with it. At the time I thought, 'Hey, it looks cool.' "

But Lindsay was misled. "It was a total scam," she said. "I didn't know it was a scam until I went another route that was legitimate."

Two years later, Lindsay got on the right path. She went to a legitimate model convention, got a

dustry is a maze, and it is filled with trapdoors and dead ends.

DON'T FALL INTO A TRAP

Beware as you start out: the broadly defined "world" of modeling is filled with people who want to prey on the dreams of naive youths. The modeling industry is a business. There are thousands more girls who dream of being a model than there are modeling jobs.

Sometimes it even seems to me that there is an entire "para-industry" that has recognized this and organized to try to make money off of people who are gullible. This para-industry thrives on the hopes and dreams of wanna-be models, and I'm sorry to say that it seems to be doing quite well.

Don't let yourself fall into bad people's clutches. They won't put your face on a billboard, but they *will* drain your pocketbook.

Look, for example, in the classified advertisements of a newspaper, and you're bound to see ads for schools, so-called agencies, contests, or photographers who hold out the hope of turning you into a model or actress. These people will probably tell you that you could be a model and that they can help get you jobs, or—worse yet—that they can "make you a star." Some of these ads are not placed by reputable agencies, rather they pose as such so they can take money from people.

Sometimes, disreputable photographers place ads like this so they can charge girls thousands of dollars to take pictures—and

some of them have worse intentions than just making a buck. In either case, the pictures they take tend to be less valuable than the snapshots you might take at home.

Always be wary of any operation that asks for money up front to get you jobs or make you a star. Never pay anyone up front. Remember that only *you* can determine your fate in modeling. It is your own personal qualities, not those you can buy, that will lead you on the path to success.

Although some of these people may be for real, I have seen, more often than not, that they are phonies. Legitimate or not, I do still wish that all companies in this industry could be more sensitive to girls' actual chances of becoming a model. It would save girls a lot of heartache and money.

reputable agent, and has been working ever since.

She is concerned about young girls getting ripped off and would like to tell them all to be careful not to fall for the same scams she did. Lindsay says the most important things are to ask questions and to get a reputable agent who doesn't charge you money to represent you.

▲

CONVENTIONS AND MODELING SCHOOLS

Should you sign up for modeling conventions, which charge an entrance fee?

First make sure that the company sponsoring the convention is legitimate (and has reputable agencies attending). Then keep in mind that for every model who does get signed with an agency through a convention, there are dozens or maybe even hundreds who don't.

As for modeling schools, we've seen that some of them are devoted to establishing girls' careers in major markets, but there are also lots of modeling schools that are in business solely for profit. These latter would more accurately

be called finishing schools; they have no ties to major agencies and often give girls false hopes.

These schools charge a lot of money for classes and photographs that do not equip people for a modeling career. The photographs students come away with are usually unprofessional—they may cost a lot, but they won't do the job as well as a snapshot taken by your mom—and the instruction does not closely resemble what a model will find when she starts to work.

If a girl has potential, an agency that is affiliated with a school may choose to represent her. But more often than not, girls who attend modeling schools are *not* chosen to be represented by reputable agencies.

It is very clear which schools are reputable and which are not, and if you dig for the right information, you can find out.

HOW IT *DOES* WORK

Reputable agencies—those that will get a model legitimate work—never advertise for new models. Those that sponsor annual contests will advertise for those events, but even in those cases, the agencies seldom charge anything but a nominal entry fee. The best, most lucrative and prestigious modeling jobs are never advertised in newspapers, posters, billboards, or on the radio. Only agents at reputable firms and their clients are privvy to them.

In the appendix to this book, I've listed the names of some of the top modeling agencies around the country. The list is not exhaustive, to be sure, and there are plenty of fine agencies that were excluded for space reasons. But it's meant to be a handy point of reference.

To sniff out frauds, it's a good idea to do some research. One way might be to ask people in the modeling or fashion business if they know of the company or person you are considering working with. Most important, always listen to yourself and follow your gut instincts: if something doesn't seem right or fair, question it and look elsewhere.

One thing that should send up a red flag in your mind: anyone who makes it seem as if the modeling industry is easy to enter. Think of all those girls at the modeling conventions, as well as the ones who tried but didn't even make it there—or girls in modeling schools learning skills they may never be able to use! Think also of the piles of photos agencies receive every week, com-

pared to the handful of girls who make it to the top. Remember that the modeling industry is incredibly tough, that people who take a stab at it have the odds stacked against them, and that it takes more than good looks to achieve success.

A reputable agency will be very honest and straightforward with you, offering a candid evaluation of your chances at making it big. Listen to them. They know a lot more than the people who stand to make money off your vanity.

USE YOUR WITS

If someone approaches you on the street, at a mall, or in a store and claims to be a talent scout, agent, photographer—whatever—he or she may very well be one. But be wary, and be smart. Never agree to meet these people or go someplace with them right away. Take their business card and investigate them. If they check out cleanly—and some will—make sure you bring a parent with you when you go to see them, and make sure to meet at their office or a public place.

Always assume that whoever approaches you may not be telling the truth. Don't be paranoid, just extremely careful and cautious. The responsibility is in your hands. It's your life and your career, and the kindest thing you can do for yourself is to start it off on the right foot. Professional representation—plus hard work, perseverance, enthusiasm, a positive attitude, intelligence, beauty, and a little bit of good timing—can translate into a very successful and lucrative career.

Being cautious doesn't end when you become a working model. Caution and awareness are important even after you have signed with an agency, are testing, or are working and traveling for modeling jobs. It is fairly safe to assume that the people you will be working with are professional, providing they are affiliated with jobs set up by your agent. But not everyone you will work with will be legitimate or behave professionally. Always look out for yourself and take care of your own interests. If someone, something, or some situation does not feel right to you, call your agent, call your parents, and excuse yourself.

Some basic rules to follow as a working model:

- Never give out your address or home phone number, unless to your agent.
- Always have people call your agent, not *you*.
- Don't agree to a job or an extension of a job before it is cleared with your agent.
- Don't go anywhere or agree to do something just because everyone on the shoot is going there or doing it.
- Don't say or do something that makes you uncomfortable just because you think it will get you a job.

First trust yourself and your parents. Your agent and your parents should always know where you can be reached. If you behave professionally, your agent will trust and respect you, and you will end up with a network of people who can help you resolve any problems.

FINAL THOUGHTS

"Everything has its beauty, but not everyone sees it."
—Confucius

MODELING CAN BE a very exciting, rewarding career. But not every pretty girl is cut out to be a model. And anyone who pursues it must view it as a job (what she does) and not her identity (who she is). Being a model is a part of a girl's life, along with her education, sports, friends, reading, family, volunteer work, and so forth. Unlike these other aspects of life, modeling offers girls a chance to make money at a young age and in a relatively short amount of time, and to travel places she might not otherwise visit.

One of the things I love most about my job is the opportunity to give so many girls their first job. They say things like: "Oh, I can't believe it!" "I almost had a heart attack!" "I nearly fainted!" "I never thought it would be me!" The appreciation they express is most gratifying.

It's also exciting for me to talk to models who are just starting out, to get to know them, to see them grow, and to see where they end up going. It's a thrill to know I have a hand in creating future stars.

For the most part in this business, it is your looks that get you there, get you noticed and get you started. But what keeps you there, what continues to get you work, are the other things about you—your personality, intelligence, perseverance, emotional stability, health, and dedication. Other factors include timing and a great agent, one who can turn an "ordinary" model into a supermodel. If it were all just as easy as looking pretty, more girls would be succeeding, and every nice-looking girl would be doing it.

Americans have a fascination with supermodels, as do young models themselves. Most models in the industry today will never achieve the status of a Cindy, Naomi, Christy, or Linda. In my years in the business, I can count on one hand the number of models I have worked with who have achieved that status. One, Niki Taylor, was and is an exceptional case—an amazing combination of beauty, grace, realness, intelligence, and spirit. She also has a strong support system of family and friends.

It has been great for me to hear firsthand from models I have worked with and some I haven't about what modeling has done for them and meant to them. They dedicate themselves to the job, put in hard work, and lean hard on the people close to them. They get so much back in return. Most models say they never dreamed modeling could bring so much to their lives: personal growth, the opportunity to learn about other people, visit exciting places, and explore new situations.

How do models measure their success? When does a model think she has "made it"? The definition of success differs from model to model. Does she feel truly successful if she gets a cover? Goes to Paris? Does a runway show for a top designer? Lands an ad campaign? Becomes a household name?

When asked, models' answers vary enormously. Some feel a major sense of accomplishment when they gain representation from a prestigious agency, when a test shoot turns out well, or when they see a single picture of themselves in a magazine, newspaper, or catalog. Some derive satisfaction from earning the money they need to continue their education, and some say they feel successful if they just enjoy their work. On the other hand, some models say they don't or won't feel successful until they have appeared on many magazine covers and all the runways, or have a cosmetics contract, or can host their own television show. In between are a million degrees of aspiration.

I have outlined the steps someone should take if she is serious about pursuing modeling. The first and most critical of these is an accurate assessment of your reasons for wanting to model, as well as your chances. The next step is to understand the demands of this highly competitive and unpredictable business, where the difference between success and failure can depend on market fads or great timing. The third step is to find legitimate agency representation, and the fourth step is to go for it.

You should view modeling as an adventure. Try it out, and keep in mind that if it doesn't work out, it has nothing to do with you as a person. Maybe

your look is not what is "in" now, but fashion styles will change, and you may be the hottest thing around in a few months or a couple of years. When and if you do take off, you will still be the person you are now.

My advice is to set your goals and work hard to achieve them. Believe in yourself, but never forget to enjoy the small successes along the way!

I hope you can recognize yourself in some of the scenarios in this book and some of the models' descriptions of themselves. If you're trying to start out in ways that some of these models have done—and getting positive results—you're heading in the right direction. If you don't see any connection between what you've read and what you are actually doing, you may be walking down the wrong path.

My goal was to provide the information necessary for you, the young reader, to make better-educated decisions about the modeling industry and whether it is right for you. I did not aim to set out any absolutes about why or how to enter the field of modeling, because it is not clear-cut. I did want to offer guidelines so *you* can make a better decision on your own, not a decision based on what other people might tell you. The decision must be entirely up to you. However you choose to pursue this career is your choice, and my hope is that you will choose wisely, and if modeling seems right to you, that you will succeed in it in ways that avoid disappointment and huge expense.

While not everyone can become a household name, it's possible to have great success both financially and personally through modeling.

As I've said, one of the most exciting aspects of the modeling industry is that things are always changing: trends come and go, and models' careers can take off or fizzle, for a variety of reasons.

Even in the short year it took to prepare this book, I saw enormous changes, both in the business climate and among the many models I interviewed. By the time this book reaches your hands, circumstances will be different again. While it's impossible to quantify all the changes and keep them totally up-to-date, I thought a glimpse of some of the evolution I've seen over the last year might give some helpful insight into what typically goes on.

First off, I've seen a truly encouraging trend in terms of the body types favored for modeling—some are larger. When I first started writing, plus-size modeling was a small category, and now, just one year later, it's becoming a hot field. The market for larger models has expanded, with more designers

and manufacturers recognizing the needs of plus-size consumers. Even manufacturers of junior-clothing lines are looking to target this market.

Remember Liris Crosse, the model who tried so hard to make it in the regular market before turning to plus-size modeling? The new attitude in the industry has been great for her. Liris appeared in the August, 1997, issue of *Seventeen* in a feature about plus-size fashions. Since she first talked to me, she has also appeared in *Black Elegance* magazine.

Liris's situation isn't unique. Many of the models you met in this book have just started landing prestigious modeling jobs, while others have left the business entirely. Some have switched agencies. Some are still in high school, adding pictures to their portfolios and getting modeling work after school. Even Carrie Tivador—although she signed a Cover Girl contract and is represented by Elite—is still home at school in Canada, working around her school schedule.

A few girls who had never been to New York have made the trip. Beau Garrett spent a week here—testing and meeting clients—and landed a six-page spread in the August 1997 issue of *Seventeen*. Then she went back home to Los Angeles, appearing in ads for Hang Ten and Esprit, and in magazines like *Dolly, Amica,* and Spanish *Elle,* and the J. Crew catalog.

Then Beau came to New York again, this time as one of forty national finalists for Elite's Model Look contest. She was among ten girls selected to compete in the international finals in Nice, France, and she also won a money contract to appear in advertisements for Keds. Beau is definitely on her way!

Another model who came to New York is Lindsay Frimodt of San Francisco. She tested, met clients, and worked for *Seventeen*. Back home, Lindsay works both in Los Angeles and San Francisco; she has appeared in *Teen* magazine and in an ad for Jonathan Martin that appeared in *Interview* and *Marie Claire*. She hopes to move to New York.

Natasha Bonheimer also visited New York, though she didn't get any work during her two-week stay. The lesson was a good one, though; Natasha went back to high school in Sacramento, and now realizes how hard the modeling industry is and how much patience is necessary. She stays in touch with her agents at Elite in Los Angeles—who are still excited about her—and recognizes that not everyone can make it overnight.

Some of the working models I spoke to have been adding to their lists of credits. Jaime Rishar has been photographed for a huge Revlon makeup

campaign, the J. Crew catalog, and countless magazines. Tomiko Fraser has been in ads for The Gap and The Limited, and has appeared in *Cosmopolitan* and *Top Model* magazine.

Tomiko has also achieved other goals she had discussed with me earlier: to start an organization to help needy children and to go back to college. In 1997, she and friends founded a nonprofit organization called Colors of Love, which supports children's charities. It's run by people of different nationalities, and the goal is to promote racial unity. Tomiko is also pursuing an independent study program.

Several models have decided to put modeling on hold in favor of school. One is Filippa Von Stackelberg, the New Yorker whose success I cited as an example of someone whose career took off right away. Despite her hot prospects, Filippa, at fifteen, decided it was more important to her to be in school and to hang out with her friends.

Another model returning to school is Heather Lett of New Jersey, who also had the beginnings of a great career. Heather stopped working and decided instead to attend college.

On the acting front, Jessica Biel—the model who appears in *Seventh Heaven*—stars in the 1997 movie *Ulee's Gold,* by Orion Pictures, with Peter Fonda. She hopes to get more film roles, and continues her work on the TV series.

Another working actress is Amy Smart of Los Angeles. At this writing, she had completed work in three independent films, including one, *High Voltage,* with Antonio Sabado, Jr. Amy is concentrating full-time on her budding acting career.

Tyra Banks has written a book, in stores now, called *Tyra's Beauty Inside & Out.* The supermodel shares her beauty secrets and it is quite inspirational.

These examples show, among other things, how important it is to keep an open mind about modeling, to decide for yourself what the right course should be. Even though modeling may be your dream, you may find it's not really what your heart desires—or what the industry has in store for you. Or, on the flip side, you may hit your stride in modeling, finding work and deriving satisfaction from a career that builds on itself.

APPENDIX

Directory of Major Model Agencies, Conventions, and Contests

This is a list of modeling agencies, conventions, and contests in the United States and modeling agencies in Canada.

If you live more than three hours from any of the agencies, you may choose to start at a smaller agency. Look them up in your telephone book, check them out with the Better Business Bureau, and ask questions. Make sure a local agency has ties to major market agencies, either directly or through conventions, or that they work with top clients directly. Try to choose the most direct path.

Since agencies can come and go, or move offices, it's a good idea to call to confirm that they are still in business and that their address has not changed.

AGENCIES

United States

ATLANTA

Arlene Wilson Model Management
887 W. Marietta Street
Atlanta, GA 30318
 (404) 876-8555

Click Model Management
79 Poplar Street
Atlanta, GA 30303
 (404) 688-9700

Elite Model Management
181 14th Street
Atlanta, GA 30309
 (404) 872-7444

L'Agence
5901-C Peachtree Dunwoody Road
Atlanta, GA 30328
 (770) 396-9015

CHICAGO

Aria Model & Talent Management
1017 W. Washington
Chicago, IL 60607
 (312) 243-9400

Arlene Wilson Model Management
430 W. Erie Street
Chicago, IL 60610
 (312) 573-0200

David & Lee
641 W. Lake Street
Chicago, IL 60611
 (312) 707-9000

Elite Model Management
58 W. Huron Street
Chicago, IL 60610
 (312) 943-3226

DALLAS

The Campbell Agency
3906 Lemmon Avenue
Dallas, TX 75219
 (214) 522-8991

Kim Dawson Agency
2300 Stemmons Freeway
Dallas, TX 75258
 (214) 638-2414

Page Parkes Models Rep
3303 Lee Parkway
Dallas, TX 75219
 (214) 526-4434

LOS ANGELES

Bordeaux Model Management
616 North Robertson Boulevard
West Hollywood, CA 90069
 (310) 289-2550

Click Model Management
9057 Nemo Street
West Hollywood, CA 90069
 (310) 246-0800

Elite Model Management
345 N. Maple Drive
Beverly Hills, CA 90210
 (310) 274-9395

Ford Models
8826 Burton Way
Beverly Hills, CA 90211
 (310) 276-8100

It Models
526 N. Larchmont Boulevard
Los Angeles, CA 90004
 (213) 962-9564

LA Models
8335 Sunset Boulevard
Los Angeles, CA 90069
 (213) 656-9572

Next Management
662 N. Robertson Boulevard
West Hollywood, CA 90069
 (310) 358-0100

United/Prima/Omar's
6855 Santa Monica Boulevard
Los Angeles, CA 90038
 (213) 468-2255

Wilhelmina Models
8383 Wilshire Boulevard
Beverly Hills, CA 90211
 (213) 655-0909

MIAMI

Click Model Management
1688 Meridian Avenue
Miami Beach, FL 33139
 (305) 674-9900

Elite Model Management
1200 Collins Avenue
Miami Beach, FL 33139
 (305) 674-9500

Ford Models
826 Ocean Drive
Miami Beach, FL 33139
 (305) 534-7200

Irene Marie Model Management
728 Ocean Drive
Miami Beach, FL 33139
 (305) 672-2929

Next Management
209 9th Street
Miami Beach, FL 33139
 (305) 531-5100

Michele Pommier Models
927 Lincoln Road
Miami Beach, FL 33139
 (305) 672-9344

Page Parkes Models Rep
763 Collins Avenue
Miami Beach, FL 33139
 (305) 672-4869

NEW YORK CITY

Boss Models
1 Gansevoort Street
New York, NY 10014
 (212) 242-2444

Click Model Management
129 W. 27th Street
New York, NY 10001
 (212) 206-1616

Company Management
270 Lafayette Street
New York, NY 10012
 (212) 226-9190

DNA Model Management
145 Hudson Street
New York, NY 10013
 (212) 226-0080

Elite Model Management
111 E. 22nd Street
New York, NY 10010
 (212) 529-9700

Ford Models
142 Greene Street
New York, NY 10012
 (212) 966-3565

I'M NY (Irene Marie Model
Management)
400 West Broadway
New York, NY 10012
 (212) 941-1333

Images Models
30 E. 20th Street
New York, NY 10003
 (212) 228-0300

IMG Models
304 Park Avenue South
New York, NY 10010
 (212) 253-8884

It Models
251 Fifth Avenue
New York, NY 10016
 (212) 481-7220

Karin Models
524 Broadway
New York, NY 10012
 (212) 334-6400

Metropolitan Models
5 Union Square West
New York, NY 10003
 (212) 989-0100

Next Management
23 Watts Street
New York, NY 10013
 (212) 925-5100

Pauline's Model Management
379 West Broadway
New York, NY 10012
 (212) 941-6000

Wilhelmina Models
300 Park Avenue South
New York, NY 10010
 (212) 473-0700

Zoli Model Management
3 W. 18th Street
New York, NY 10011
 (212) 242-1500

PHOENIX

Ford/Robert Black Agency
7525 E. Camelback Road
Scottsdale, AZ 85251
 (602) 966-2537

Leighton Agency
2231 E. Camelback Road
Phoenix, AZ 85016
 (602) 224-9255

SAN FRANCISCO

City Model Management
123 Townsend Street
San Francisco, CA 94107
 (415) 546-3160

Look Model Agency
166 Geary Street
San Francisco, CA 94108
 (415) 781-2822

Mitchell Agency
323 Geary Street
San Francisco, CA 94102
 (415) 395-9291

Stars, The Agency
777 Davis Street
San Francisco, CA 94111
 (415) 421-6272

SEATTLE

Heffner Management
1601 Fifth Avenue
Seattle, WA 98101
 (206) 622-2211

Seattle Models Guild
1809 Seventh Avenue
Seattle, WA 98101
 (206) 622-1406

Canada

Access Agency
110 Clarence Street
Ottawa, ONT K1N 5P6
 (613) 241-3105

Charles Stuart International Models
212-1008 Homer Street
Vancouver, BC V6B 2X1
 (604) 222-3177

Elite Models
477 Richmond Street West
Toronto, ONT M5V 3E7
 (416) 369-9995

Folio Montreal
295 de la Commune Ouest
Montreal, QB H2Y 2E1
 (514) 288-8080

Ford Canada
3 Sultan Street
Toronto, ONT M5S 1L6
 (416) 962-6500

Giovanni Model Management
333 Adelaide Street West
Toronto, ONT M5V 1R5
 (416) 597-1993

Ice Model/Talent Management
344 Dupont Street
Toronto, ONT M5R 1V9
 (416) 968-7804

Patti Falconer Agency
2523 17th Avenue
Calgary, ALB T3E 0A2
 (403) 249-8112

CONVENTIONS

United States

Model Search America
588 Broadway
New York, NY 10012
 (212) 343-0100

New York Model Contracts
2424 Edenborn Avenue
Metairie, LA 70001
 (504) 835-5654

The Palm Group
345 N. Canal Street
Chicago, IL 60606
 (312) 382-5368

ProScout
1 E. Superior Street
Chicago, IL 60611
 (312) 642-8880

CONTESTS

Agencies

Elite Model Look
111 E. 22nd Street
New York, NY 10010
 (212) 529-9700

Ford Supermodel of the World
142 Greene Street
New York, NY 10012
 (212) 966-3565

LA Looks Model Search Contest
(LA Models)
8335 Sunset Boulevard
Los Angeles, CA 90069
 (213) 656-9572

Next "Find the Next Model" Search
23 Watts Street
New York, NY 10010
 (212) 925-5100

Wilhelmina Teen Search Contest
300 Park Avenue South
New York, NY 10010
 (212) 473-0700

Magazines

Seventeen
850 Third Avenue
New York, New York 10022
 (212) 407-9700

Teen
110 Fifth Avenue
New York, New York 10011
 (212) 935-9150

YM
375 Lexington Avenue
New York, New York 10017
 (212) 499-2000

ABOUT THE AUTHOR

As Model Editor for *Seventeen* magazine for over ten years, Donna Rubinstein "made" hundreds of modeling careers. She has been interviewed for many publications, including *People* magazine and the *New York Times,* and has been featured on *Oprah, Entertainment Tonight* and MTV's *House of Style,* as well as other television appearances. She travels regularly to modeling conventions and contests in search of fresh talent and to advise and inform aspiring models. Donna is a graduate of Syracuse University. She is also a certified Reflexologist, practices yoga daily and is studying to become an instructor. She lives in New York City.

Readers interested in contacting Donna are encouraged to do so by writing to her in care of her publisher:

Perigee Books
The Berkley Publishing Group
A division of Penguin Putnam Inc.
375 Hudson Street
New York, New York 10014